THE
WARPED
SIDE
OF OUR
UNIVERSE

ALSO BY KIP THORNE

Modern Classical Physics (with Roger D. Blandford)

The Science of Interstellar

The Future of Spacetime (with Stephen W. Hawking, Igor Novikov, Timothy Ferris, Alan
 Lightman, and Richard Price)

Black Holes and Time Warps: Einstein's Outrageous Legacy

Black Holes: The Membrane Paradigm (with Richard H. Price and Douglas A. Macdonald)

Gravitation (with Charles W. Misner and John Archibald Wheeler)

Gravitation Theory and Gravitational Collapse (with B. Kent Harrison, Masami
 Wakano, and John Archibald Wheeler)

ALSO BY LIA HALLORAN

Your Body Is a Space That Sees

Black Hole Survival Guide written by Janna Levin, artwork by Lia Halloran

Liveright Publishing Corporation

A Division of W. W. Norton & Company

Celebrating a Century of Independent Publishing

THE WARPED SIDE OF OUR UNIVERSE

AN ODYSSEY THROUGH BLACK HOLES, WORMHOLES, TIME TRAVEL, AND GRAVITATIONAL WAVES

KIP THORNE
LIA HALLORAN

For information about permission to reproduce selections from this book, write to
Permissions, Liveright Publishing Corporation, a division of W. W. Norton & Company,
Inc., 500 Fifth Avenue, New York, NY 10110

For information about special discounts for bulk purchases, please contact
W. W. Norton Special Sales at specialsales@wwnorton.com or 800-233-4830

Manufacturing by Toppan Leefung in China
Design by Rebeca Méndez with Jason Lee
Rebeca Méndez Studio, Los Angeles, CA

LIBRARY OF CONGRESS CATALOGING-IN-PUBLICATION DATA

Names: Thorne, Kip S., author. | Halloran, Lia, 1977– illustrator.
Title: The warped side of our universe / Kip Thorne and Lia Halloran.
Description: First edition. | New York, N.Y. : Liveright Publishing Company, [2023] |
 Includes bibliographical references.
Identifiers: LCCN 2023010398 | ISBN 9781631498541 (cloth) |
 ISBN 9781631498558 (epub)
Subjects: LCSH: Space and time—Poetry. | Gravitational waves—Poetry. |
 Black holes (Astronomy)—Poetry. | Wormholes (Physics)—Poetry. | LCGFT: Poetry.
Classification: LCC PS3620.H7676 W37 2023 | DDC 811/.6—dc23/eng/20230418
LC record available at https://lccn.loc.gov/2023010398

Liveright Publishing Corporation, 500 Fifth Avenue, New York, N.Y. 10110
www.wwnorton.com

W. W. Norton & Company Ltd., 15 Carlisle Street, London W1D 3BS

1 2 3 4 5 6 7 8 9 0

For Felicia and Carolee

PREFACE

This book embodies, through poetry and paintings, the ethos of a wild and unfamiliar side of our universe: objects and phenomena made from warped spacetime. *Our universe's Warped Side.*

Weirdly, this book grew out of an article commissioned by *Playboy* magazine. It was an era when *Playboy* was trying to distinguish itself from other men's magazines by including high-quality literature and art. In August 2010, *Playboy*'s literary editor, Amy Grace Loyd — who earlier had edited Kip's book *Black Holes and Time Warps* — invited Kip to write an article for *Playboy*. Kip suggested as a topic "The Warped Side of the Universe," with art by Lia. After perusing some of Lia's paintings, Amy and the art editor enthusiastically agreed. The following July we submitted a 6,000-word manuscript (prose, not poetry) and nine paintings, including some with Lia's girlfriend (now wife), Felicia.

Amy — after presenting the article and paintings to Hugh Hefner and his *Playboy* team — wrote to us in anguish: "It seems Hef and our art director do not think the images Lia has come up with are quite right. . . ." Lia's depiction of Felicia was not up to the "Femlin standard" that Hefner required for *Playboy* women. Not aspiring to that standard, we held our ground: Accept Lia's paintings as is, or we take the article elsewhere. The rejection was firm, with a kill fee.

We soon came to rejoice. It was an incredible opportunity to transform our little article into something far more beautiful and impactful: this magnificent book that embodies the exciting discoveries and speculations of recent years about the strangeness of black holes and wormholes, bizarre flows of time, and the birth of our universe — our universe's *Warped Side*. As part of this transformation, we chose to include just one space traveler in our book's verse and paintings: Lia's wife, Felicia.

Our transformed book invites viewers into the wonders and wildness of the Warped Side of our Universe, as an experience of intimacy and beauty.

This book, like our short article, began as prose and paintings. Each time we met, our conversations and enthusiasm triggered new directions of prose and ideas for new paintings. For Lia,

a freewheeling, independent artist, this collaboration was a new kind of challenge, unlike anything she had done before: translate Kip's complex ideas about the unseen universe — ideas he conveyed to her in words and sketches — into simple but elegant, often breathtaking, paintings that would transport the viewer.

For Kip, it became an even more radical challenge. When he saw the book's first, preliminary layout, with Lia's paintings beside his prose and a few lines of prose broken into stanza-like segments, he had an epiphany: his prose was almost poetic. So — although he had never before written poetry consciously, aside from a few love poems to his wife — he vowed to transform his prose into verse, a challenge that has hugely changed the feel of the book, making esoteric ideas more accessible.

As a youth, Kip doted on the poems of Robert Service (the Canadian poet known as "the Bard of the Yukon"), particularly *The Cremation of Sam McGee*. Service's tetrameter/trimeter *rhythm* — with its four-beat and three-beat lines* — had lodged in Kip's brain and emerged almost effortlessly a half century later as the backbone of our book's verse.

However, for Kip this is far more flexible and supports a far greater variety of metrical digressions than in Service's more rigid, traditional ballad poetry. And Kip does not aspire to marry rhyme with meter. After some struggles, he decided that attempted rhyming would too severely constrain his depictions of the Warped Side's landscape.

Creating this book has been fully collaborative between us, with verse inspiring paintings and paintings inspiring verse. We began the paintings with some verse in hand and with discussions about what objects and phenomena to depict visually. From there we shared reference photos and sketches that served as inspiration for the paintings. Then Lia created preliminary drawings that led to changes in Kip's verse, and Kip commented on the drawings until final paintings emerged. For each painting in the book, there were anywhere from three to ten preliminary paintings. In the midst of the Covid pandemic, we flew by private jet to the LIGO Observatory in Hanford, Washington, so Lia could photograph LIGO from the air and inside as reference shots for her paintings. All of the original artwork in the book is painted with ink on drafting film, with no digital manipulation.

* "There are **strange** things **done** in the **mid**night **sun** ⁄
 by the **men** who **moil** for **gold** . . ."

Over the thirteen years that we have taken to bring this book to completion, Kip and his physicist colleagues have transformed sparse speculation about the Warped Side into richer understanding. Via computer simulations, he and students and colleagues have predicted that strange physical structures stick out of black holes, structures made from warped spacetime: *vortices* of twisting space and *tendices* that stretch and squeeze. And they have seen, in the simulations, wild storms in the warping of spacetime, storms created when black holes collide; and they have watched the storms' fighting vortices and tendices embrace and entwine with each other to become gravitational waves. While we were molding this book, the thousand-person-strong LIGO project, which Kip cofounded with Rainer Weiss and Ronald Drever forty years ago, discovered those gravitational waves arriving at Earth from far away: humans' first direct contact with our universe's Warped Side. Through those waves, the LIGO team has confirmed that spacetime storms are real and behave as depicted in the simulations and in Lia's paintings.

This book has evolved into a vehicle for describing, in about 200 pages and 200+ paintings, these remarkable new discoveries of the past decade, and many other Warped Side discoveries and speculations. Lia's paintings evoke their essence visually; Kip's verse evokes their essence poetically. The paintings and verse intertwine, complementing and reinforcing each other.

Through this book, we invite you, the reader, to experience with us the amazing and beautiful *Warped Side of Our Universe*.

KIP THORNE AND LIA HALLORAN

Pasadena and Los Angeles, California
22 September 2022

PROLOGUE

/ Our universe is varied and vast —
 galaxies, planets, stars and moons
 quasars, pulsars and magnetars
 all made from atoms and molecules
 just like you and me
 and all that we hear and touch and see.

Our universe is also endowed
 with a marvelous, shadowy side that is *Warped*
 — phenomena forged
 from warped spacetime.
Witness the ravenous, fat black hole
 that Lia here depicts
 ingesting her wife,
 Felicia.

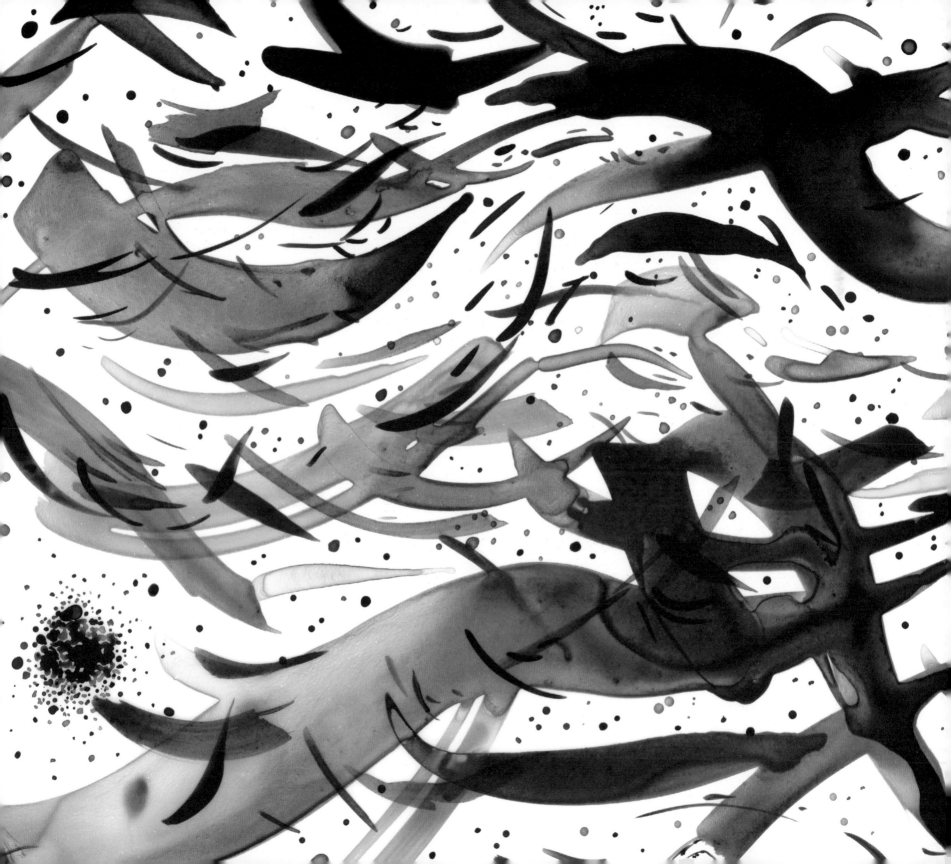

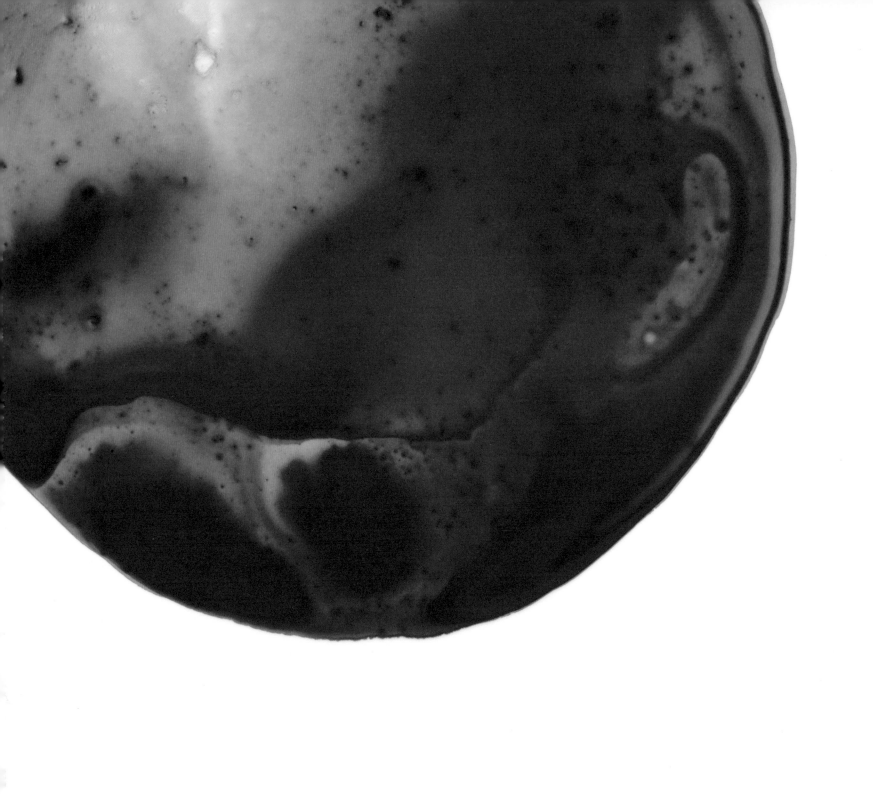

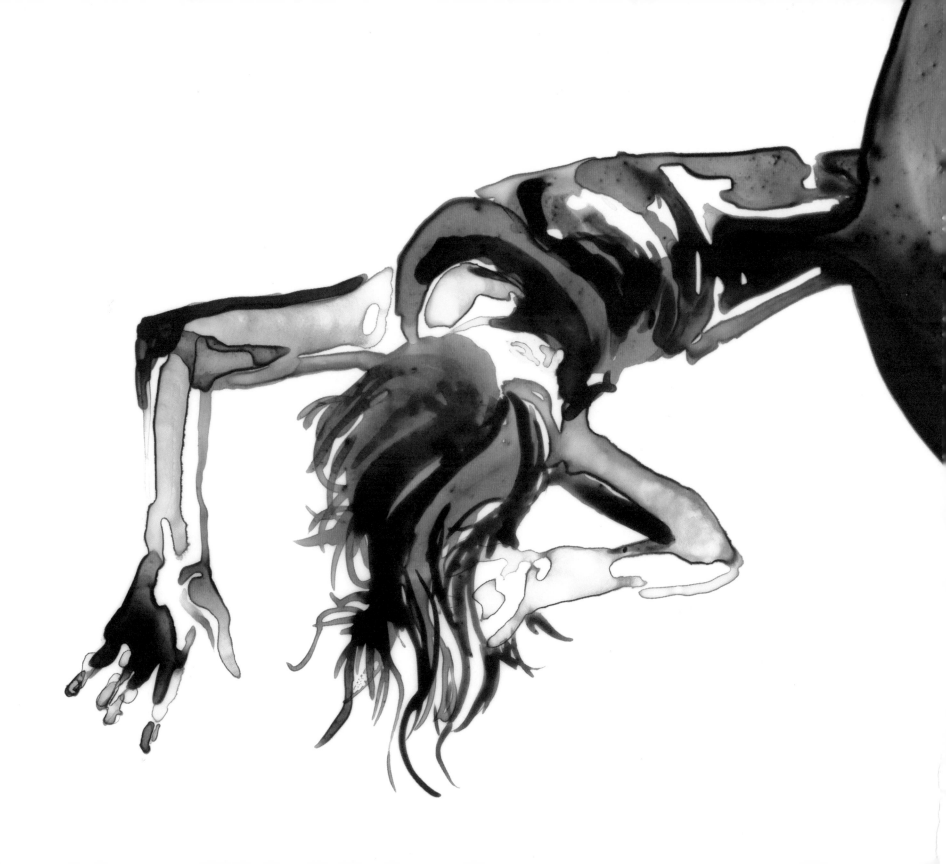

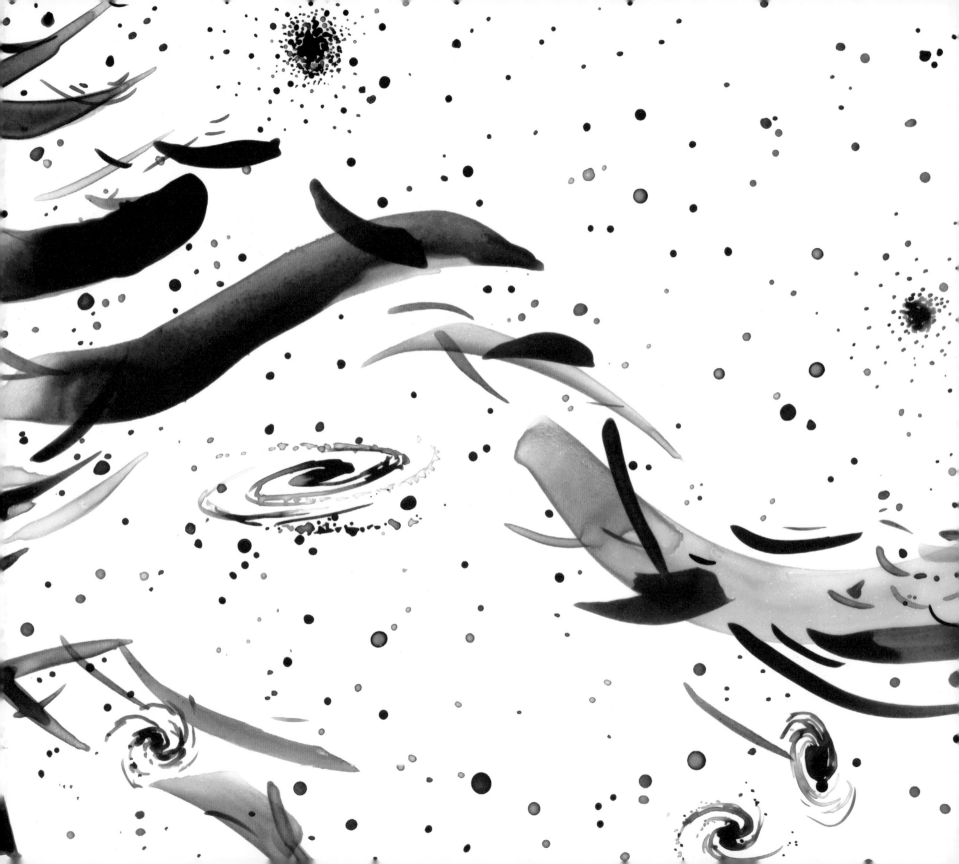

/ Although this Warped Side is entwined
 in the weft of our matter-filled universe
 — its stars, its planets and nebulae,
 its galaxies and its comets,
We humans
 never saw it,
 until just recently.

Why did we never see?

Warped spacetime cannot produce
 light or other signals
that yesterday's technology was able to perceive.

So *now* how has that changed?

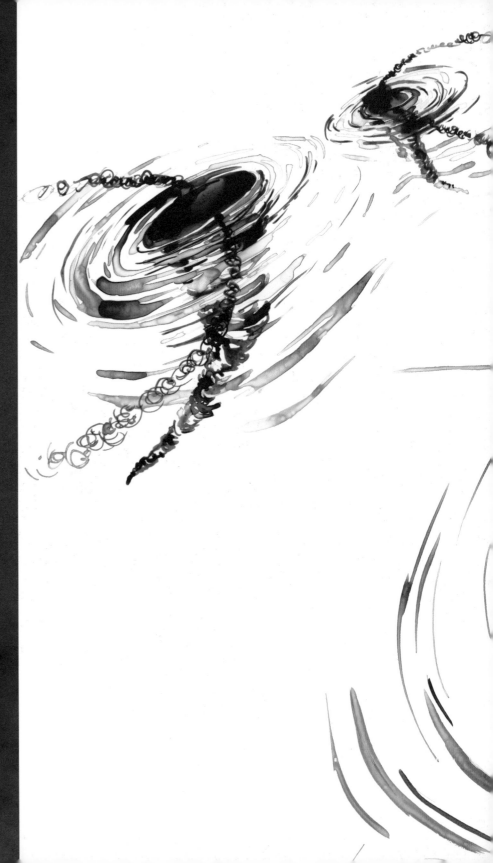

A very long time ago,
 a billion years in the past
— while here on Earth
 multicelled life
 arose and spread around the globe —
in a galaxy far, far away,
 two spinning black holes danced 'round one another,
 rippling the fabric of space and time.

The ripples
 — we call them gravity waves —
 sucked energy from the holes' orbit.
So
 the holes spiraled inward
 eclipsing each other
 toward a climactic collision.

The holes at half of light speed
catastrophically
 collided and merged
in a brief, cataclysmic storm
 of writhing and twisting spacetime
that brought the waves to crescendo.

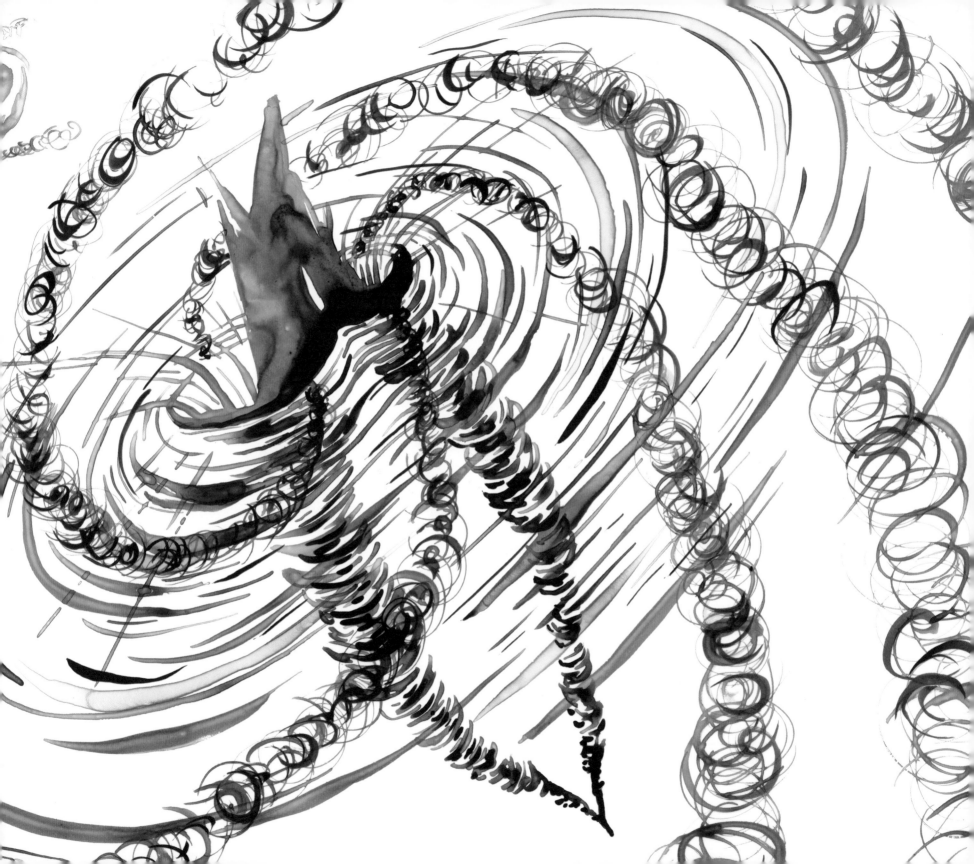

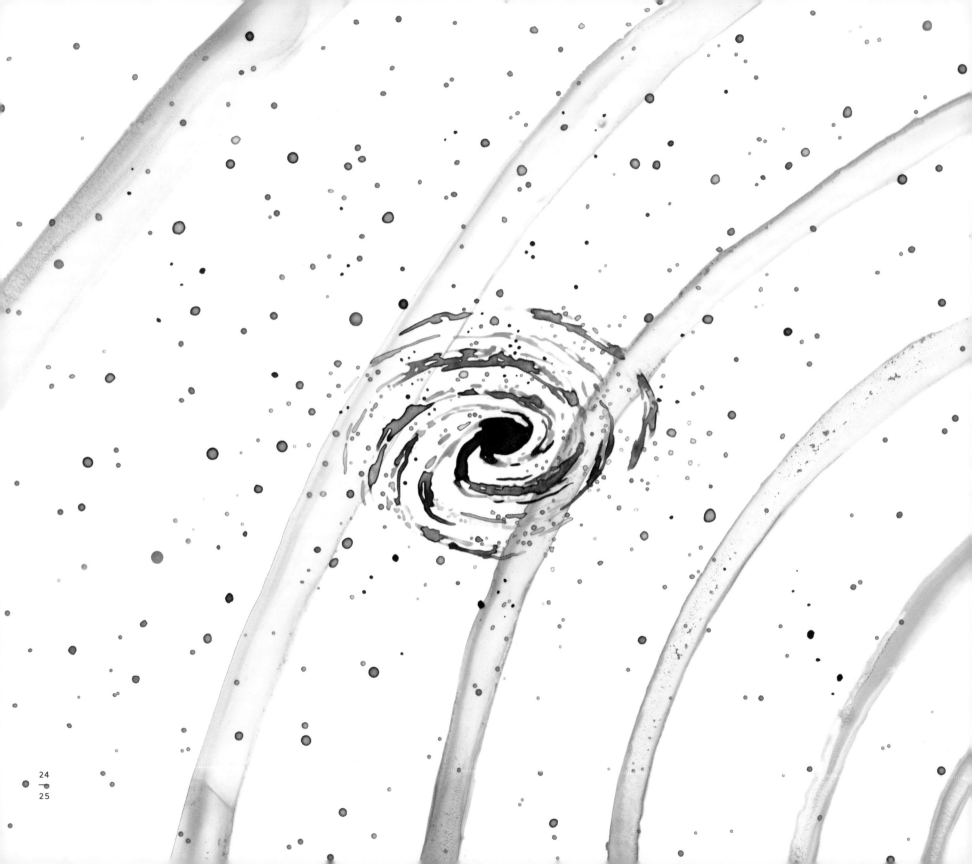

The climaxing gravity waves
 from this catastrophic collision
surged out of their birthing galaxy
 and into interstellar space.

 Spreading across our universe
 for nearly a billion years,
 they stretched and they squeezed
 all that they met
 (stars and planets and nebulae . . .)
 in patterns that encoded
 a portrait of their birth:
Colliding Holes and Spacetime Storm.

Then
fifty thousand years ago
 — when humans shared Earth with Neanderthals —
the spreading and weakening gravity waves
 sailed into our spiral-armed Milky Way.
 Our galaxy. Our home.

On September fourteenth of twenty fifteen
near the Antarctic peninsular tip
the waves, flying upward
plunged into the Earth
— through air, and then oceans, then rock . . .

Whispering up through Earth's bowels unscathed
and emerging just north of New Orleans
the gravity waves came face to face
with a complex and huge, L-shaped invention
designed and built to perceive them:

LIGO.
 The Laser
 Interferometer
 Gravity-Wave Observatory.

Flowing through LIGO, the gravity waves
 stretched and then squeezed microscopically
 two very long beams of bouncing light,
 that extracted the portraits
 the waves had encoded:
Colliding Holes and Spacetime Storm.

This tiny shudder in LIGO was
 momentous for
 the whole human race:
 our very first moment of contact with
The Warped Side of
 Our Universe.

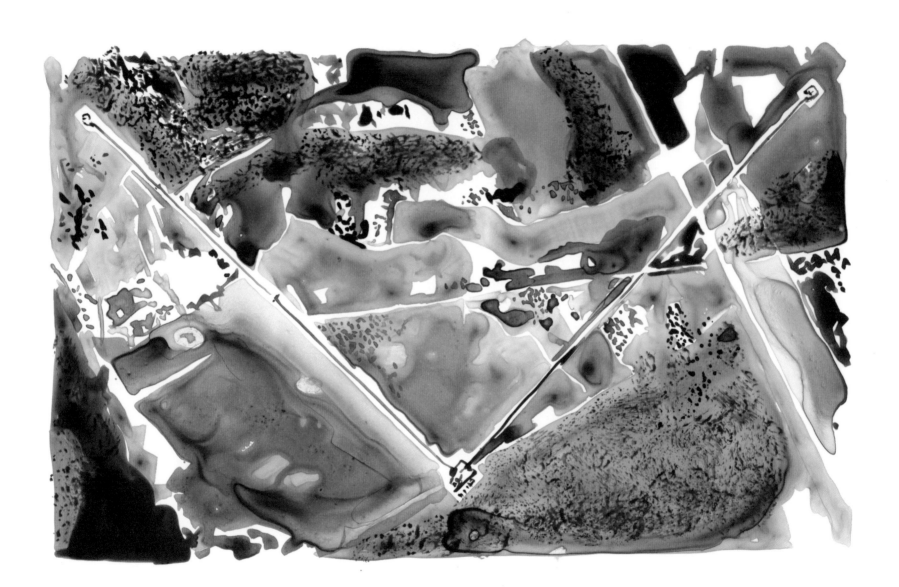

The Warped Side of Our Universe
 is home to many beasts —
Beasts that are forged
 from warped space and time

Beasts that may well include
 BLACK HOLES and WORMHOLES
 TIME MACHINES and COSMIC STRINGS
 GRAVITY WAVES
 and SINGULARITIES
 our UNIVERSE'S BIG-BANG BIRTH
 and MANY OTHER BEASTS
 WONDROUS, WEIRD, and WILD

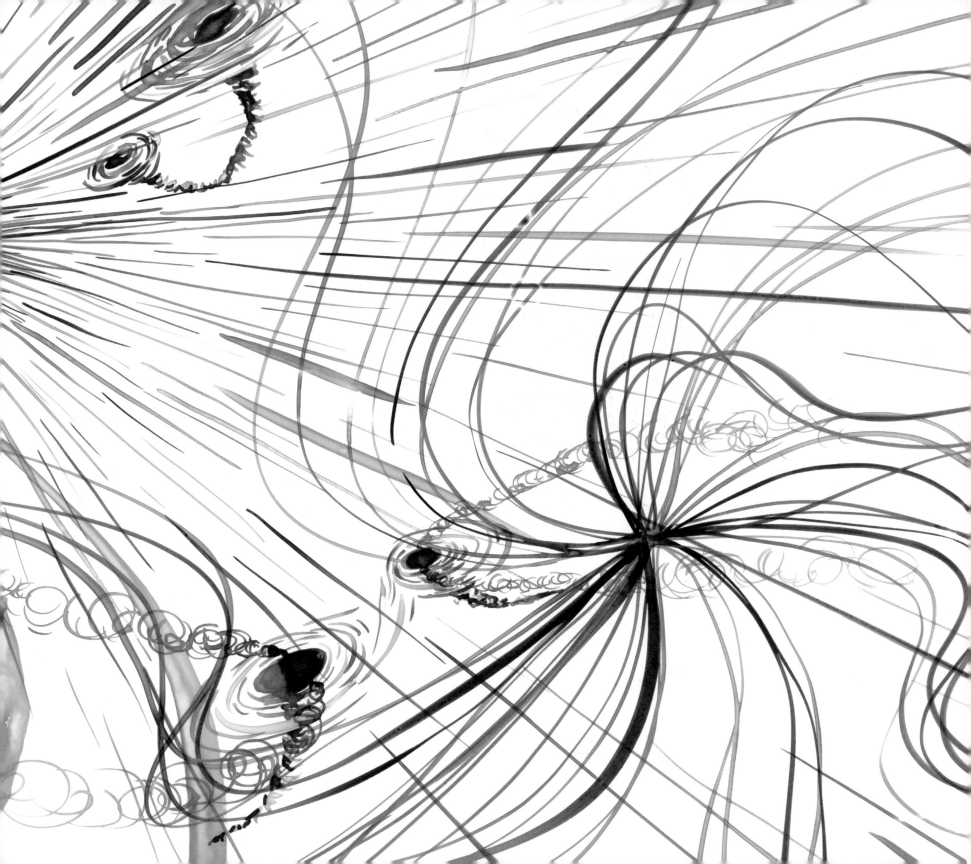

For decades, I — a beast
 materially composed —
have been consumed by quests
 to fully comprehend
this *Warped Side of Our Universe*.

How?
Through tricks of mathematics and
 computer simulations
 probing Albert Einstein's
 relativity equations.

And in a thousand-person fleet
 of scientists and engineers
we've pursued a quest
 to invent, construct and utilize
 our behemoth LIGO
 for humans' first encounters with
the Warped Side of Our Universe.

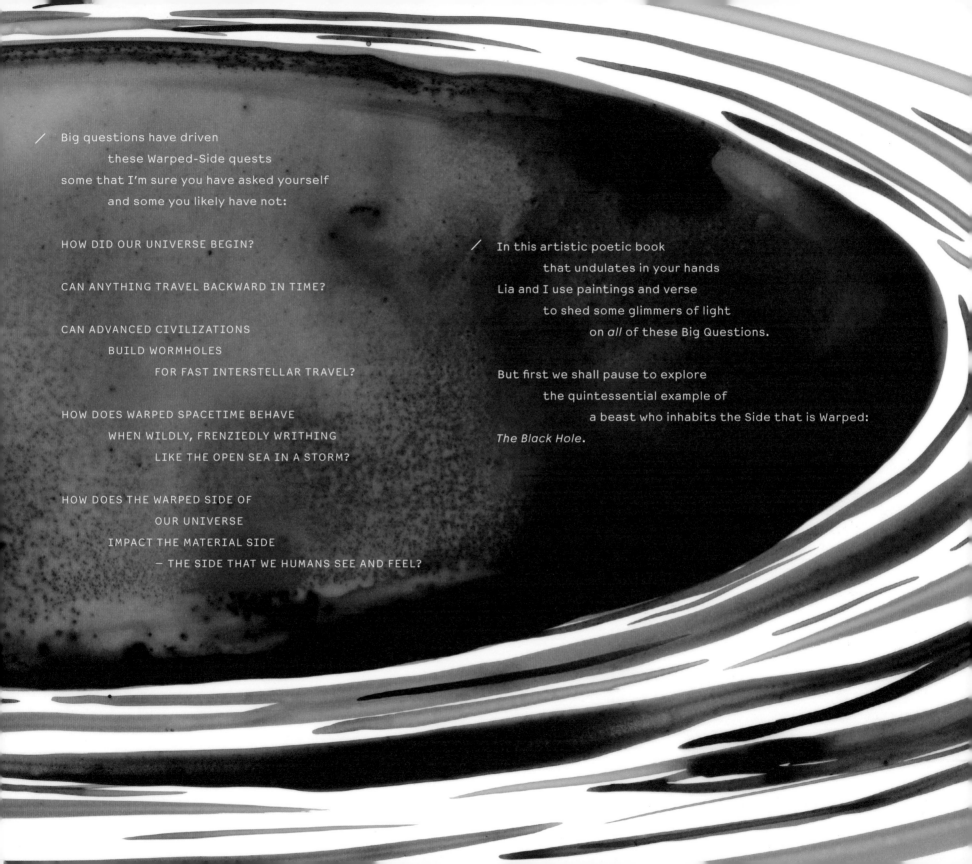

Big questions have driven
 these Warped-Side quests
some that I'm sure you have asked yourself
 and some you likely have not:

HOW DID OUR UNIVERSE BEGIN?

CAN ANYTHING TRAVEL BACKWARD IN TIME?

CAN ADVANCED CIVILIZATIONS
 BUILD WORMHOLES
 FOR FAST INTERSTELLAR TRAVEL?

HOW DOES WARPED SPACETIME BEHAVE
 WHEN WILDLY, FRENZIEDLY WRITHING
 LIKE THE OPEN SEA IN A STORM?

HOW DOES THE WARPED SIDE OF
 OUR UNIVERSE
 IMPACT THE MATERIAL SIDE
 — THE SIDE THAT WE HUMANS SEE AND FEEL?

In this artistic poetic book
 that undulates in your hands
Lia and I use paintings and verse
 to shed some glimmers of light
 on *all* of these Big Questions.

But first we shall pause to explore
 the quintessential example of
 a beast who inhabits the Side that is Warped:
The Black Hole.

1 / THE BLACK HOLE

Black Holes Are Weird

In the nineteen-twenties and-thirties
 when black holes first emerged from
 equations of relativity
 Einstein didn't believe.
They were *far* too bizarre for belief!

But now we know that Einstein was wrong.
Among the stars of our universe
 quintillions of black holes are sprinkled.
And millions inhabit our galaxy.
 Our Milky Way. Our home.

The black holes *all*
 are hidden from view
They emit no light whatsoever.
Nevertheless
 they make themselves known
 when their gravity tugs on stars,
 and on planets, gases, and galaxies.

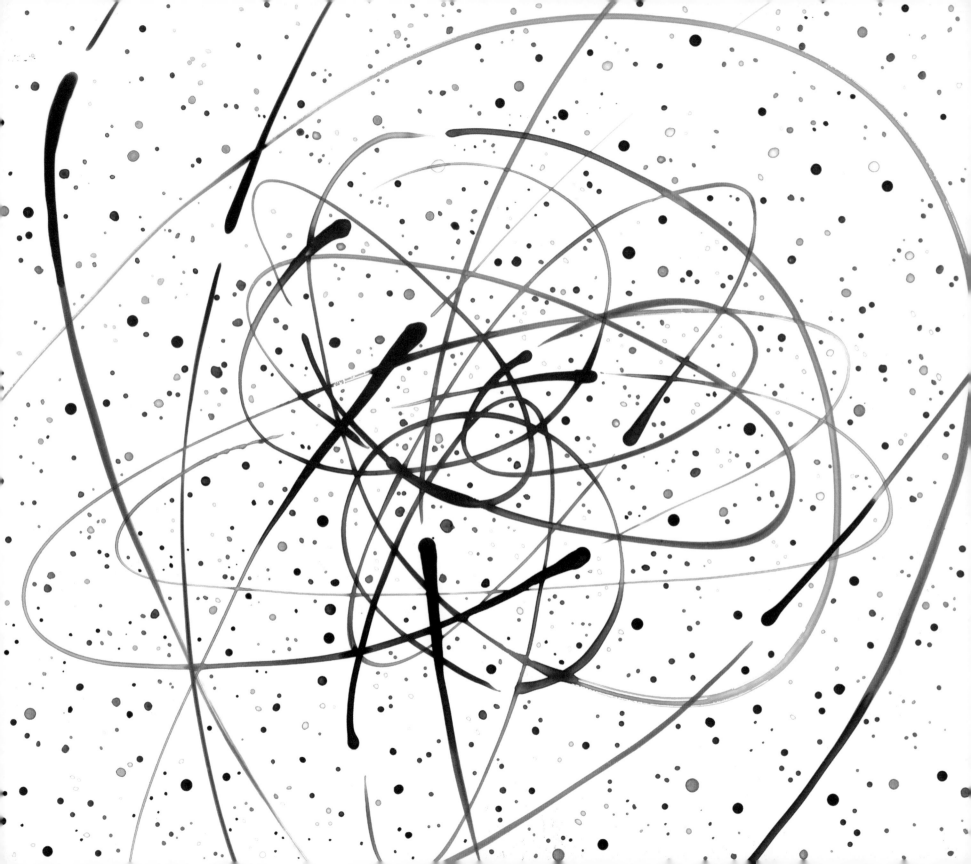

A Black Hole Is Made
 from Space That Is Warped

What space is warped? you may very well ask.

Nothing less than *all* of the space
 of the universe in which we live.
The space of *all* our activities
 with three familiar dimensions:
 East and West. North and South. Up and Down.

What is the *way* space is warped? you might ask.

The measurable distance across a black hole
 is tremendously large.
The measurable distance around the black hole
 is very much smaller.
If space were flat, that could not be.
This is the way space is warped
 Says the math of relativity.

The space of our whole universe may be warped
 in a larger space with higher dimensions
 — four or five or ten or more —
 dimensions that humans never can see,
dimensions we physicists call *the bulk*.

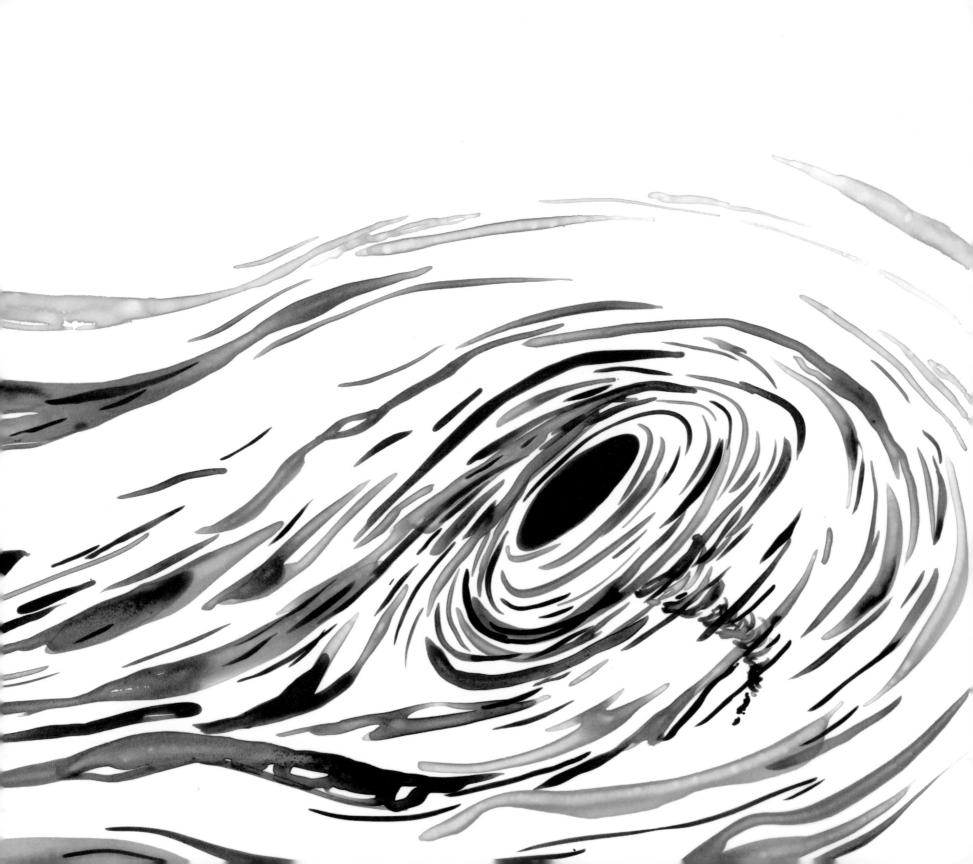

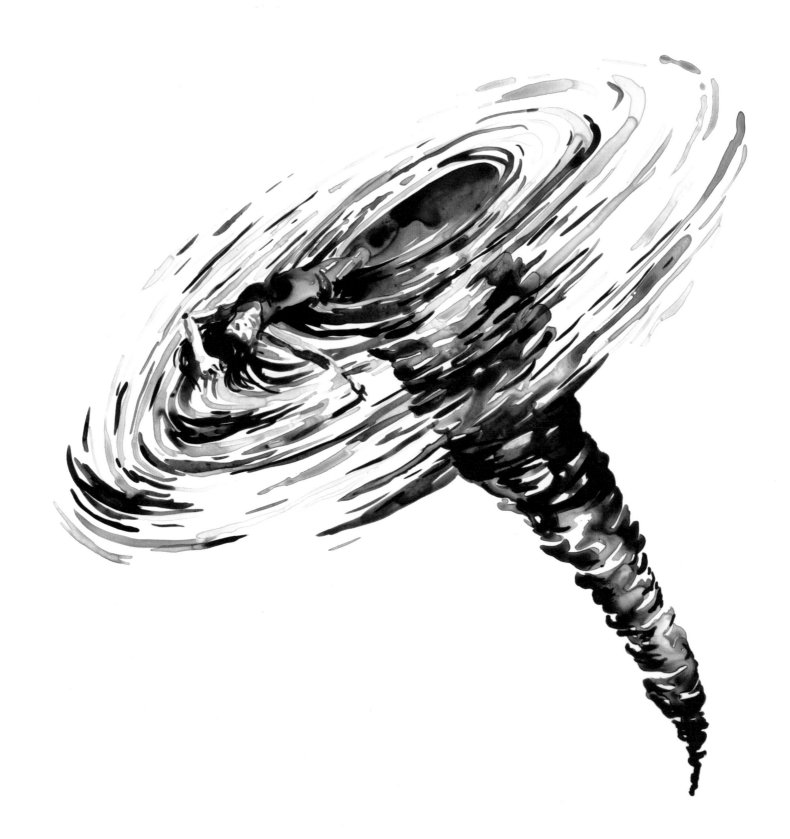

/ How can we visualize this warping
 in Lia Halloran's dazzling paintings?

We pretend that the space of our universe
 has just *two* dimensions, instead of three.
This space she depicts as a stretched rubber sheet
 a membrane or *brane*, in physicists' argot
 a brane that resides in the bulk and is bent
 (a bulk whose dimensions we pretend are just *three*
 because that's the best we can do, or see).

As viewed by creatures who live in the bulk
 — *bulk beings* I shall call them —
our brane near the hole bends down like a funnel
making huge the distance across the black hole —
 the distance *we* measure inside of our brane
 the distance traversing the funnel's surface —
 inward
 then downward
 back up and then out.

Like everything else that we humans can see
Felicia — Lia's fabulous wife —
 resides with us inside of our brane.
As bulk beings watch, gravity drags her
 along the brane's surface, then into the funnel
 and downward toward the funnel's *tip*:
 A vicious and lethal tip, it is
 the black hole's *singularity*.

We also reside inside of that brane,
 though far from the hole,
 where the brane's flattened out.
We see Felicia by light rays that cruise
 inside of the brane
 and not through the bulk.
To extend to our eyes, these rays from Felicia
stay clear of the funnel
 where gravity's so strong
 that they couldn't climb out.

As seen by us humans inside of our brane,
 the funnel therefore possesses a *mouth*
A mouth from which no rays can escape.
A mouth into which we never can see.

As the hungry black hole
 ingests poor Felicia
staring with light rays,
 we see her legs vanish
into the funnel's yawning black mouth:
 a circular mouth
 that's really a sphere
 since our brane's dimensions
 are actually three.

And therefore we see
 Felicia's legs vanish
into a yawning, *black, spherical hole*.

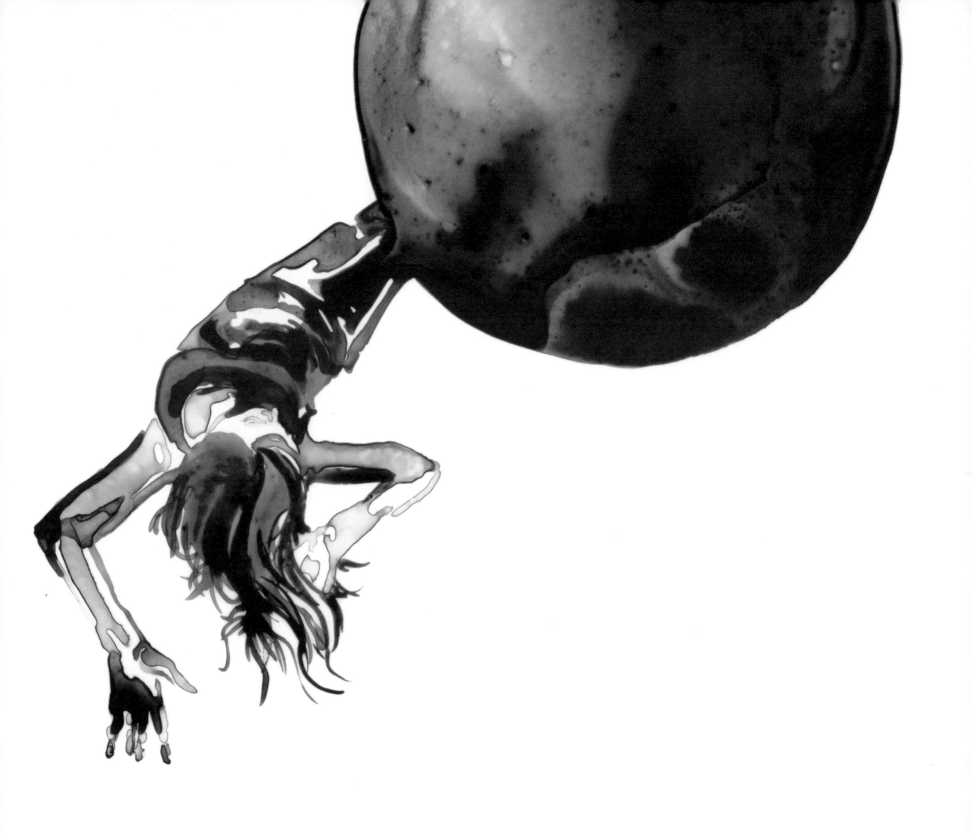

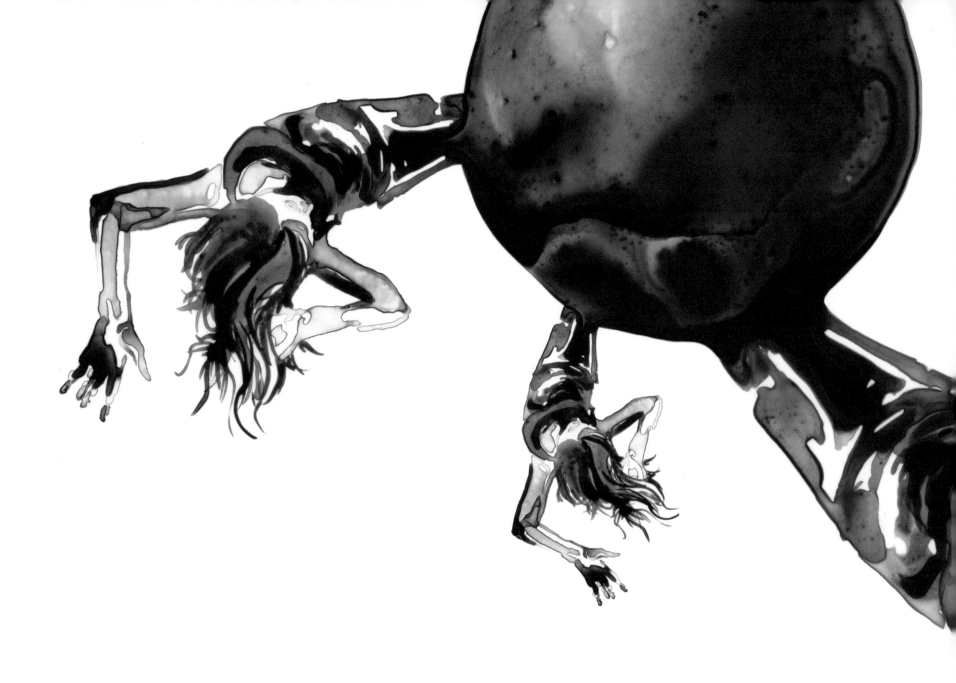

/ The light rays that carry
 Felicia's image
are bent by the hole's gravitational pull
 and by
 its warped
 spacetime.

Some rays fly straight inside of our brane
 and carry a large Felicia image.
Others bend sharply
 around the hole's mouth
 carrying a second, much smaller image,
 an image distorted by bends of the rays.

And so we perceive two Felicias in motion —
 both cruelly ingested by the black hole.

And staring more closely
 a third and a fourth
 a fifth and then more.
Each a successively smaller image
 of Lia's frightened, ill-fated wife.

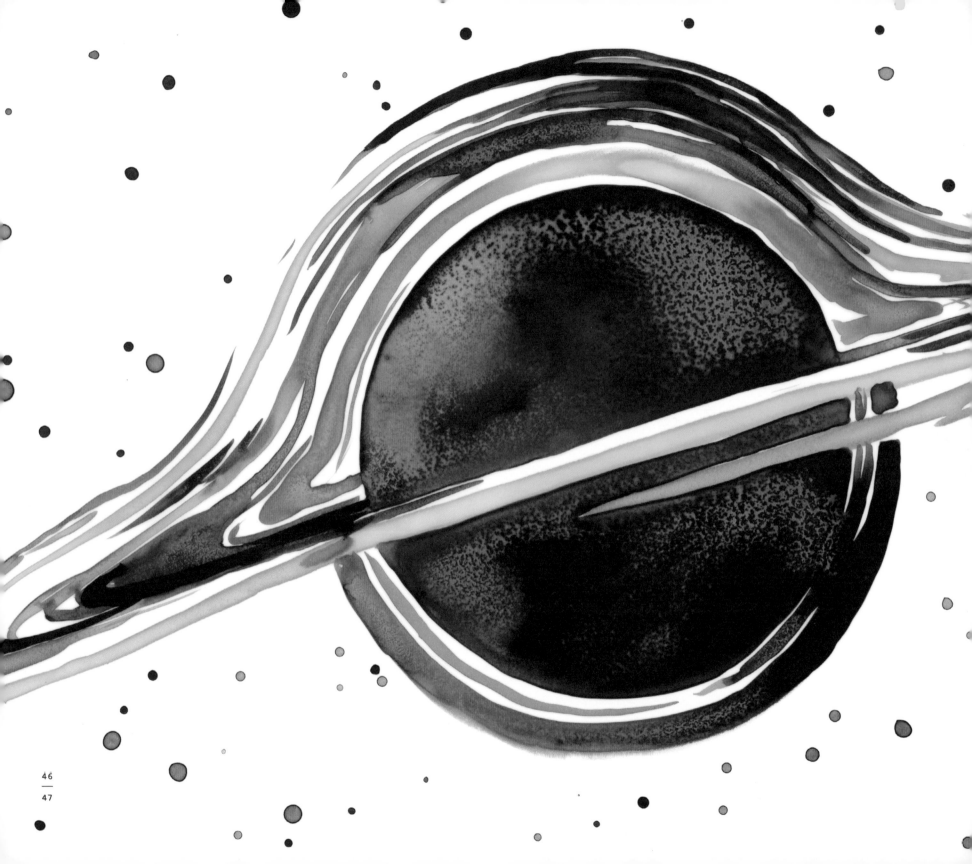

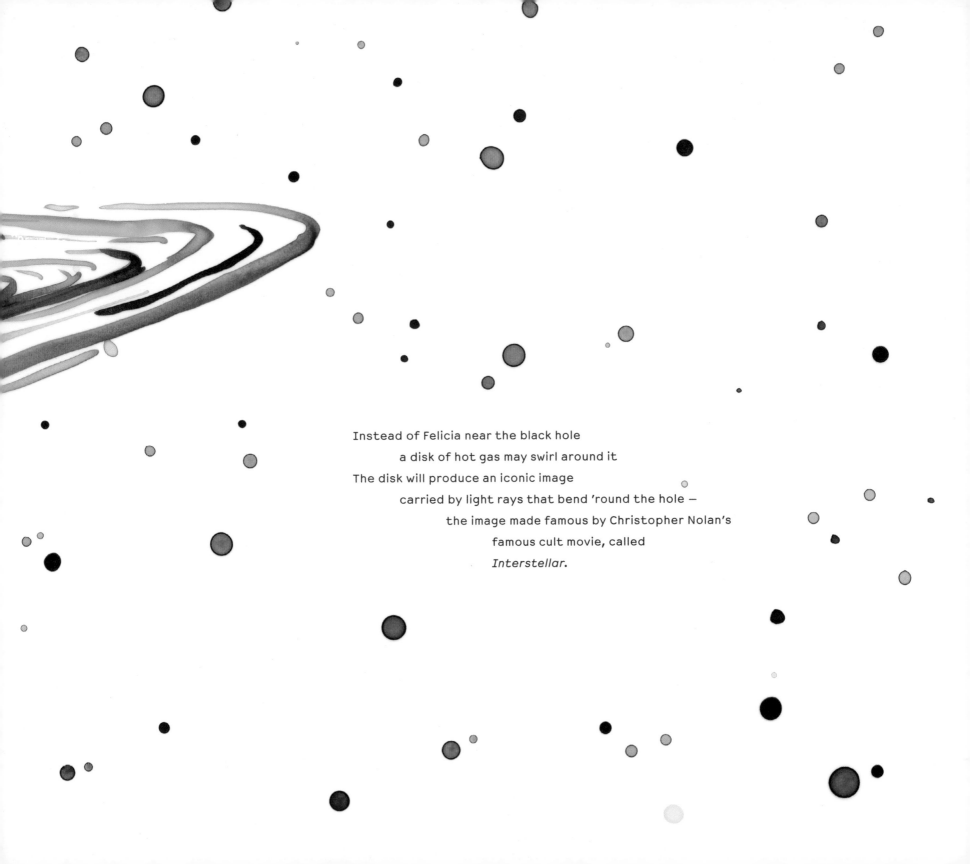

Instead of Felicia near the black hole
 a disk of hot gas may swirl around it
The disk will produce an iconic image
 carried by light rays that bend 'round the hole —
 the image made famous by Christopher Nolan's
 famous cult movie, called
 Interstellar.

Einstein's Law of Time Warps

Einstein's Law of Time Warps asserts:
Things like to live where they age the most slowly
and gravity pulls them there.
The slower is the aging,
the stronger will be the gravity.

Here on Earth we age more slowly
than in the space between the planets
— more slowly by merely one second
in every hundred years.

What a minuscule slowing of time!
But slowing enough to produce the pull
— ten meters per second squared —
of gravity binding us onto the Earth
according to Einstein's Time-Warp Law.

A Black Hole Is Made

 from Time That Is Warped

The gravity near a black hole's mouth

 is unbelievably strong.

So it has to arise inexorably

 from enormous slowing of time.

If Felicia hovers near the mouth of the hole

 for only a single hour,

when safely returning home, she'll find

 a million years on Earth have passed.

You and I and Lia

 long since have died.

And Earth has changed

 unimaginably.

At the lip of the black hole's mouth

 time slows down to a stop

so gravity there is boundlessly strong.

 Nothing there can escape its grip:

 not light, not rockets, not particles,

 not anything at all.

Whatever is drawn

 past the lip of the mouth

 forever is lost from our universe.

So the lip of the mouth

 is a black-hole *horizon*

into which we never can see

 — unless we, too, plunge through the lip

 with return

 an impossibility.

And what of time
 inside the horizon,
 below the black hole's lip?
What can be slower than time fully stopped?

Beneath the black-hole horizon
 time is cascading downward,
 toward a vicious,
 chaotic
 singularity
lurking within the black hole's core.

A stormy singularity
 where space and time
 are wildly warped.

A chaotic singularity
 where tendices and vortices
 erratically stretch and squeeze and swirl.

A lethal singularity
 destroying all that plunges through.
 Even space and time.

When Felicia falls
 through the horizon,
 to escape she must swim upward,
 struggling against the unstoppable flow
 of down-cascading time.
Backward in time she must swim
 — her only hope for escape.

But Einstein's laws forbid such a swim.
 So Felicia is gripped by the forward flow
 of down-cascading time.
 And is dragged to tragic death
 in the wild, chaotic singularity
 — if the black hole is young.

And what if the black hole is old?
 Possibly can she survive?

Let's just let that query gestate . . .

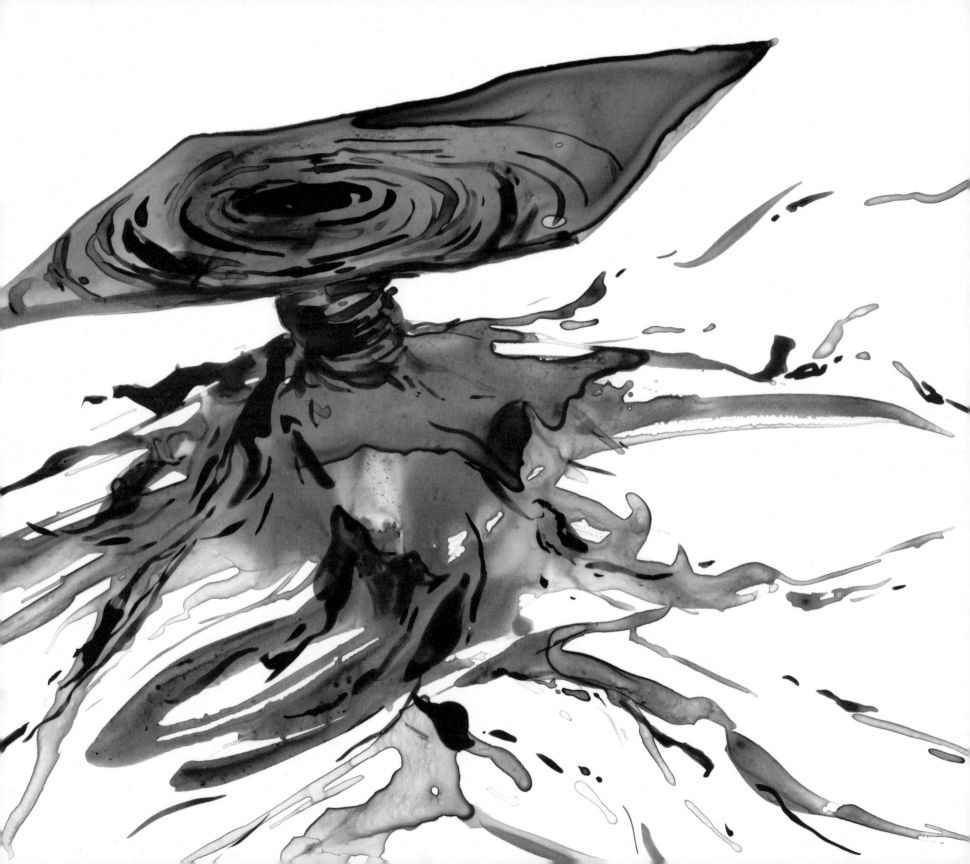

A Black Hole Is Made from Vortices
of Rapidly Twisting Space

/ Just as Earth spins 'round its poles
 so also a black hole rotates.
The hole's rotation makes space 'round it swirl
 like air inside a tornado.

And just as the swirling air
 drags all the tornado can catch
 — cats and cows and cars and clocks —
so, also, a black hole's swirl
 drags everything nearby
 into a whirl around the hole.
 Fast near the hole's horizon
 languid far away.

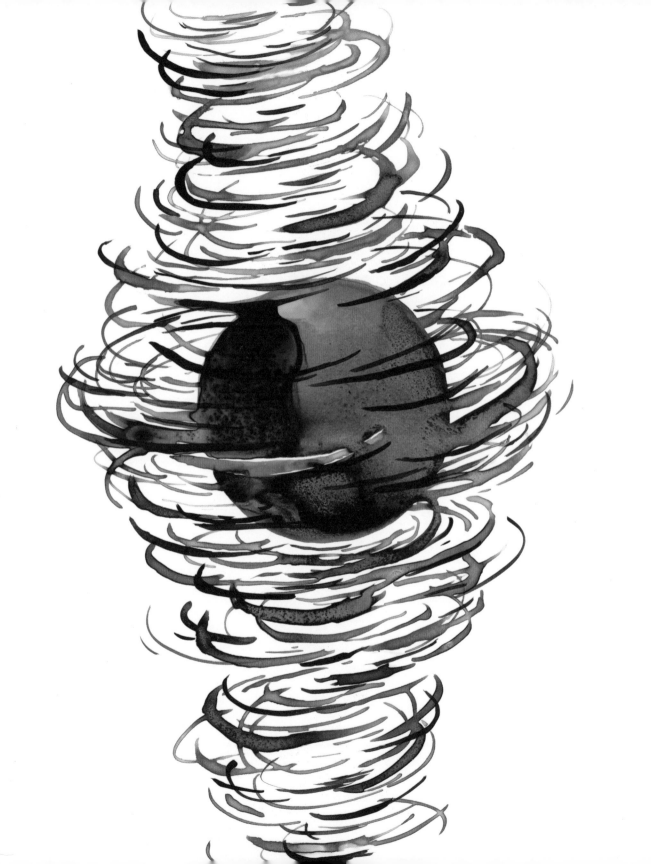

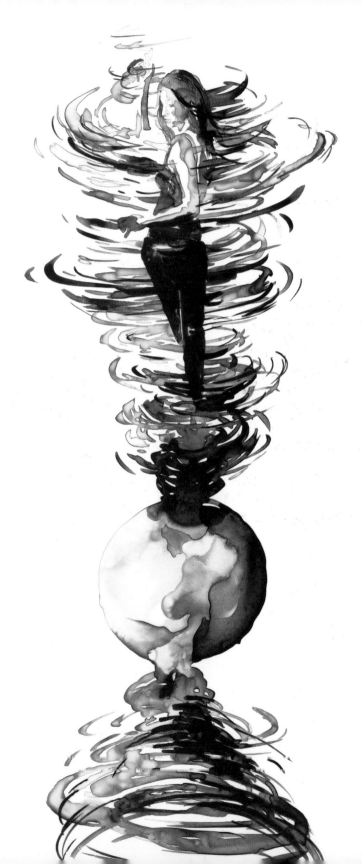

As Felicia, aghast, falls feet first
 into the spin of a black hole's north pole
her feet, nearer the hole than her head,
 get dragged around more strongly.
So her lovely body gets twisted.

Her eyes see her feet turn clockwise, and
 her feet see head turn clockwise, so
The swirl near the hole's north pole comprises
 a *clockwise vortex of twisting space*
 bound to the hole's horizon.

On the other side, the south-pole side
 of the rapidly spinning black hole,
a *counter-clockwise vortex*
 of rapidly twisting space
 bound to the hole's horizon
 twists all that passes through.

A Black Hole Is Made from Tendices
of Stretching and Squeezing Space and
a Chaotic Singularity

As frantic Felicia
 falling feet-first
 inside a spinning black hole
 approaches its *singularity*
she is gripped
 by a *tendex* of stretching space
 that strings her out
 from head to foot
and gripped by another
 with front-back squeeze
and gripped by a third
 that squeezes her sides.
She is being spaghettified.

And then —
 the stretching tendex begins to squeeze
 compressing her from head to foot.
The side-squeeze tendex begins to stretch
 straining her arms from hand to hand
 — a head-foot squeeze,
 a sideways stretch,
 a front-back squeeze.
And then another sudden switch
 — another and another.
In wild chaotic succession
 the switches get frightenly quicker
 the stretch-and-squeeze terribly stronger
 the chaos ever more violent.

The wildly switching tendices
 tear frantic Felicia apart
then rip up the atoms
 from which she was made
— *if* the black hole is young.

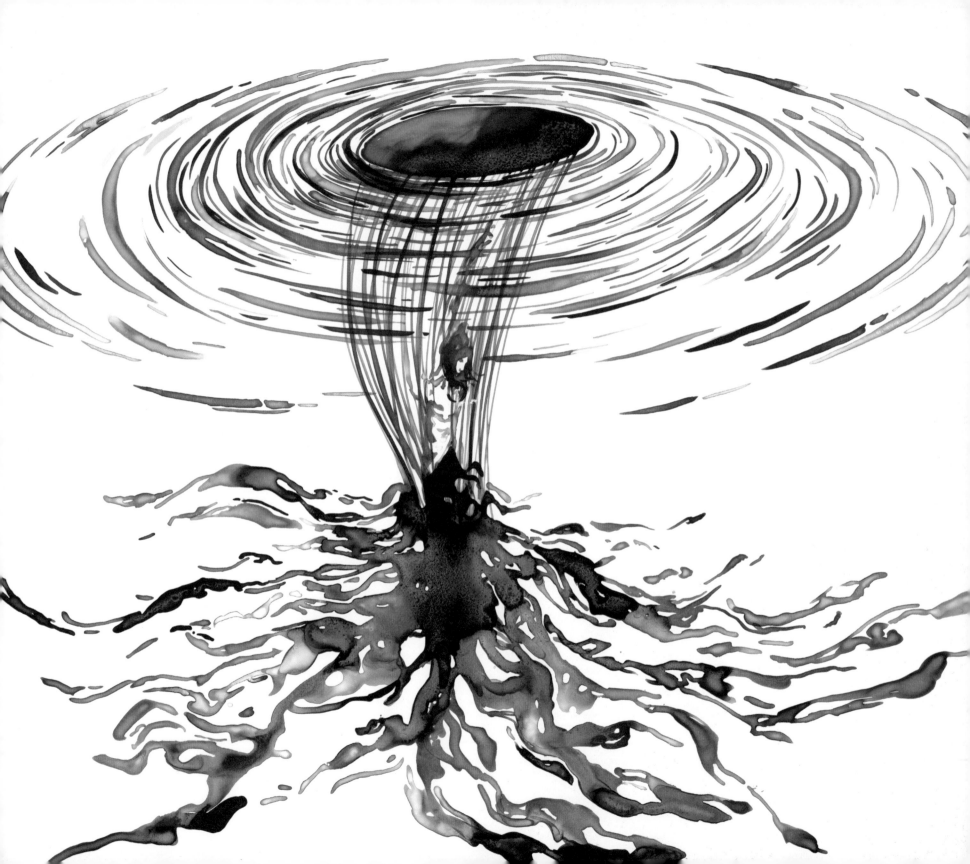

And what then?

The shattered atoms smash into
 the *singularity's core*.
A core that is an enigma
 controlled by *quantum gravity laws*.
New laws that arise from a fiery marriage
 of quantum mechanical fluctuations
 and wildly warped spacetime.

We physicists struggle
 to learn these new laws.
We hope to know them one day.
We speculate these new laws might be
 something resembling
 string theory.

Since quantum gravity theory
 is in its infancy still
it hasn't yet revealed
 the nature of the cores
 of singularities.
Not yet.
 But it will.
 I'm confident it will.

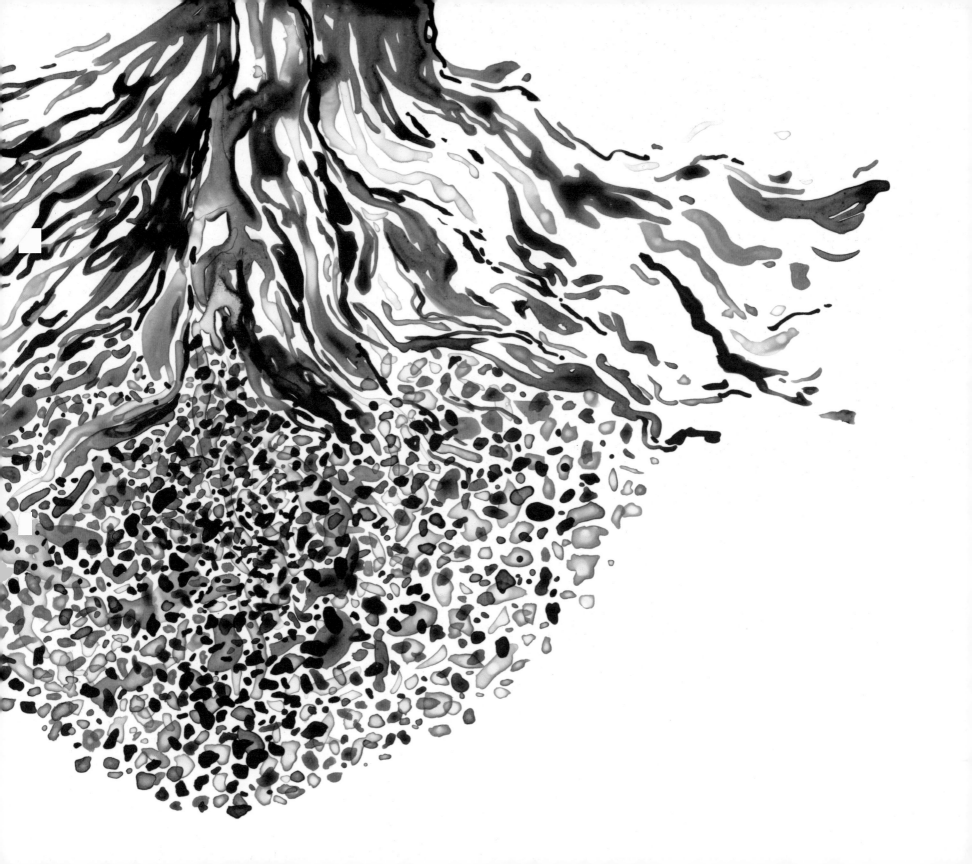

A Black Hole Entombs
Three Singularities

/ When down-cascading time
 inside of a spinning black hole
strongly grips frantic Felicia
 and drags her inexorably
 toward the singularity
Is she truly doomed?

Conceivably not.

If the black hole has aged
 for more than a day
then lurking inside of its *core*
 are
 not just one singularity,
 But *three!*
 The chaotic one with merciless ripping
 And two that are far more gentle.

Whence come they, the gentle ones?

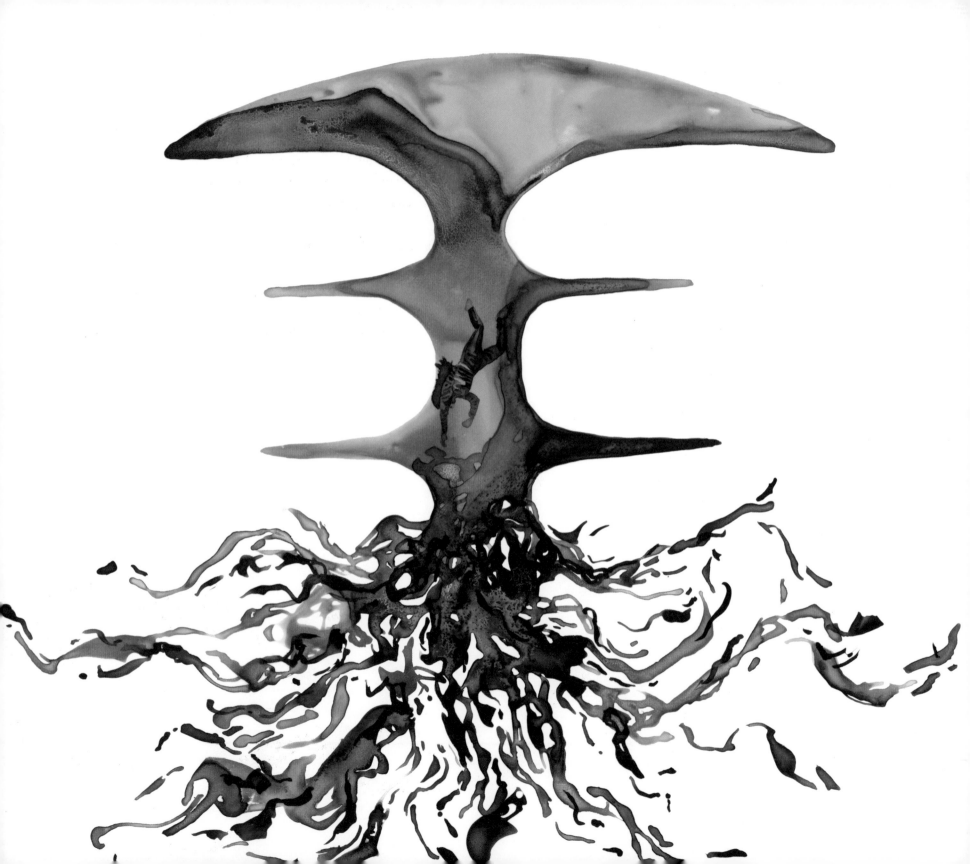

These two singularities
 — one plunging down, one flying up —
appear (deceptively?) gentle.
If Felicia is slammed by either of these
 instead of the vicious, chaotic one
She actually might survive.

Probably not, but just possibly so.
Her fate is likely controlled by
 The laws of quantum gravity.
Mysterious laws.
 As yet so poorly known.

/ Inside the hole
 the ticking rate
 of down-cascading time
 slows almost to a stop.

So all that falls into the hole
 after frightened Felicia,
 over thousands and millions and billions of years
 plunges through the horizon
 in a fragment of a second
 (as seen by frenetic Felicia).
Compressed into a sheet so thin
 it forms a singularity
— one that's plunging downward.

And of all that fell into the hole
 before Felicia's descent,
small bits were scattered back up.
Likewise compressed
 into a sheet
 they form a singularity
 this one flying upward.

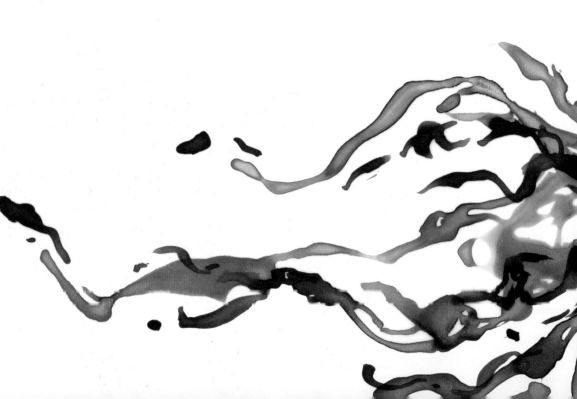

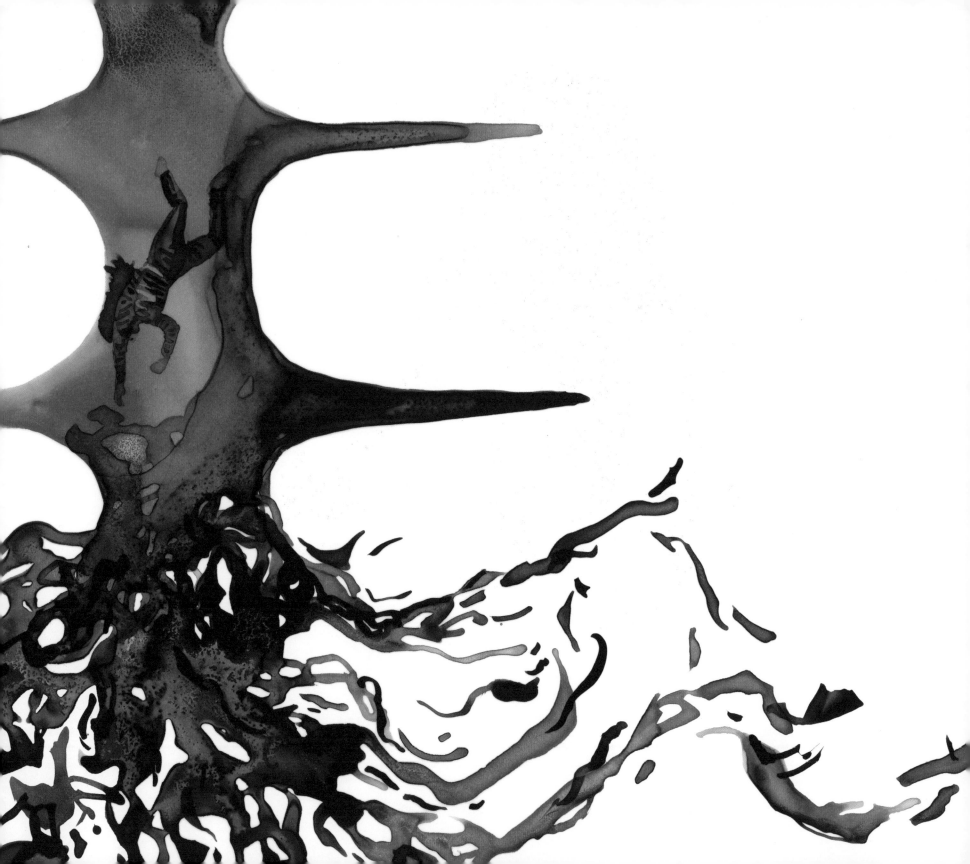

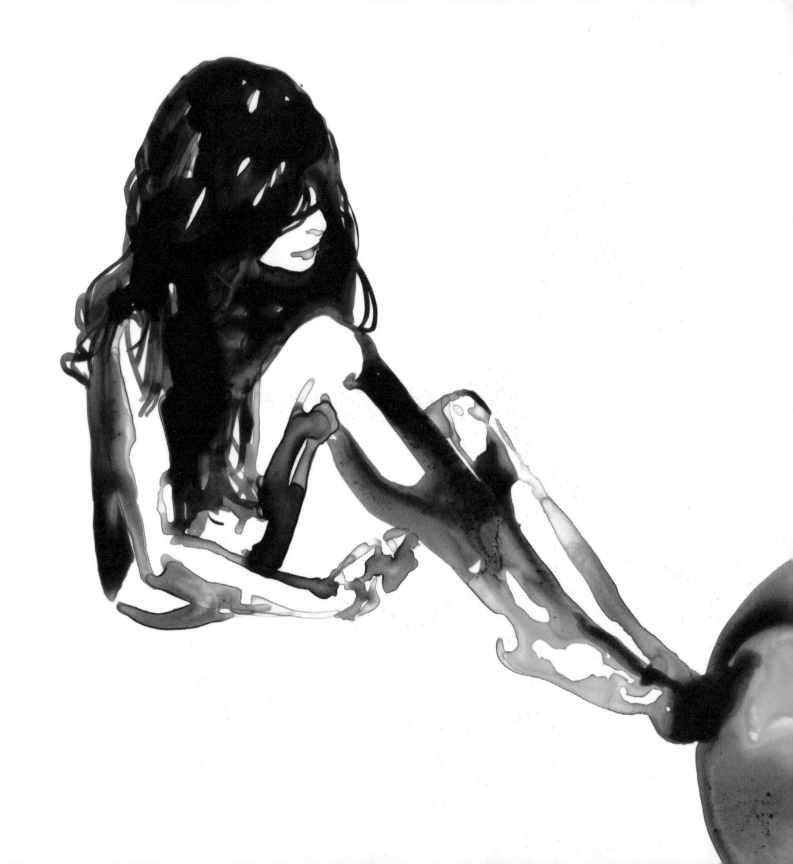

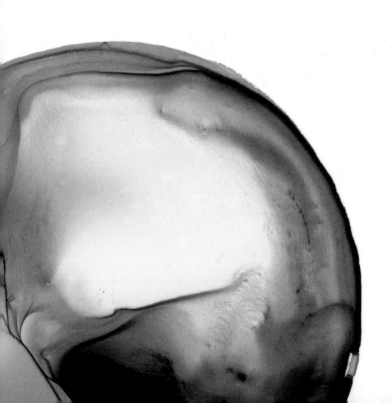

What Is
 a Black Hole?

What is Felicia? She's
 the sum of all her parts:
Her face, her silken hair
Her arms and breasts
Her hands and legs and feet
Her heart, her brain
Her precious personality.

And what is a black hole? It's
 the sum of all its parts:
Its space that is warped
 (the funnel a bulk-being sees).
Its vortices of whirling space.
Its tendices that stretch and squeeze.
Its slowing time and down-cascading time.
Its horizon and
 its singularities.
All made from warped spacetime.

2 / WORMHOLES AND TIME MACHINES

Thought Experiments

 Extreme

In nineteen-hundred and eighty-five
 a phone call from Carl Sagan
 profoundly impacted my views on how
 to probe the nature of space and time.

In a movie and novel called *Contact*
 that Carl was struggling to craft
 he was sending his heroine through a black hole
 from Earth to the distant star Vega.

"Am I in trouble?" he queried me
 "In trouble, indeed!" I replied.
"Your heroine can't survive the trip
 she'll perish inside the black hole. But . . .
there's a different beast you could possibly use:
 a *wormhole* that links the star Vega
 to your heroine here on the Earth."

At that time we experts on warped spacetime
 as yet were completely unsure
of what all the laws of physics dictate
 about wormhole births and deaths.

So while Carl re-crafted his novel
 with the black hole replaced by a wormhole
I began to challenge myself
 with a query quite weird and extreme:

Do the Laws of Physics permit
 an alien civilization
 infinitely advanced
 to create and maintain a wormhole
 for travel between the stars?

Then a year after that I challenged myself
 with a query more wildly extreme:

Can an alien civilization
 infinitely advanced
transform wormholes into time machines
 for traveling backward in time?

And several years later, as I became wiser,
a third question weird and extreme:

Do time machines always self destruct
 the moment they are turned on?

We physicists answer deep questions with
 experiments in laboratories.
But that is impossible here.

To answer our questions extreme
 we need technology far beyond
 any that humans can hope to create.

So instead, for these questions,
 we must seek the answers
 from the math of the physical laws
 that control everything in our universe:
 the ultimate laws of physics.

Since the answers must come from the power of thought
 we call this a *thought experiment* . . .
or, for questions like ours, so very extreme,
 A Thought Experiment Extreme.

So the phone call from Carl triggered for me
 an amazing epiphany:
*If we know the relevant physical laws,
 then from thought experiments extreme
 we can learn the deepest of truths about
 how space and time behave
 when extremely and wildly warped.*

*And if we do not know the laws,
 then still there's lots of hope:
Our thought experiments extreme
 may teach us major new insights
 about the physical laws
 that are fuzzily ill-understood.*

That is why Lia and I
 devote this second chapter
to Thought Experiments Extreme
 and what they have taught us about
 how space and time behave
 when wildly, extremely warped.

Of Ants and Wormholes
and Crystal Balls

Imagine that you are a tiny ant
 confined by the laws of your colony
 to live on the skin of an apple.
That apple skin is your whole universe
 a membrane from which
 you can never escape.

The distance across your universe
 — from apple's bottom to apple's top —
 seems dreadfully large to you.

Imagine a wormhole abruptly appearing
 gnawed by a worm
 through your apple's core.

Now you can choose your ambling route
 from apple's bottom to apple's top:
The long route around your universe
 along your apple's skin.
Or the shorter wormhole trek
 down through the apple's bulk.

Imagine our own universe — our brane —
 is bent in the higher-dimensional bulk.
So our Milky Way galaxy's center is just
 a few thousand miles away from the Earth
 — a few thousand miles across the bulk.

You and I and everything on
 the material side of our vast universe
 are forever confined to our brane.
We never can ever escape.

We cannot traverse the bulk — unless
 An appendage protrudes from our brane
 stretching across the bulk.

The appendage's surface
 is part of our brane.
A very swift shortcut
 to Milky Way center.
A *wormhole* through the bulk.

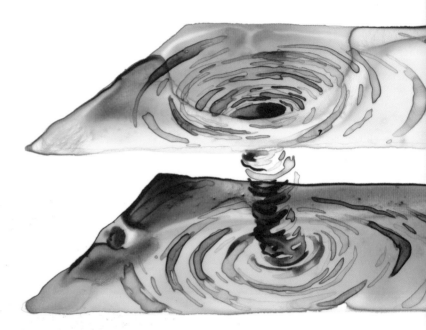

With one space dimension suppressed
 in Lia's evocative painting
The mouth of the wormhole looks like a circle.

With the missing dimension restored
 that circle becomes a sphere.
The wormhole's marvelous spherical mouth.

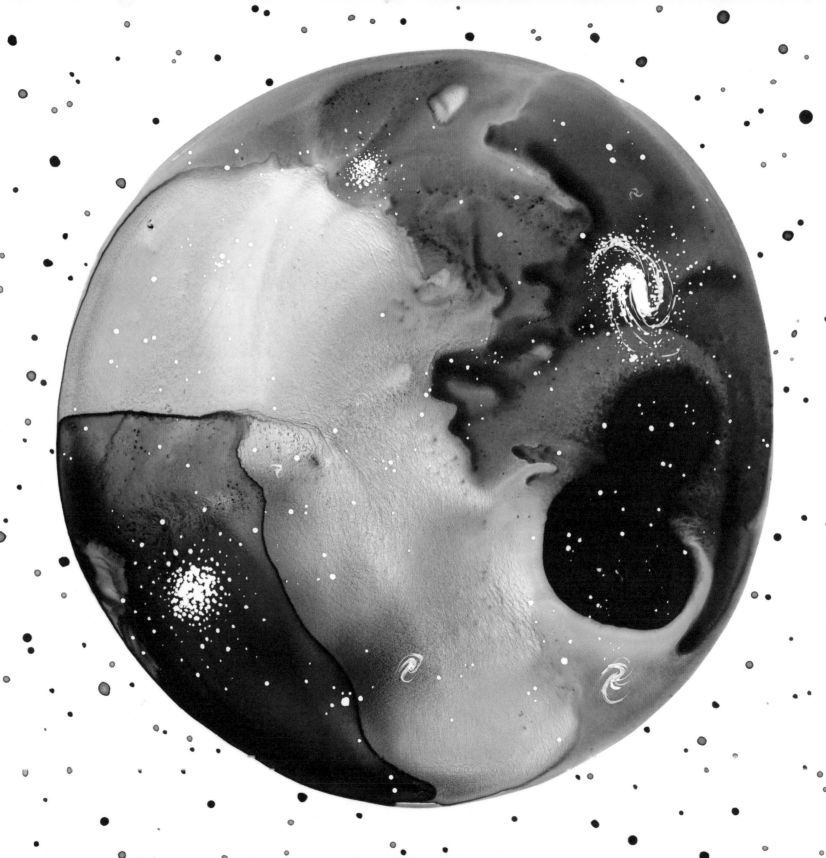

Light from the core of the Milky Way
 cruising through the wormhole
carries to Earth an image of *all*
 that lives inside the Milky Way core:
 stars and dust and nebulae
 and shadows of a huge black hole.

Peering into the wormhole's mouth
 we see the image as though it were
 embedded inside a crystal ball
 a miniature edition
 of stars and dust and nebulae
 and shimmering black-hole shadows
 embalmed inside the crystal.

What a beauteous crystal ball
 the wormhole mouth resembles!

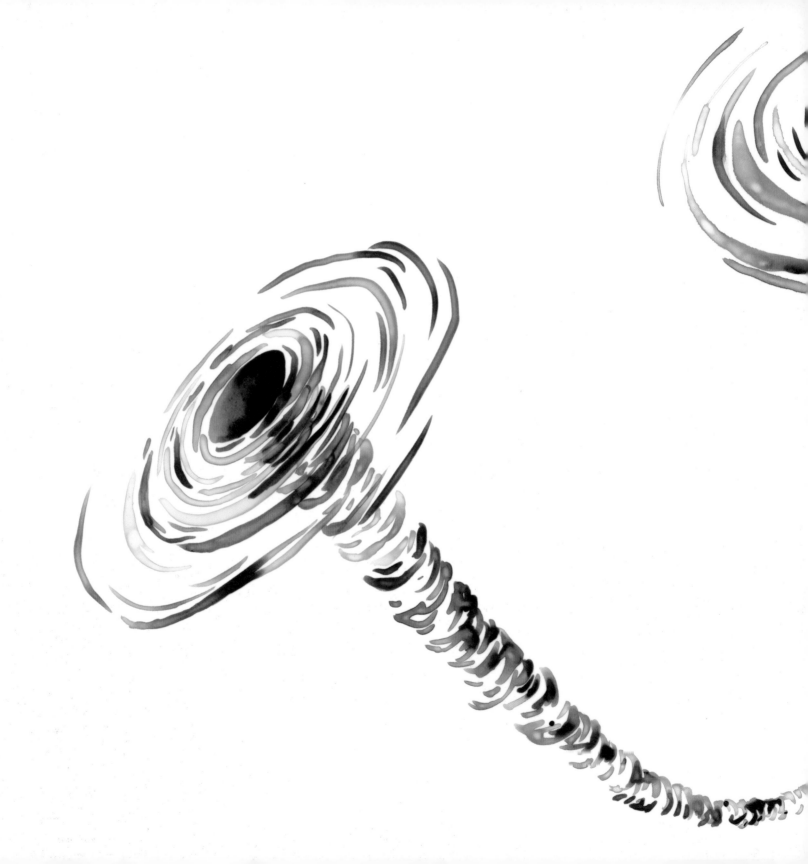

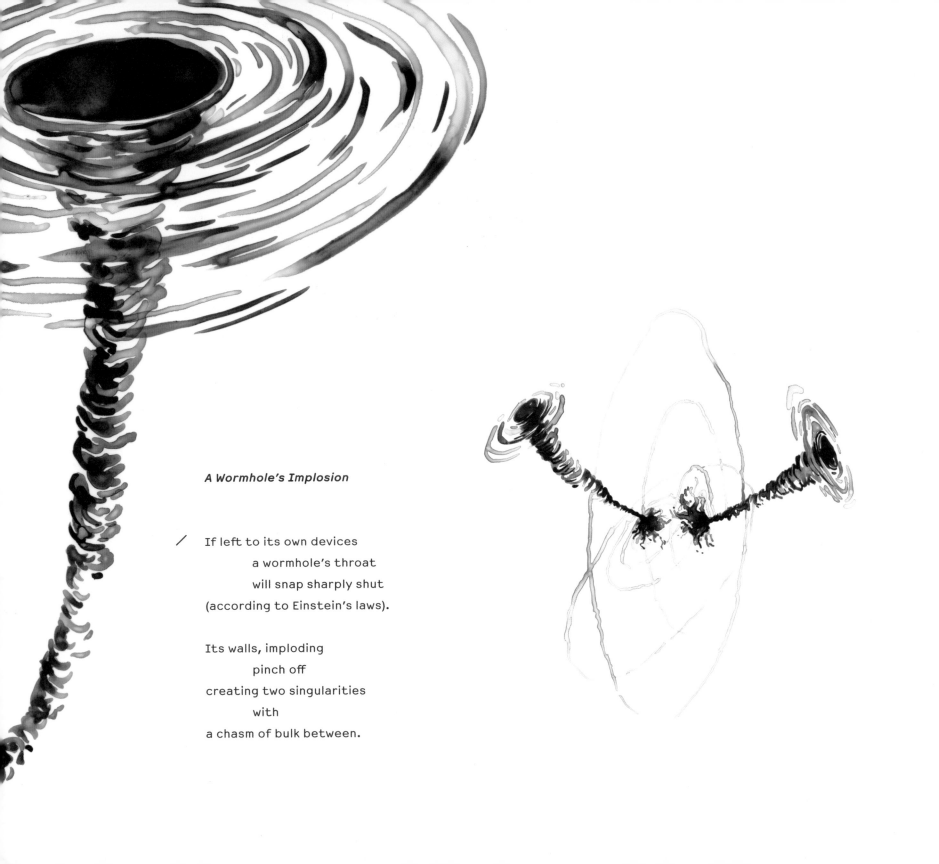

A Wormhole's Implosion

/ If left to its own devices
 a wormhole's throat
 will snap sharply shut
 (according to Einstein's laws).

Its walls, imploding
 pinch off
creating two singularities
 with
a chasm of bulk between.

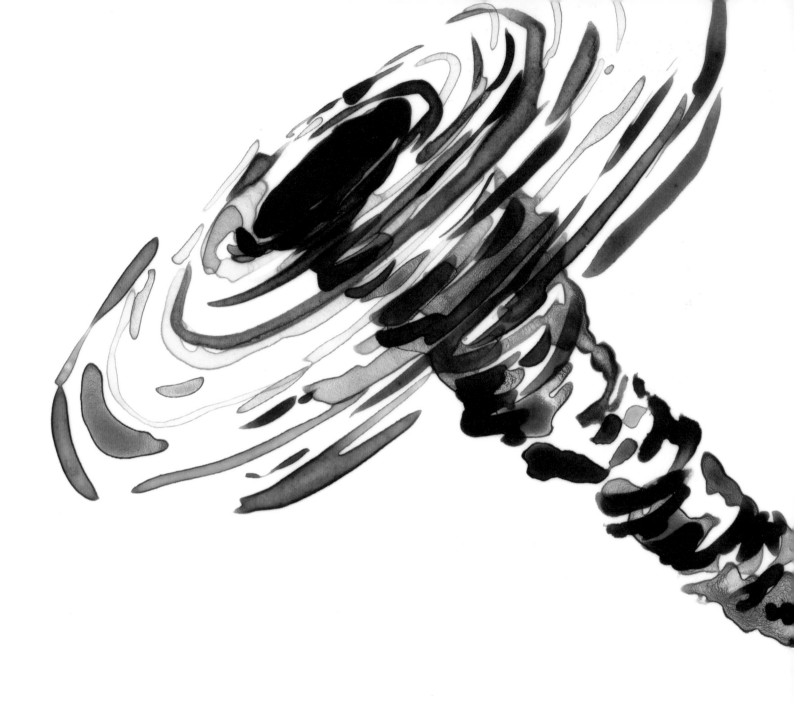

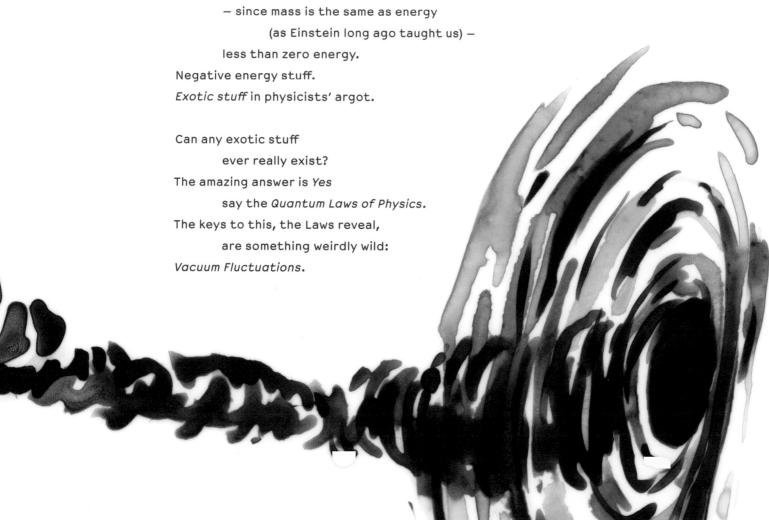

/ To hold the wormhole open
some *being* must place
inside of its throat
material *stuff* that repels its walls
prying them apart.
Stuff that anti-gravitates.

To anti-gravitate
— according to Einstein's gravity laws —
that stuff must weirdly possess
less than zero mass, and
— since mass is the same as energy
(as Einstein long ago taught us) —
less than zero energy.
Negative energy stuff.
Exotic stuff in physicists' argot.

Can any exotic stuff
ever really exist?
The amazing answer is *Yes*
say the *Quantum Laws of Physics*.
The keys to this, the Laws reveal,
are something weirdly wild:
Vacuum Fluctuations.

Vacuum Fluctuations

/ Imagine a box filled with nothing.
All has been
 removed from the box
 that *possibly can be* removed.
Only a *vacuum* remains.

This vacuum *smolders*
(so sayeth the quantum physics laws)
 with infinitesimal fluctuations
 of everything
 that ever could
 reside inside the box:

Electric fields and forces
 magnetic fields and forces
 gravity fields and forces
 cats and cars and cows and clocks
 (with tiny probabilities)
flash into surreal existence
 ever so very briefly
and then, and then . . . flash out.

Amazingly —
These infinitesimal fluctuations
 harbor no net energy
 and generate no gravity.
So sayeth the weird quantum laws
 if we have discerned them correctly.

/ Under special controlled conditions
 one region of space can lend
 some of its quantum fluctuations
 to other adjacent regions.

With augmented fluctuations,
 each borrowing region suddenly
 possesses positive energy.
 Its gravity attracts.

And with decreased fluctuations
 the lending region suddenly
 possesses negative energy.
Its gravity repels.
It has become exotic.

But what is borrowed must be returned
 and quickly, and quicker still
 when the lender is the vacuum
(so sayeth the weird quantum laws).
 And so . . .
Exotically fluctuating stuff
 lives only fleetingly . . .

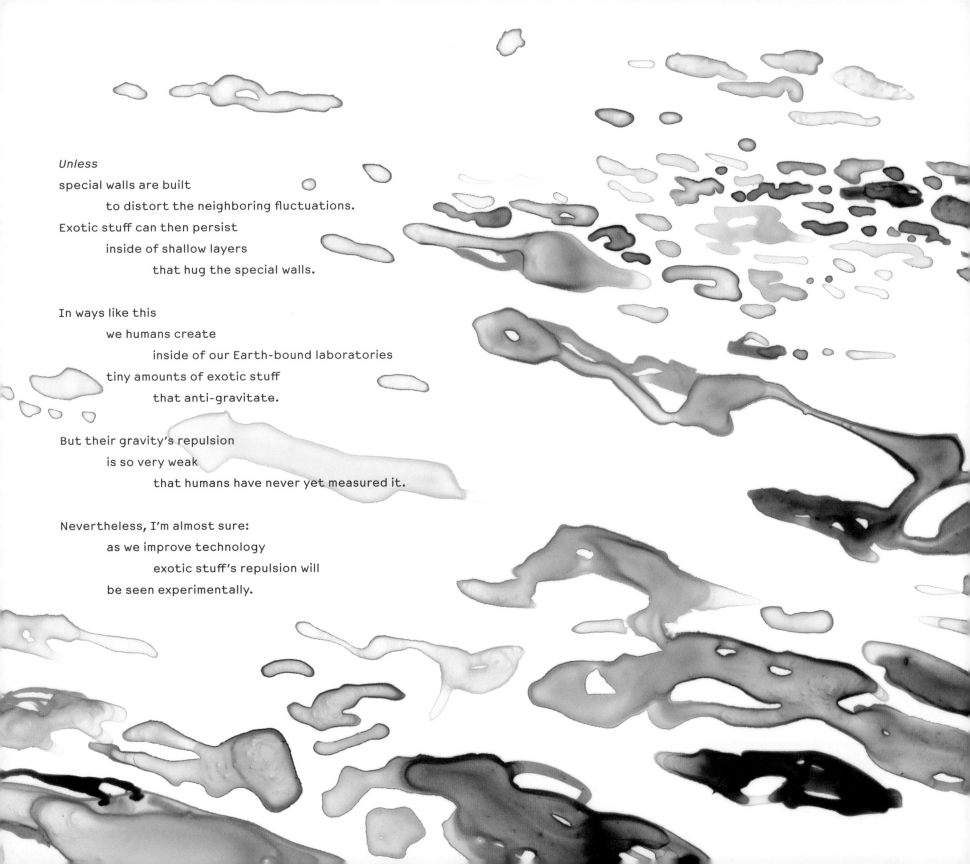

Unless
special walls are built
 to distort the neighboring fluctuations.
Exotic stuff can then persist
 inside of shallow layers
 that hug the special walls.

In ways like this
 we humans create
 inside of our Earth-bound laboratories
 tiny amounts of exotic stuff
 that anti-gravitate.

But their gravity's repulsion
 is so very weak
 that humans have never yet measured it.

Nevertheless, I'm almost sure:
 as we improve technology
 exotic stuff's repulsion will
 be seen experimentally.

Can Exotic Vacuum Fluctuations
Hold a Wormhole Open?

Imagine an alien civilization
 far more advanced than ours
 — as advanced as the laws of physics allow.
 Infinitely advanced.

Somehow this civilization's beings
 have constructed a wormhole so humans can cruise
 from Earth to a distant black hole
— as envisioned in Christopher Nolan's remarkable
 sci-fi film *Interstellar*.

Do the laws of physics truly allow
 any civilization's beings
 to load a wormhole's throat
 with sufficient exotic stuff
 to prop it open just long enough
 for humans to cruise on through?

We don't know.
We simply do not know.

Although we continue to probe
 the Quantum Laws of Nature
 attempting to prove yea or nay,
So far we've been far too doltish
 to solve this mystery.

There is so very much that
 we humans don't yet comprehend
 about the physical laws
 that govern our vast universe.

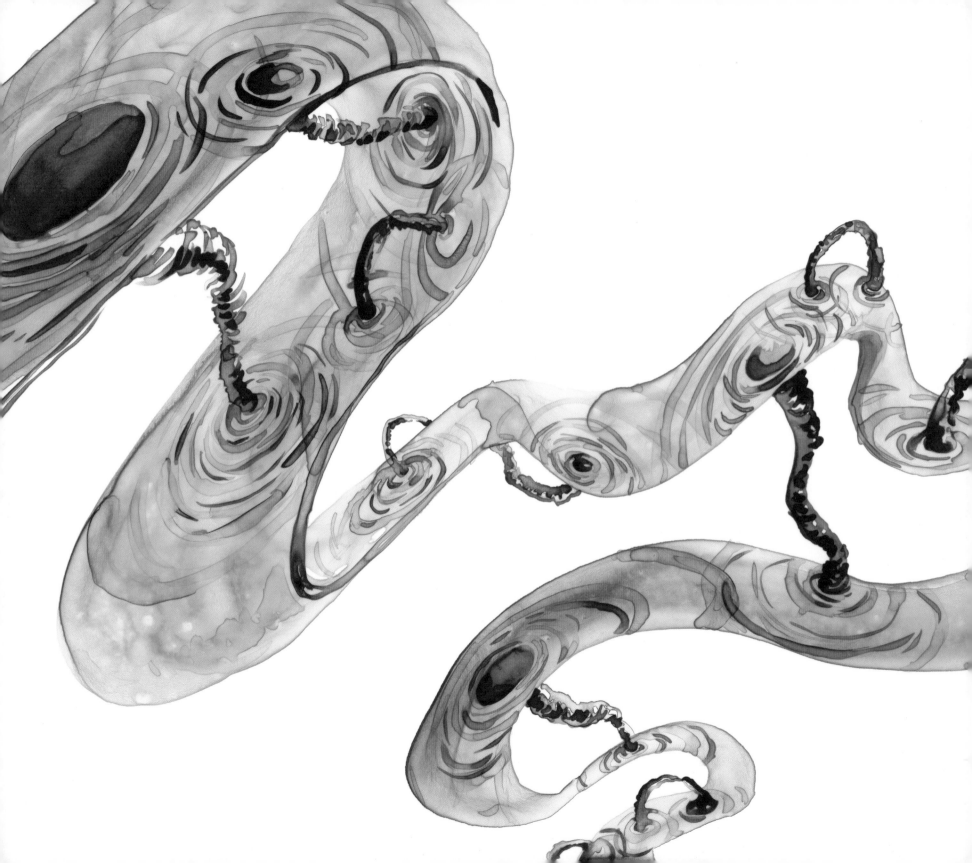

Creating Big Wormholes

We physicists tend to suspect
 that space itself is fashioned
 from fluctuating wormholes:
A *quantum foam* of wormholes
 with every one of them
 a trillion trillion trillion times
 smaller than a human.
 A hundred million trillion times
 smaller than a proton.

Could an alien civilization
 infinitely advanced
grab such a tiny wormhole and,
 staunching its fluctuations,
 inflate it to human size
 for intergalactic travel?

We don't know.
 We simply do not know.
 Yet we continue to ask.

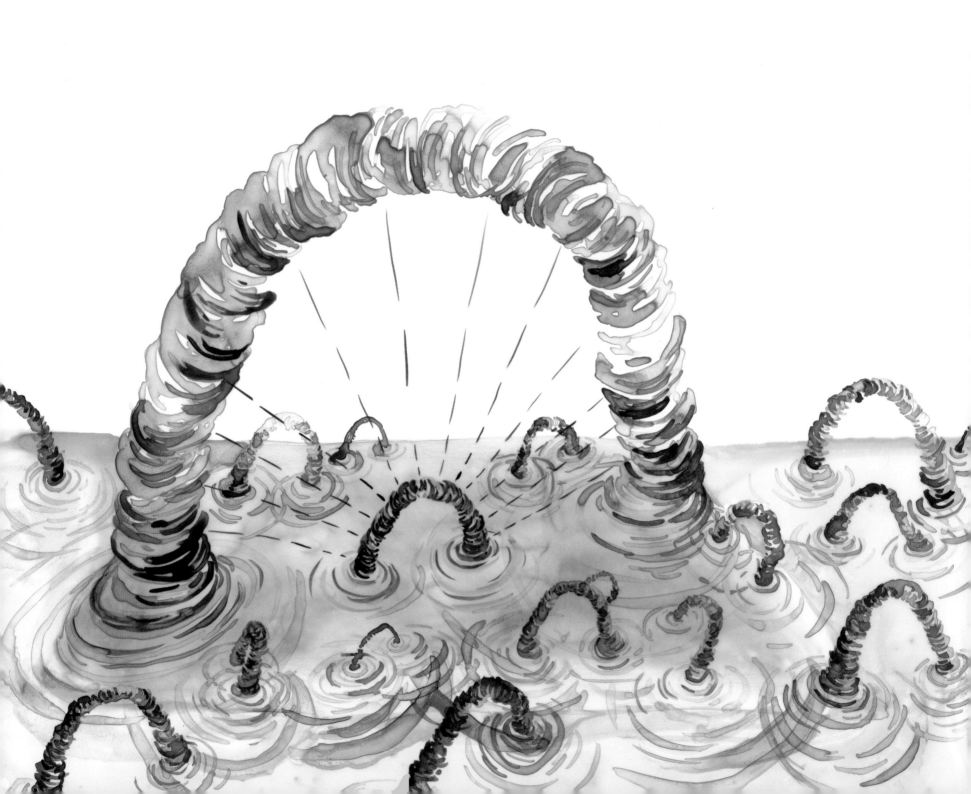

From Wormhole

 to Time Machine

Imagine strange beings from a civilization
 infinitely advanced.

In a starship, cruising at close to light speed
 they transport a wormhole mouth
 through interstellar space and back
 while the other mouth stays at home.

Time, as sensed by the traveling mouth
 is slowed.
The round trip takes only one year.

Time, as sensed by the stay-at-home mouth
 is normal.
The trip takes one hundred years.

So
 As seen in the external universe,
 the traveling mouth has aged
 very much less than the stay-at-home mouth
 — less by ninety-nine years.

But —
As seen through the wormhole by the strange beings
 the two mouths' times
 flow equally fast or slow.
The mouths age precisely the same.

Now pause and think very carefully
 about what this implies . . .
Implications Amazing:

After the trip is over, if
 you enter the mouth that made the trip
 you'll emerge from the nearby stay-at-home mouth
 ninety-nine years in your past.

The wormhole has metamorphosed
 into a time machine.

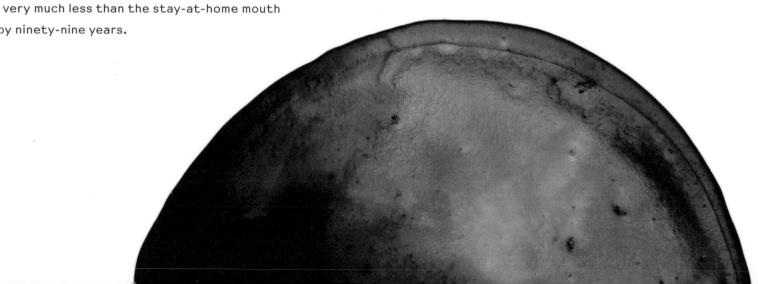

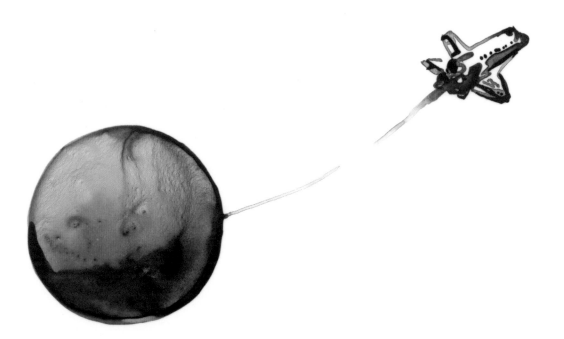

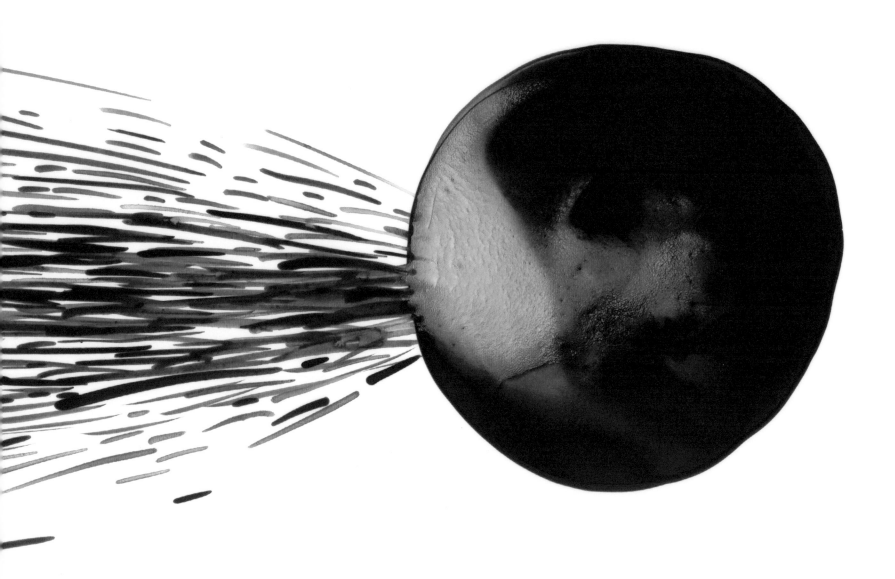

Do Time Machines Self-Destruct?

/ Do the laws of Nature
 really allow
creation of time machines?

Maybe not.
We're rather unsure.

Einstein's laws of spacetime warps
 from which these predictions emerge
 are not the sole controllers
 of time-machine creation.

Control, in fact, is shared with
 the quantum physics laws
 which make a weird prediction:

This time machine
— and also all others,
no matter how constructed —
might self-destruct explosively
at the moment of its creation:

As the traveling mouth is returning home,
there comes a precise moment when
A photon can plunge down the traveling mouth,
zoom through the wormhole backward in time,
and then
emerging out of the stay-at-home mouth,
return at light speed to the traveling mouth,
arriving on top of itself
an infinitesimal moment
after its trip began.

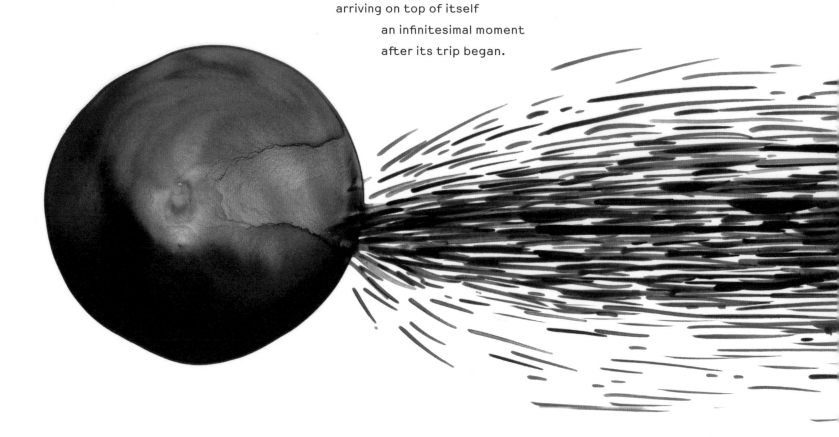

This photon, with finite size
 has piled on top of itself
 on top in space, and on top in time.
So what began as a single photon
 now is transformed into two.

Those photons together
 repeat that trip,
 transforming into four;
then eight, sixteen, thirty-two, and then
 more and more and more —
All the same photon that traveled in time
 over and over and over.

The photon's energy grows
 exponentially
 — until predictably
Its gravity sucks the wormhole walls inward,
 pinching them off
 in a catastrophic
 photon explosion and wormhole implosion.

The time machine has destroyed itself
 at the moment of its creation.

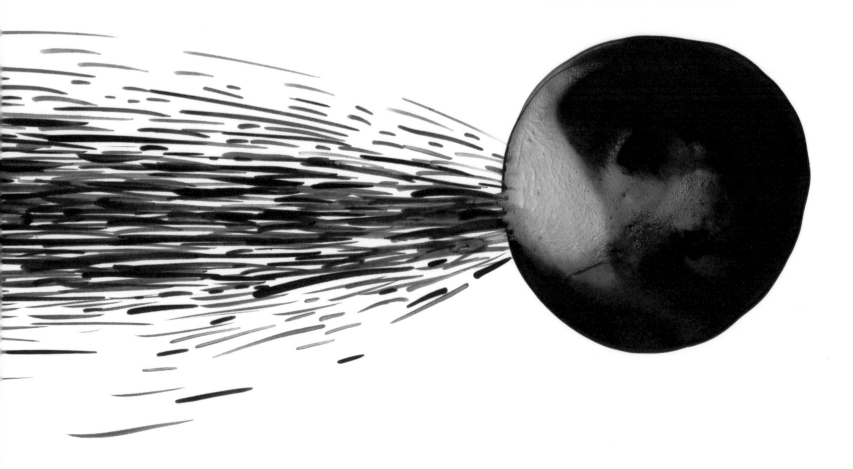

Could the strange beings from a civilization
 infinitely advanced
prevent all these photons from traveling through
 and rescue the time machine?

No.
Not at all.
I think but am not sure.

Suppose the strange beings shield the mouths
 from everything that's stoppable.
Still the vacuum remains
 with all of its fluctuations —
 including *unstoppable virtual photons*
 with ultra-high-frequency oscillations —
 vibrations incredibly fast.

These unstoppable virtual photons
 plunge through the wormhole
 over and over
 — and over and over and over —
 piling explosively onto themselves.

How strong is this explosion?
Strong enough to totally
 destroy the time machine
 at the moment of its birth?

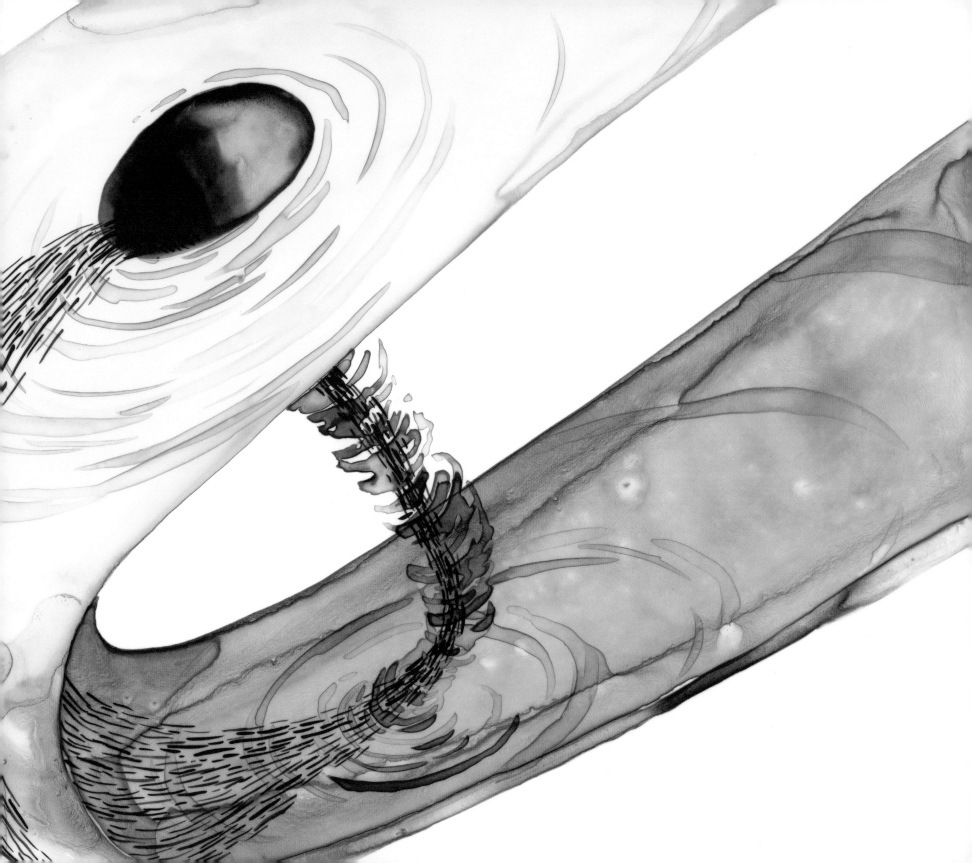

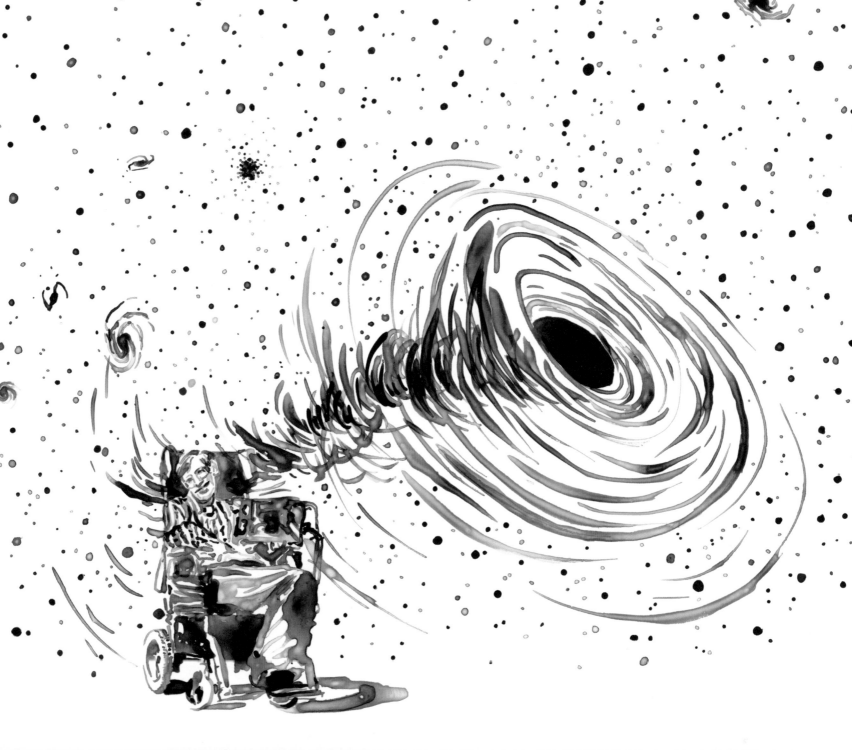

Stephen William Hawking
 — anchored to his wheelchair
 with mind and spirit soaring high —
Anchored Soaring Hawking
 explored this problem deeply
 in ninteteen ninety-one
 as did my students and I.

The explosion's fate, we learned,
 is controlled by *Quantum Gravity Laws*
— laws that we physicists don't comprehend
 sufficiently well.
Not yet.

Time Travel:
 Another mystery
 controlled by *Quantum Gravity*.

But

Anchored Soaring Hawking
 so often a very wise oracle
was rather sure that he knew
 the answer to the mystery
 — the answer so tightly gripped by
 the Laws of Quantum Gravity.

Hawking encoded his answer in
 his *Conjecture of Cosmic Censorship*:

Time machines inevitably
 will always self-destruct
 to prevent anything
 from traveling through
 that might change the history
 of our past.

This, Hawking firmly declared
 keeps our universe safe and secure for
 historians of every species
 — no matter how highly advanced.

Lia's
Time-Machine Story

/ To capture some of the essence
 of time-machine destruction
Lia has created
 a simple little story:

Lia's wife, Felicia,
 browses a book that I wrote long ago
beside a wormhole's left mouth.

Felicia, finished browsing,
 hands over to Lia the book.

With book in hand Lia walks 'round
 to the right mouth and into it thrusts the book.

Lia's hand, holding the book,
 dips through the wormhole and backward in time
emerging from the left mouth
 when Felicia has just finished browsing.

Felicia, accepting the book, now has two.
 Both the very same book
 one of them younger, the other one older.

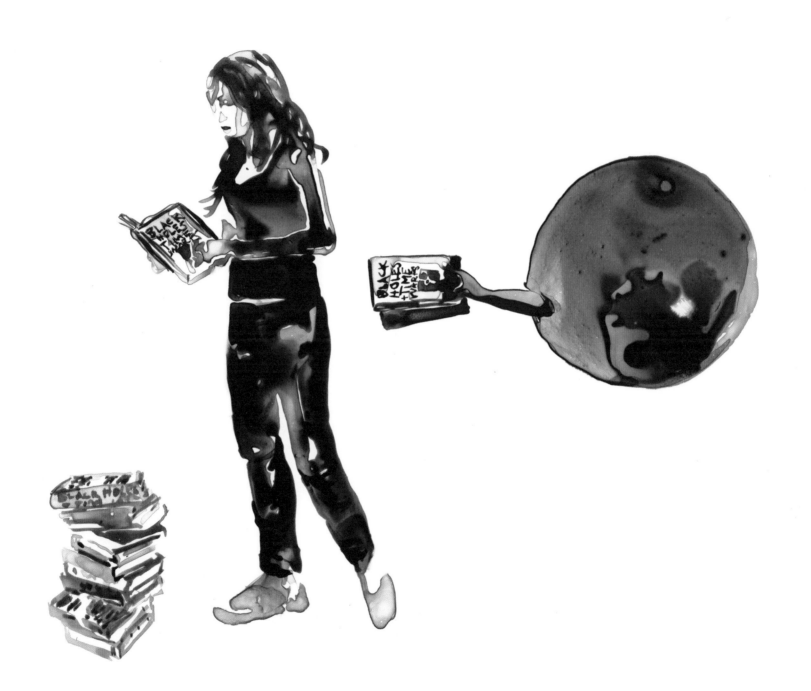

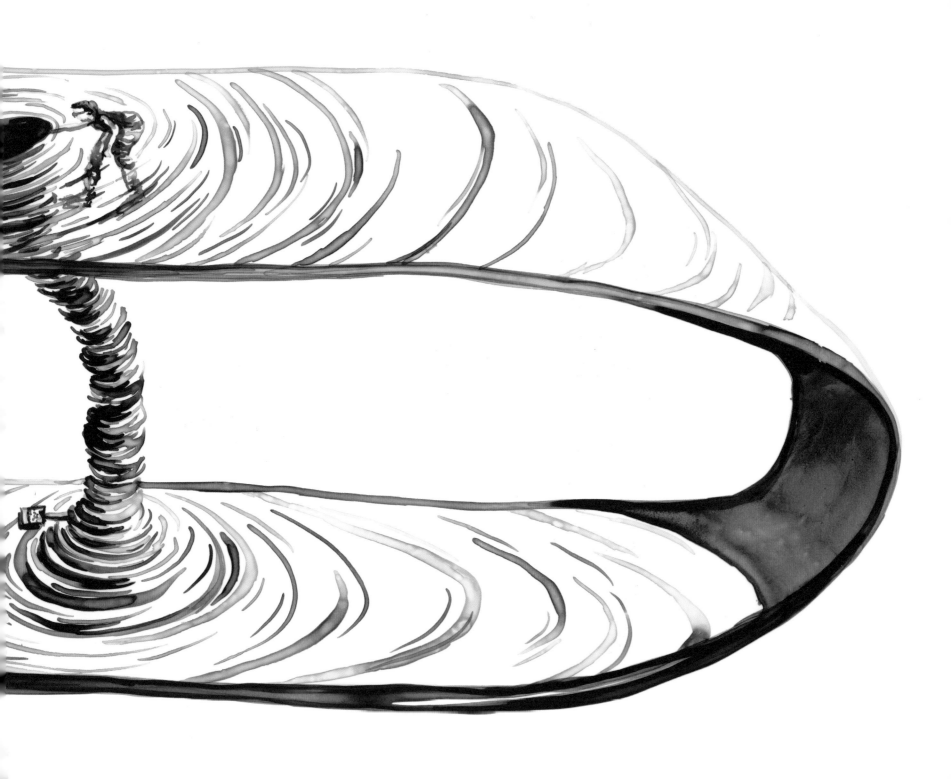

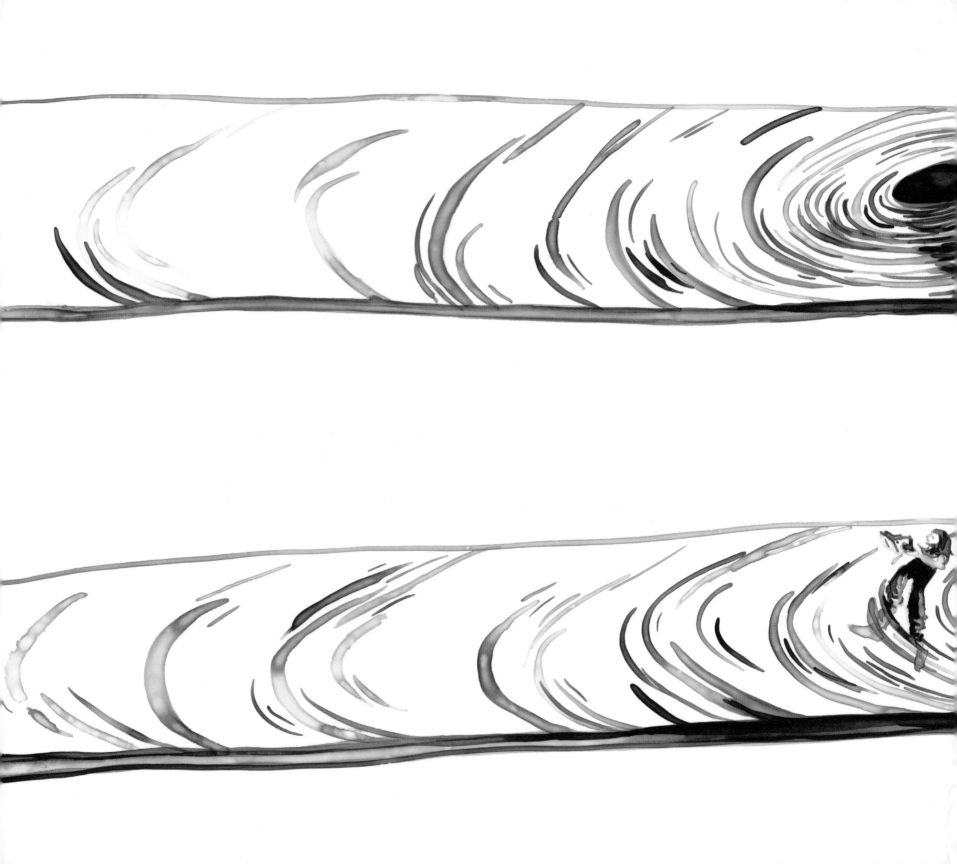

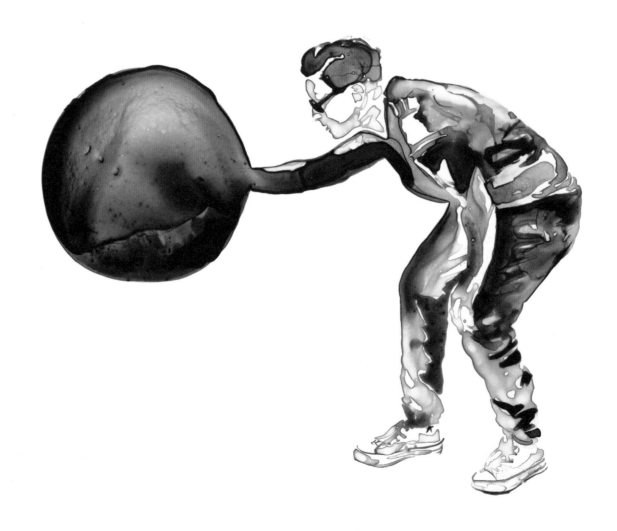

Lia strolls back to the wormhole's left mouth,
 and taking both books from Felicia
 walks them around to the wormhole's right mouth.
Then through the wormhole and backward in time
 she offers both books to Felicia.

Felicia now has four.
And repeating this over and over and over
 one of my books becomes
 as many as anyone ever could want.

The weight of the pile of books
 growing exponentially
 develops a mammoth gravity
 that shatters the time machine
 — while Lia rescues Felicia
 averting a far worse tragedy.

3 /

GEOMETRODYNAMICS: WARPED SPACETIME IN A STORM, AND GRAVITATIONAL WAVES

First Pass

 Quickly

When spinning black holes collide
 they create
 a storm in the fabric
 of space and time.

In that terribly violent storm:
 Twisting-space vortices vibrate and generate
 stretch-and-squeeze tendices, fully entwined
 with their vortex parents.
 And stretch-and-squeeze tendices spiral and generate
 twisting-space vortices fully entwined
 with their tendex parents.

A geo-metro-dynamical storm:
 a storm in the rates of flow of time.
 a storm in the shapes of space.

Hold on.
Slow down.
OK.
Step by step.

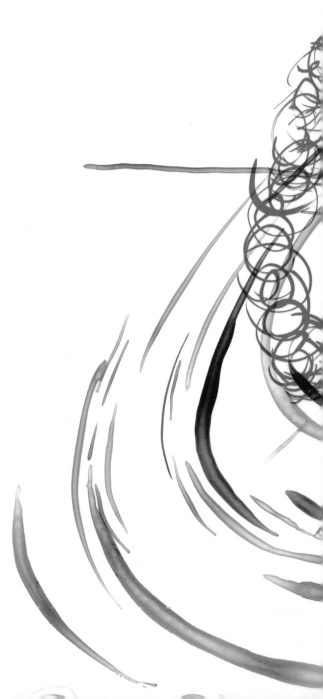

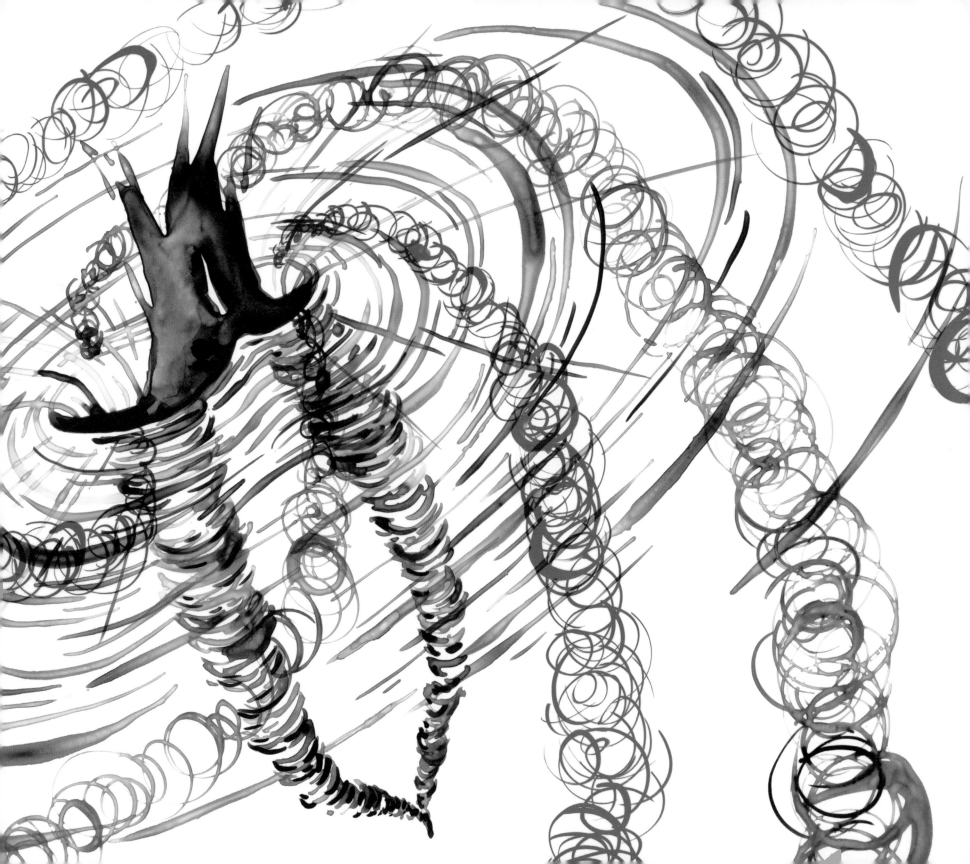

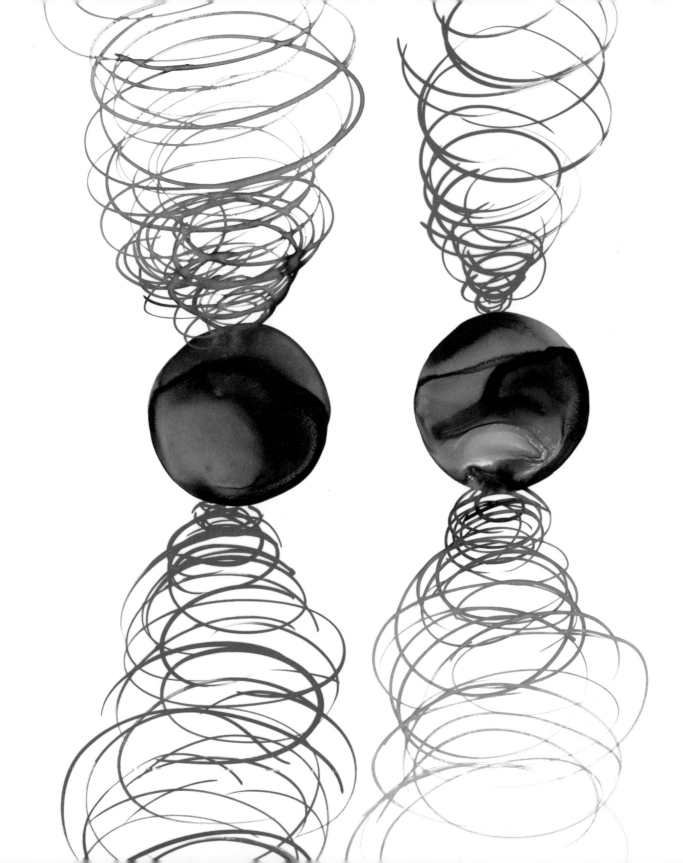

When Spinning Black Holes Collide Head-On:
Fighting, Entwining Vortices
Morph into Gravity Waves

Two black holes flew toward a collision
 — identical holes
 with transverse and opposite spins.

The left hole happened to carry
 an upward-pointing vortex
 of clockwise twisting space
 and downward-pointing vortex
 with counter-clockwise twist.
The right hole's spin was reversed:
 counterclockwise up
 and clockwise vortex down.

The two holes collided head-on.
Their horizons merged into one.
And what happened next was amazing to see
 in simulations my students performed
 on a Beowulf supercomputer cluster
 — a cluster endowed with
 The Might of the Kings.

The clockwise vortices
 reached around the hole
and merged to form a single vortex
 bound to the hole's horizon —
 emerging from the upper left
 descending to the lower right.

The counter-clockwise ones
 reaching around the hole
merged to form a single vortex
 rising from the upper right
 descending to the lower left.

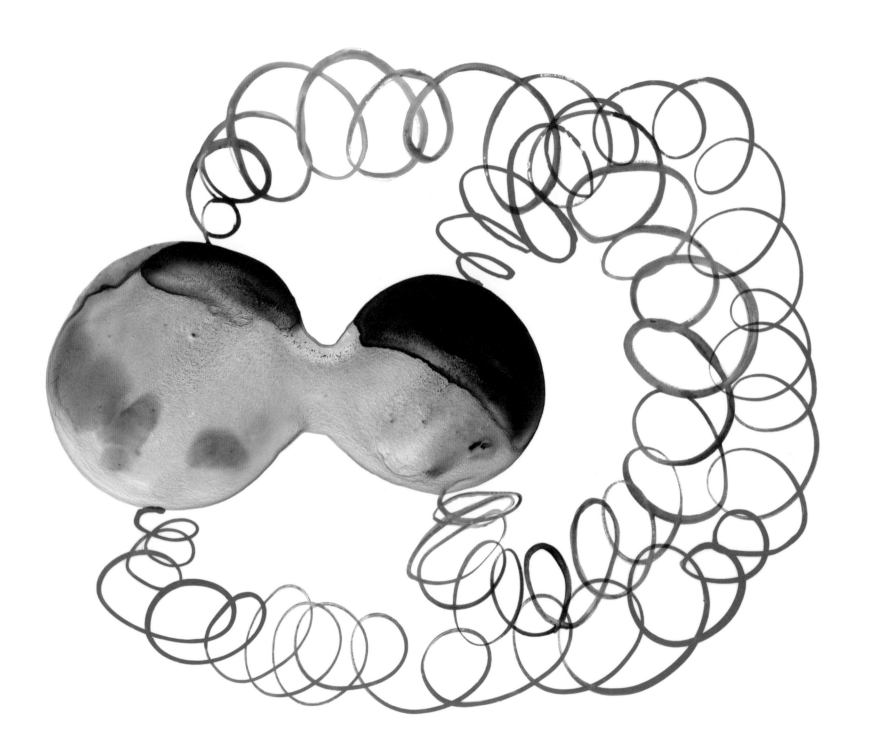

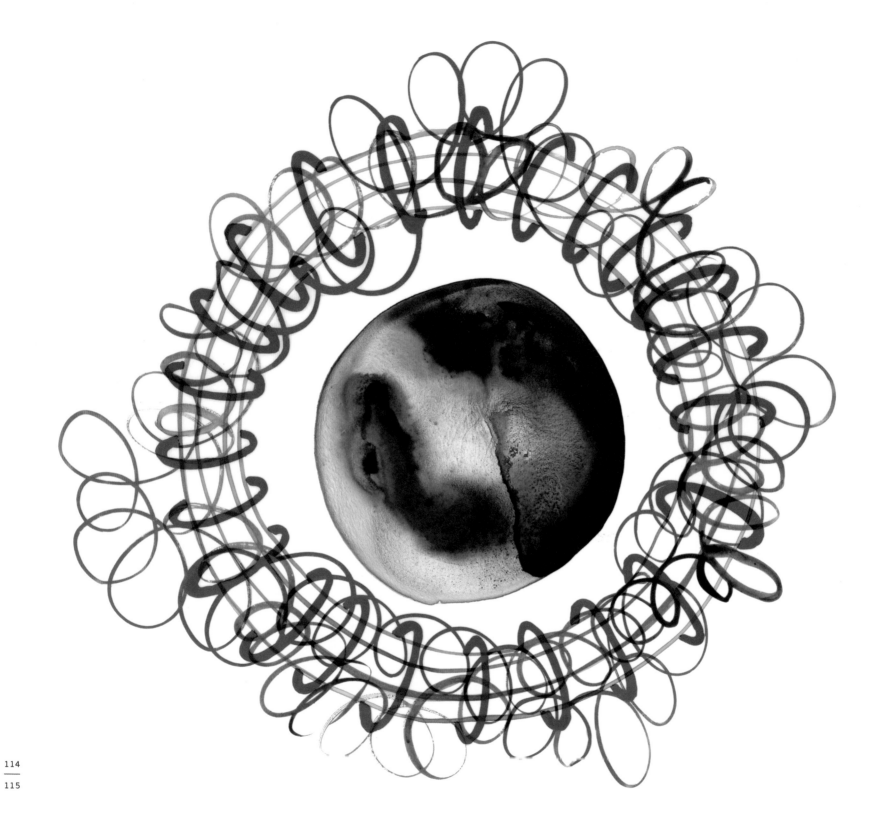

A violent battle ensued.
The opposite vortices flung one another
 off of the merged black hole.
Liberated, they swiftly embraced
 to form a torus around the hole
 — like a smoke ring
 from a smoker's tongue —
a ring of intertwined vortices
 entangled with one another.

The ring expanded at the speed of light.
And as it swept on outward,
 the motion of its vortices
 created *stretching* tendices
 wrapped 'round the ring's long loop
 and also *squeezing* tendices
 around the ring's short loop.

And the ring's expanding vortices
 pushing against the hole
cloned their mirror images:
 new counterclockwise vortex
 from upper left to lower right
 new clockwise vortex reaching
 from upper right to lower left.

Another battle ensued.
 This new generation of vortices
 flung one another off of the hole.
Liberated, they rushed to embrace
 forming a new-generation ring.

The newly minted ring
 expanding at the speed of light
 generated tendices
 reversed from those that came before:
 squeezing around the ring's long loop
 stretching around the ring's short loop.

Ring after ring after ring
 each weaker than before
expanding at the speed of light
 into intergalactic space —
Across the universe they flew.
Gravity waves they had become.

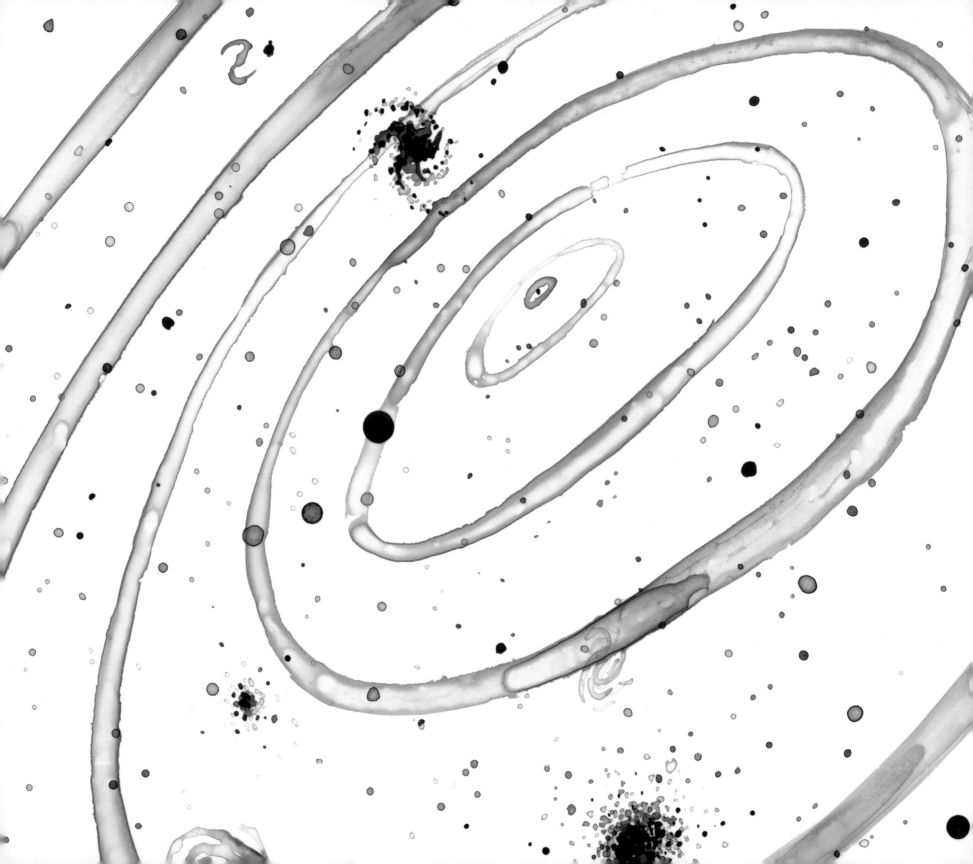

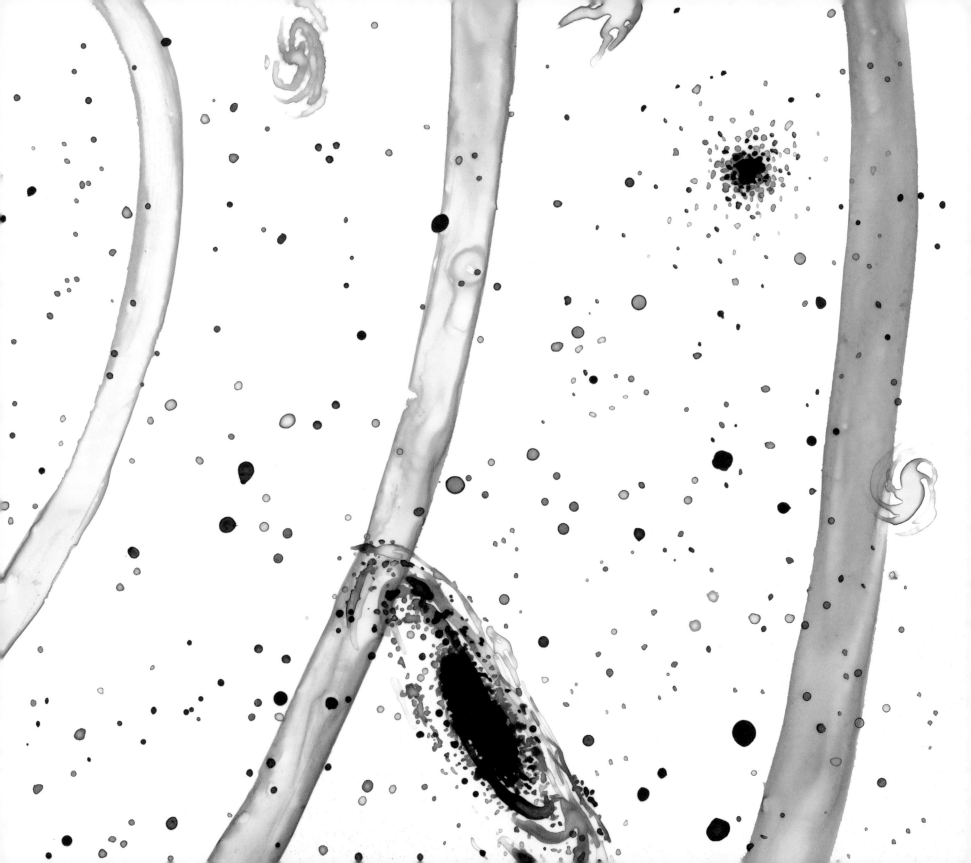

When Orbiting Black Holes Collide:

Spiraling Vortices

Morph into Gravity Waves

/ What else did my students euphorically learn

by solving the Einstein equations

on their Beowulf supercomputer?

— their cluster endowed

with The Might of the Kings.

/ Two spinning black holes orbit each other

— identical holes

that happen to spin

'round axes that lie in their orbital plane.

A being inspecting our brane from the bulk

sees the holes' funnels stretch downward.

From the top of each funnel

— the black-hole horizon —

two spin-induced vortices come into view

with equal but opposite twists.

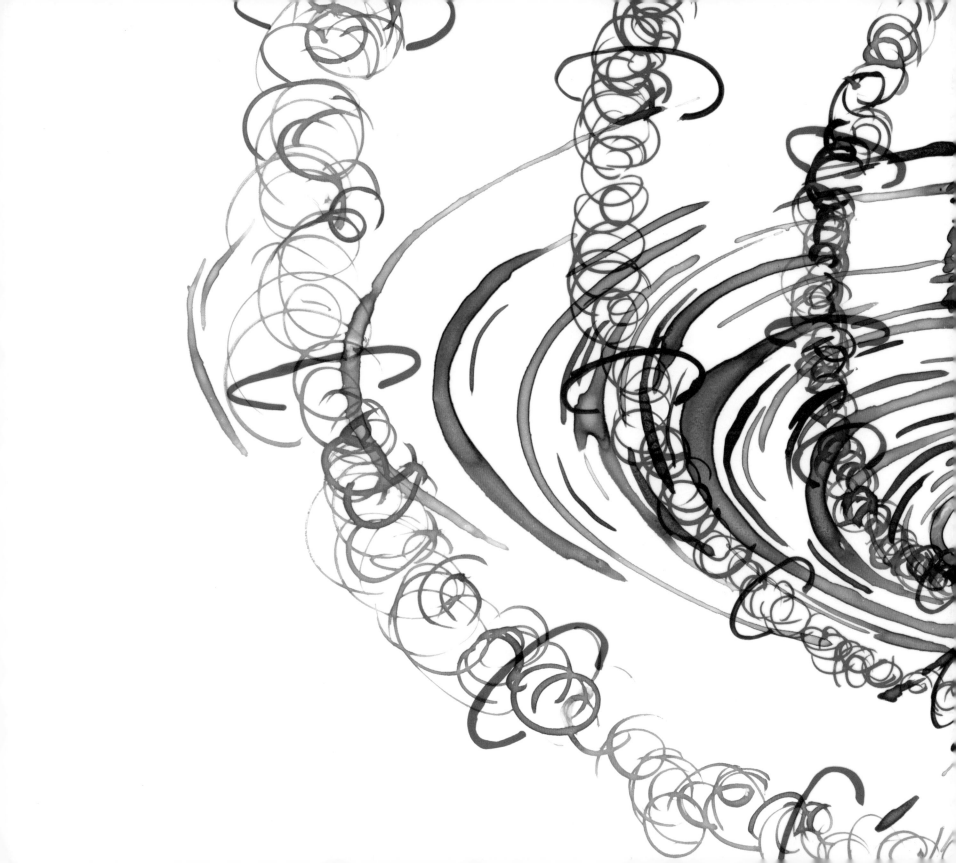

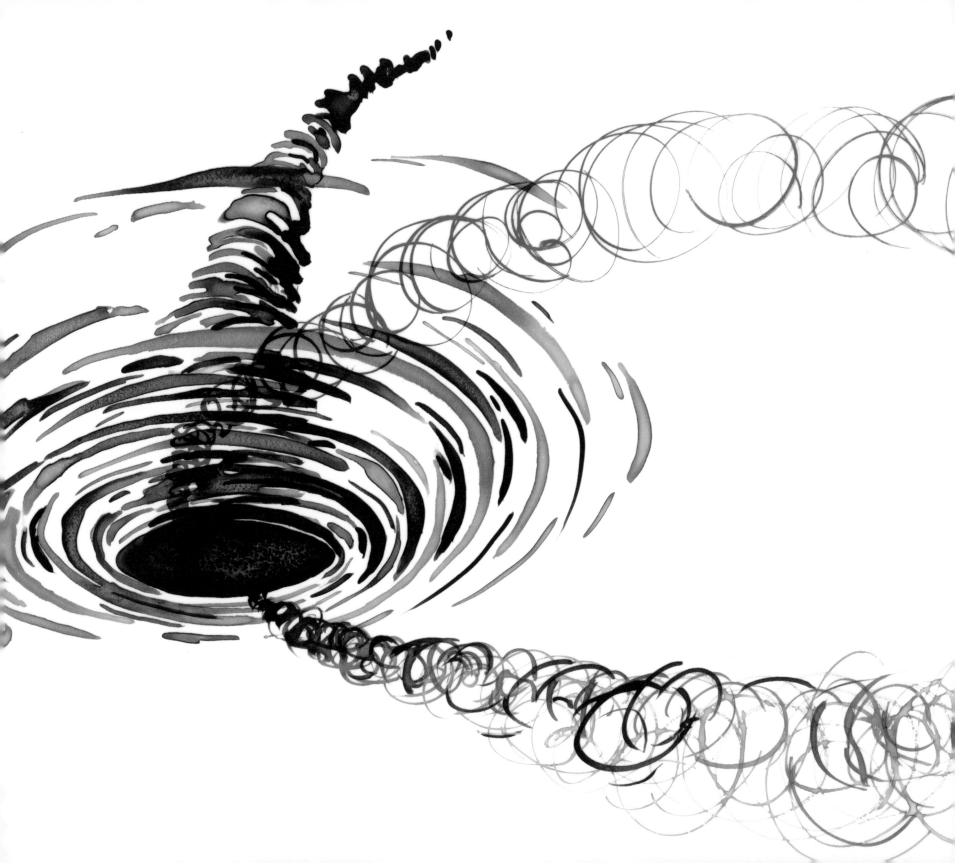

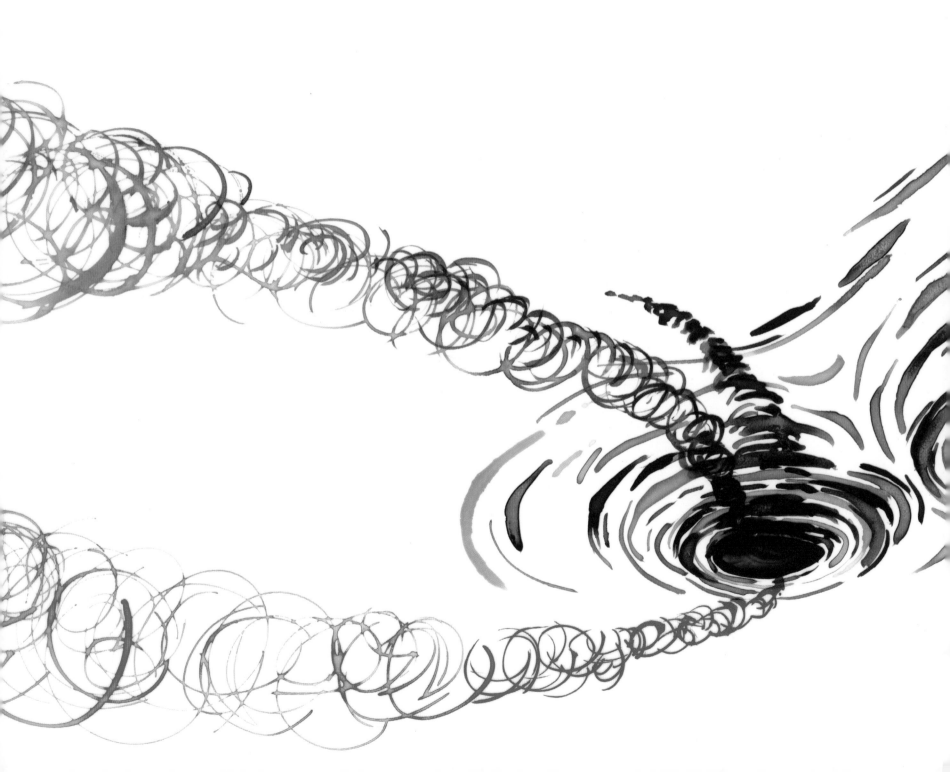

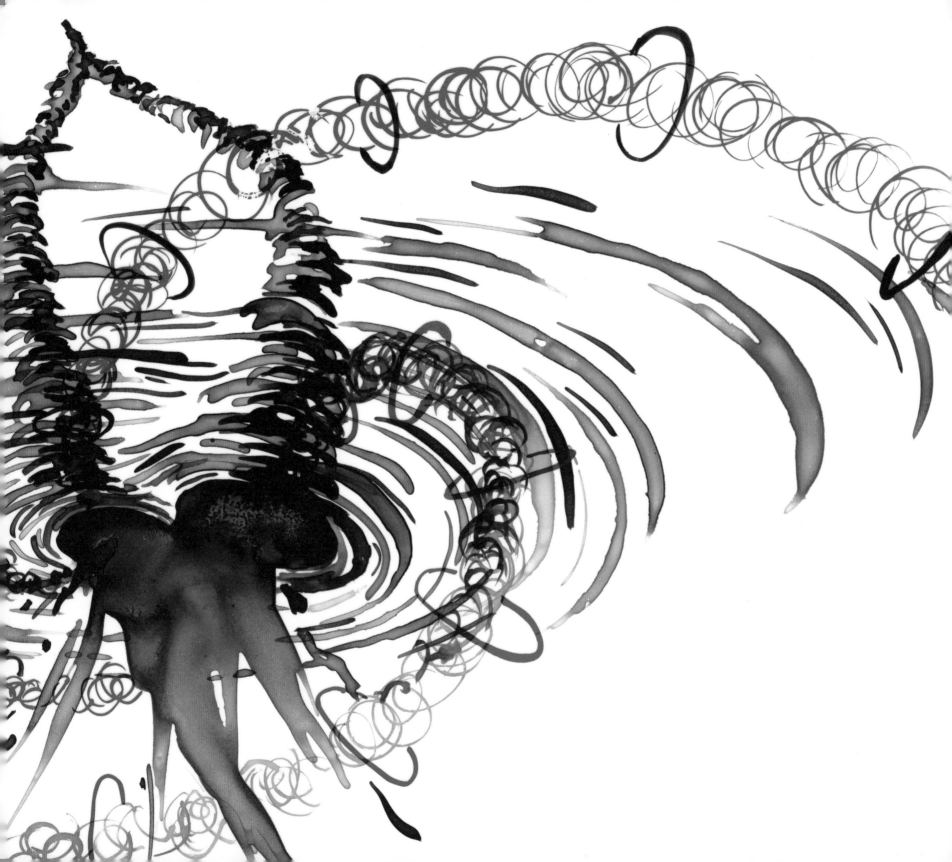

/ As the holes circle 'round one another
 their vortices bend backward
 trailing out spirals of twisting space
 like water swinging outward
 from whirling sprinkler heads.

Each of the spiraling vortices
 sweeps outward at the speed of light
creating by its motion
 tendices that stretch and squeeze
 tendices entwining
 with their vortex parents.
A *Gravitational Wave*.

These outward-sweeping gravity waves
 sap energy from the holes' motions,
 forcing their orbit to shrink.

Smaller and smaller the orbit draws in
 until, in a powerful cataclysm,
 the two black holes collide and merge
 in a huge geo-metro-dynamical storm.

Tendex-Generated Waves

/ But wait.
I have told you
 and Lia has shown you
only half of the story.

Really? There's more?
 So much for my mind's eye to see?

When two black holes collide and merge
 their horizon, now a dumbbell shape
 not only grips four vortices
 it also holds three *tendices*:
 one *stretching* tendex at each dumbbell end
 and a *squeezing* tendex shaped like a fan
 circling around the dumbbell neck.

As the dumbbell horizon tumbles in space
 its tendices that stretch and squeeze
 bend backward into trailing spirals.

Spiraling out at the speed of light
 these tendices create and entwine
 vortices of twisting space
 and thereby they transform themselves
 into soaring *Gravity Waves*.

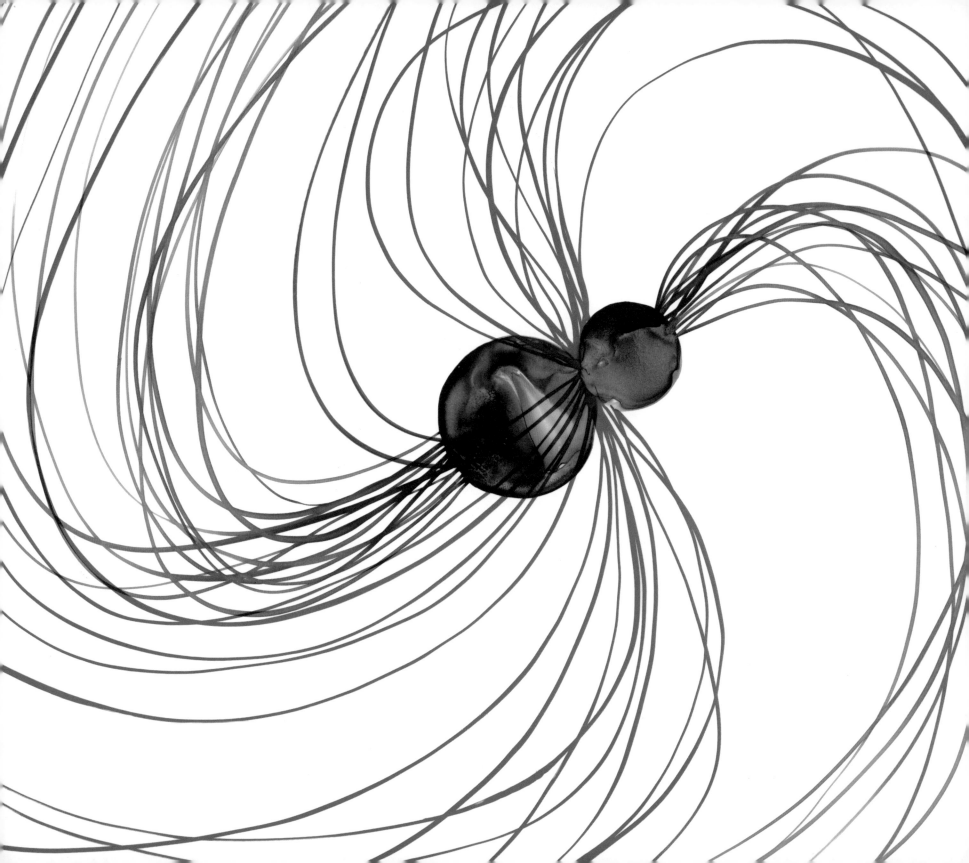

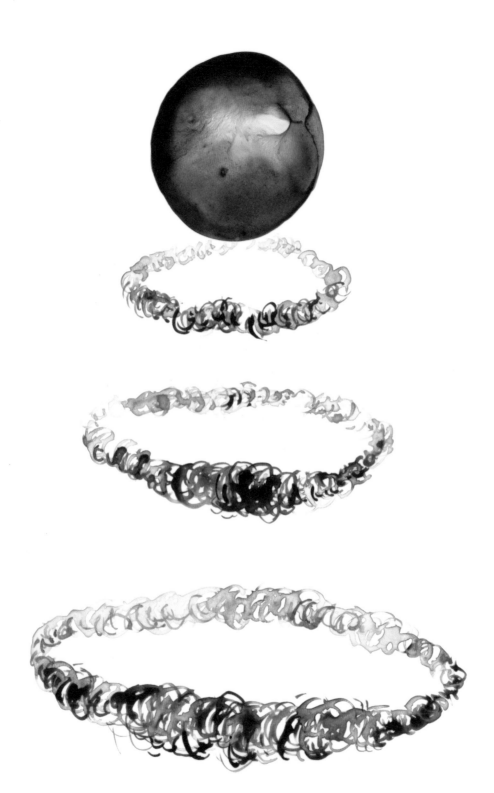

This second set of waves
 made by spiraling tendices
 bound to the hole's horizon
accompanies the first wave set
 made by spiraling vortices
 also bound to the hole.

South of the merging holes
 the two wave sets reinforce one another.
Together they are hugely strong.

The northern waves
 largely cancel each other.
Together they are rather weak.

Just as a firing gun recoils,
 so the merged black hole recoils.
Kicked by the strong southern-hemisphere waves,
 the hole recoils northward.

This geo-metro-dynamical kick
 can be so gigantically strong
that it launches the wave-spewing hole
 out of its parent galaxy, into intergalactic space
 there to wander alone
 for eon after eon.

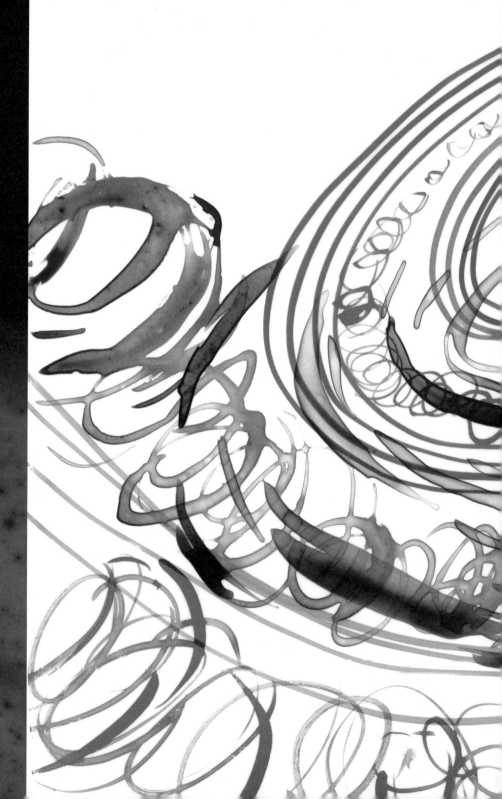

The Waves' Tremendous Power

These gravity waves are hugely strong
 fifty times more total power
 — more luminosity —
 than all of the light
 from all of the stars
 in all of our universe
 combined.

Fifty universe luminosities
 from two black holes colliding.
But not any light or infrared
 or gamma rays or radio.
No waves electromagnetic at all.
None of any type.

Fifty universe luminosities
 carried wholly and solely by gravity waves
 by tendices and vortices entwined
 by structures made from warped spacetime.

And all of this power comes from where?
 From the tendices and the vortices
 bound to the hole's horizon.

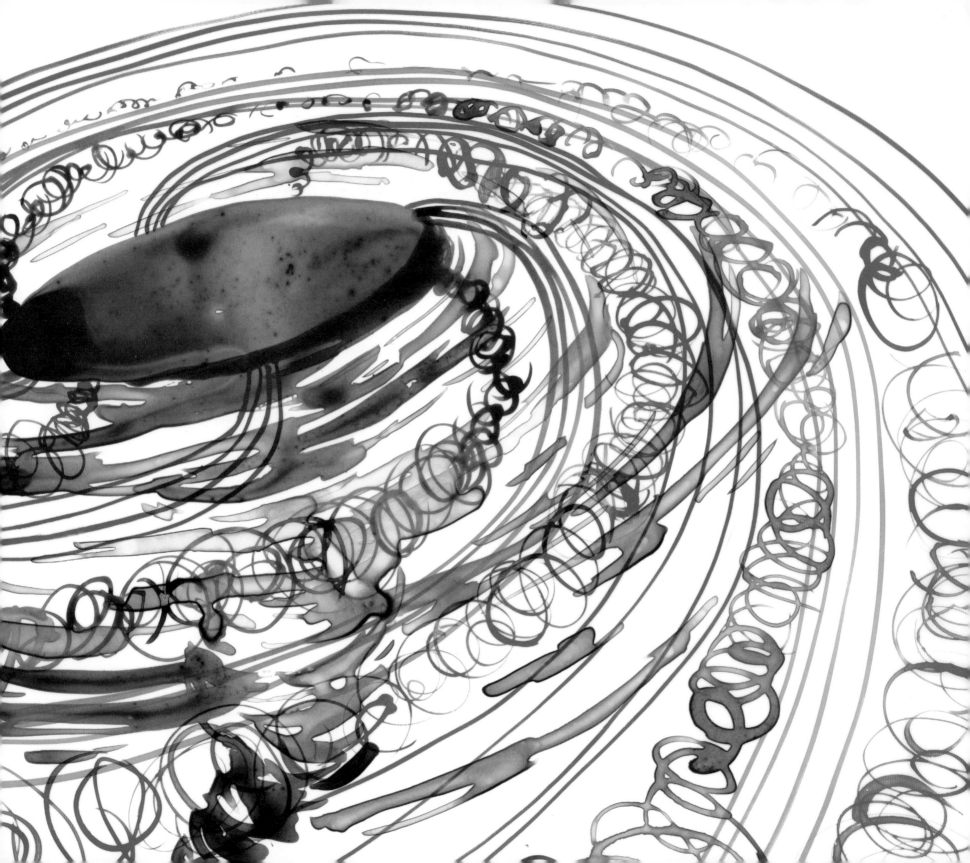

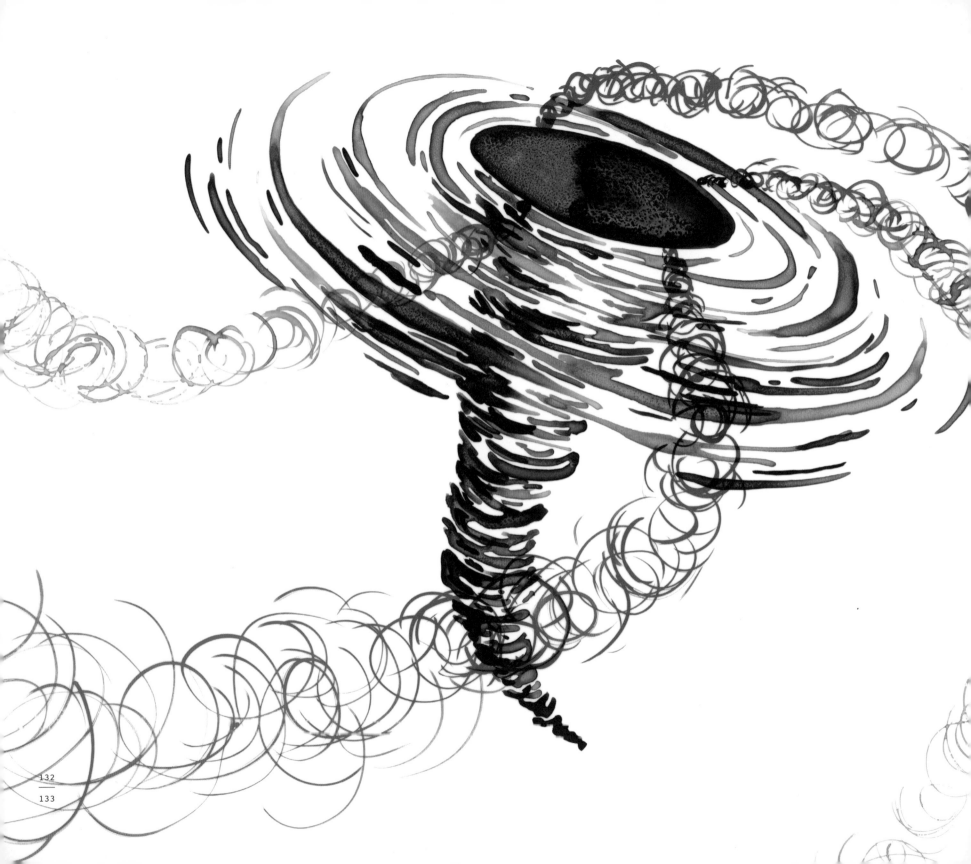

/ As the waves depart
 one after another —

The spiraling vortices
 gripped by the tumbling hole
decay and die and disappear.

The tumbling dumbbell horizon
 smooths into a flattened sphere
and all its spiraling tendices
 also decay, and disappear.

The colliding holes' two funnels merge.
And the merged black hole settles down
 into pure quiescence.

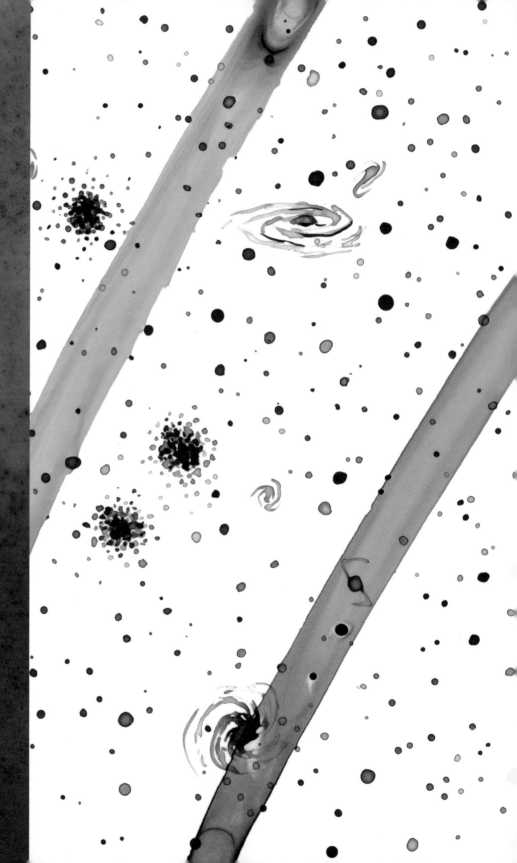

Across the Universe
 to Earth

The colliding holes' gravity waves
 leaving behind the merged black hole
fly into inter*stellar* space.

From star to star
 — giant and dwarf, red and blue —
 they fly,
 across their birthing galaxy
 into inter*galactic* space.

From galaxy to galaxy
 — large and small, diffuse and spiraled —
 they fly,
 toward our Milky Way and Earth.

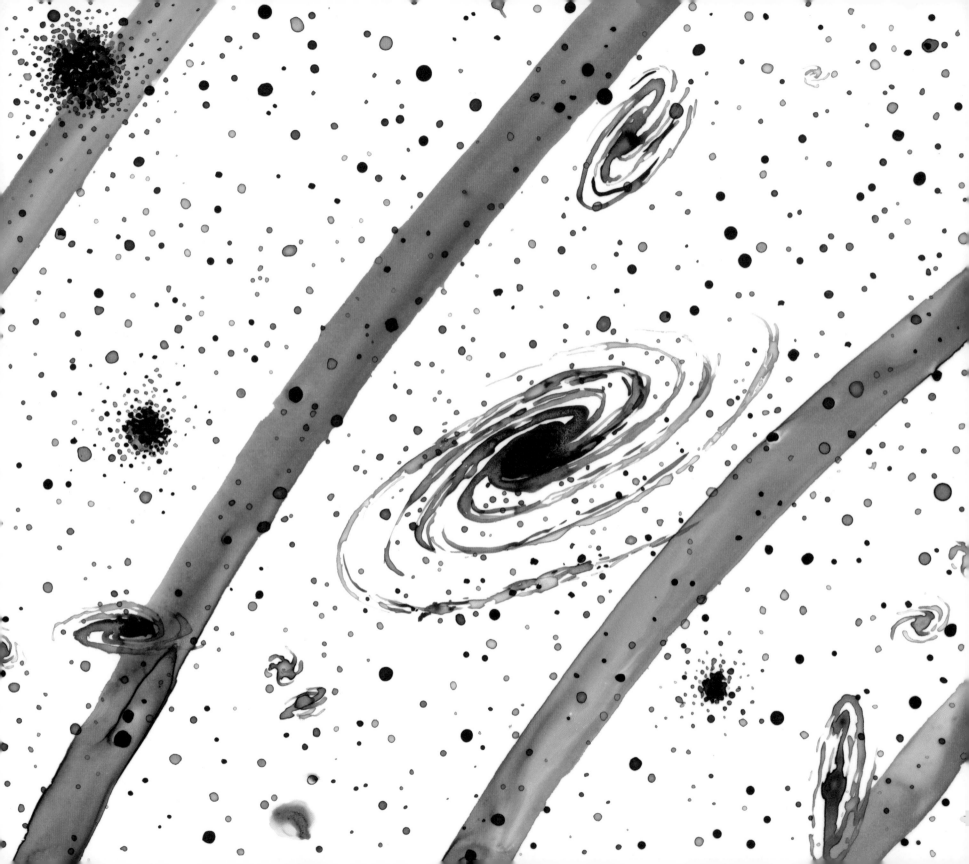

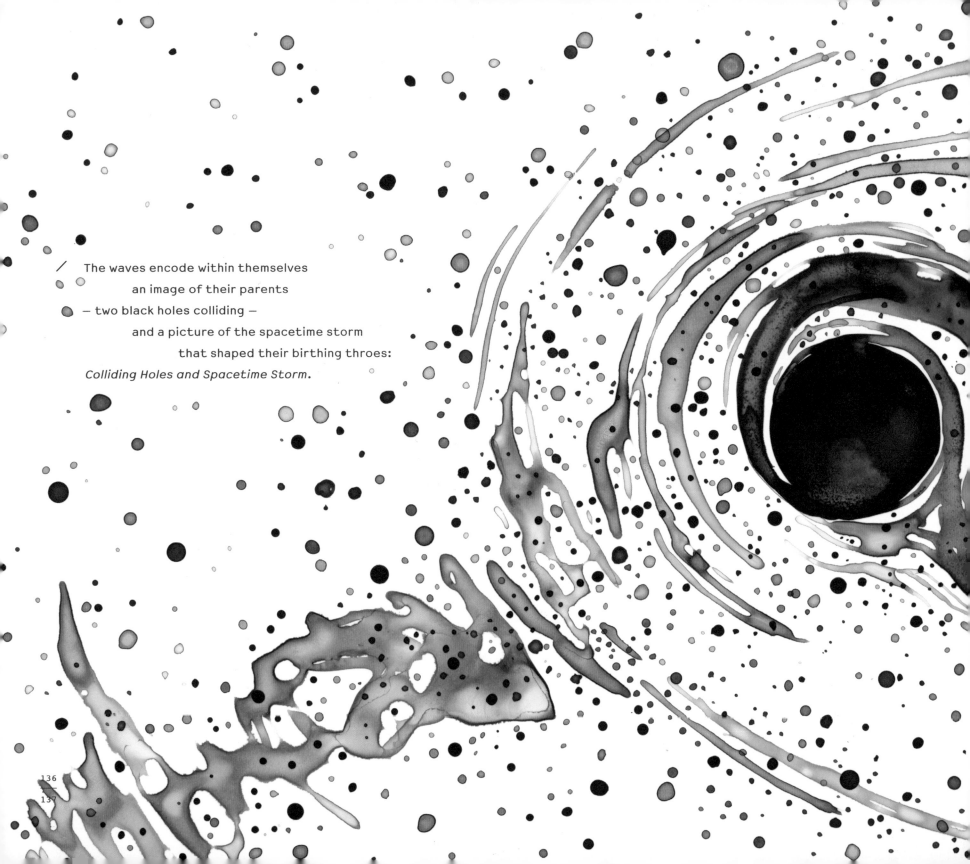

The waves encode within themselves
an image of their parents
— two black holes colliding —
and a picture of the spacetime storm
that shaped their birthing throes:
Colliding Holes and Spacetime Storm.

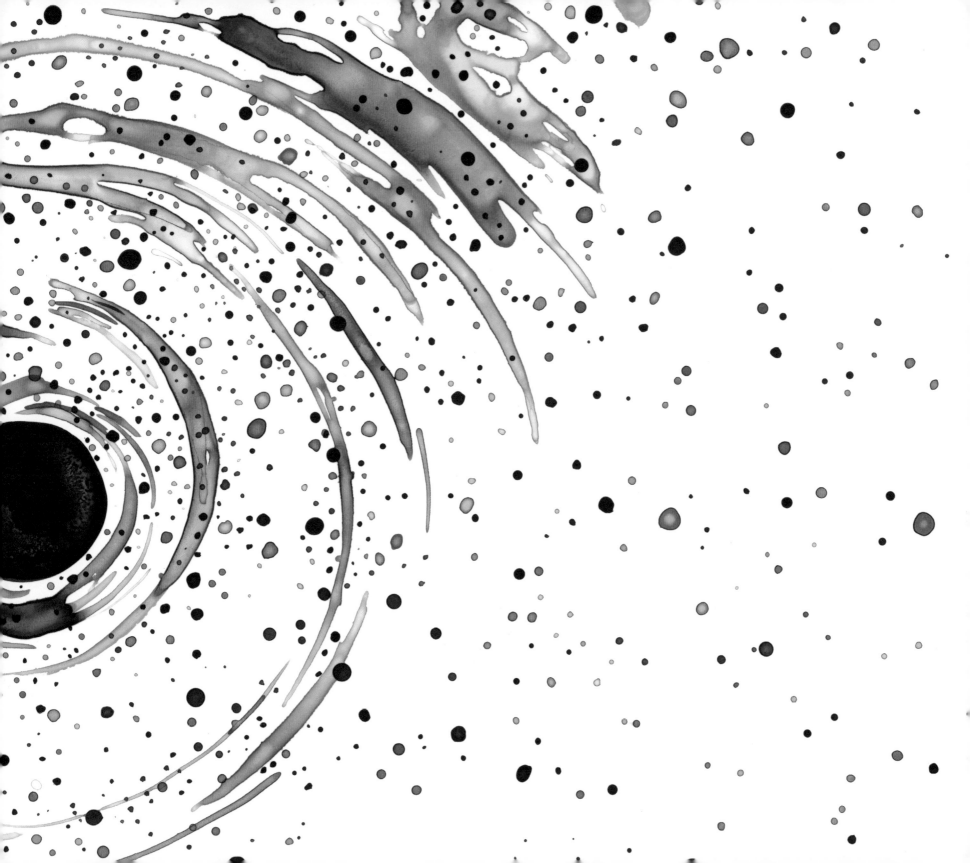

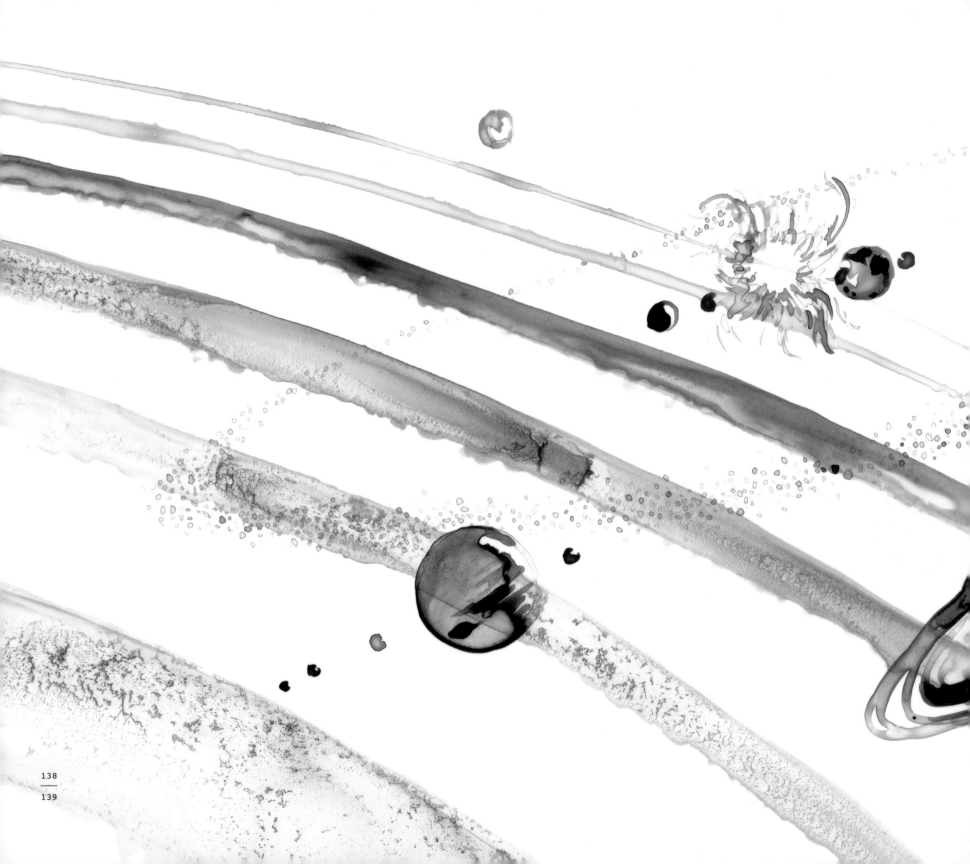

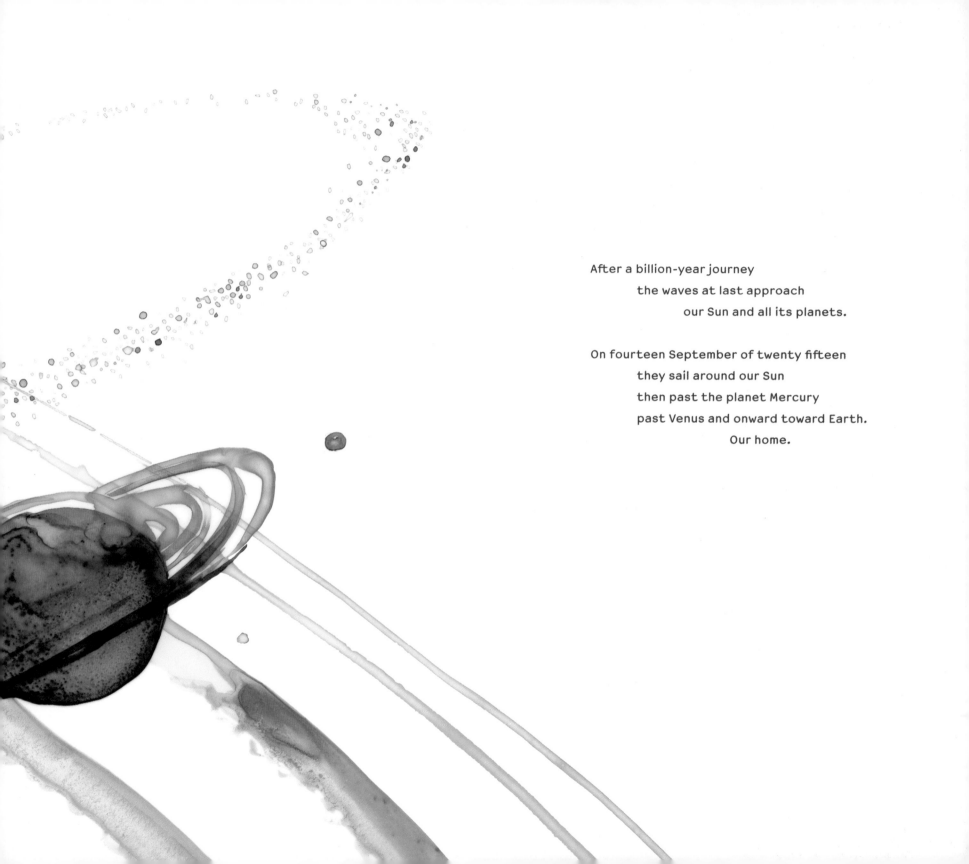

After a billion-year journey
the waves at last approach
our Sun and all its planets.

On fourteen September of twenty fifteen
they sail around our Sun
then past the planet Mercury
past Venus and onward toward Earth.
Our home.

LIGO

The Laser Interferometer

Gravitational-Wave Observatory

Waiting on Earth
 near New Orleans
 — where American Jazz was born —
and waiting on Earth
 near Hanford
 — the town that made fuel
 for the first atom bomb —

Waiting in these historical spots
 are observatories named *LIGO*.

Each is an L-shaped, man-made behemoth
 that senses the passing gravity waves
 and deciphers the message they carry:
 colliding holes and spacetime storm
 in which the waves were born
 so very far away
 and very long ago.

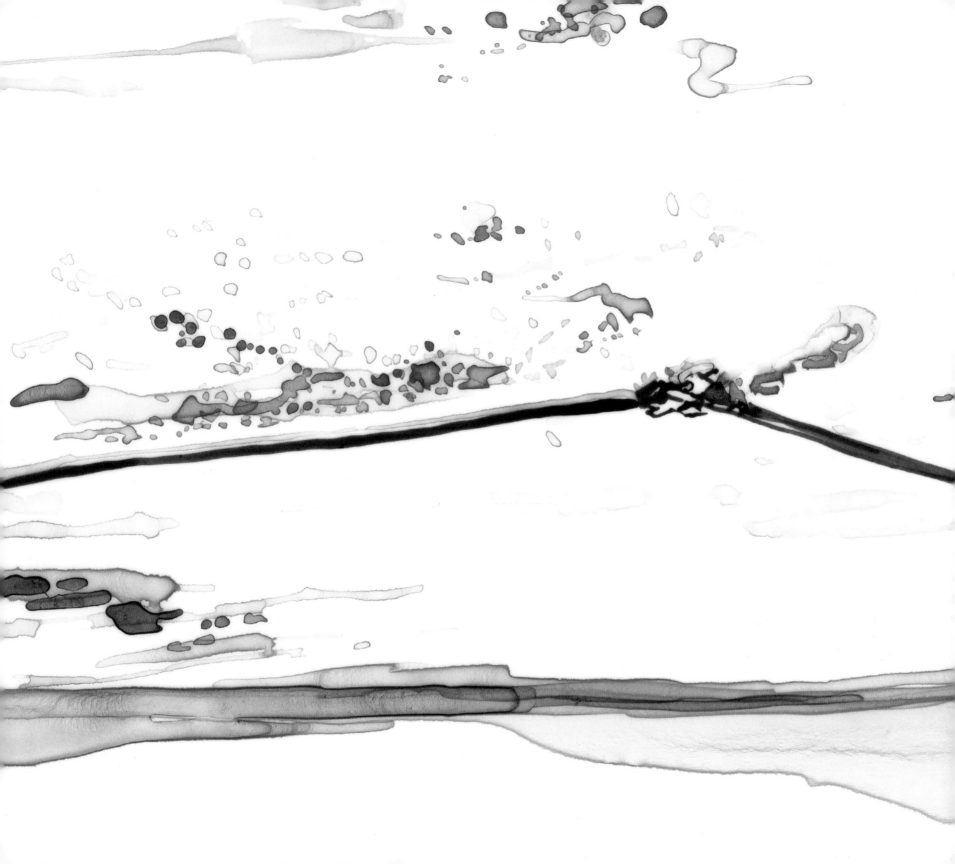

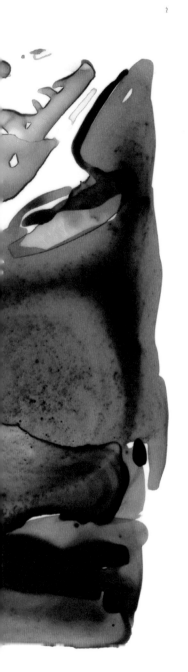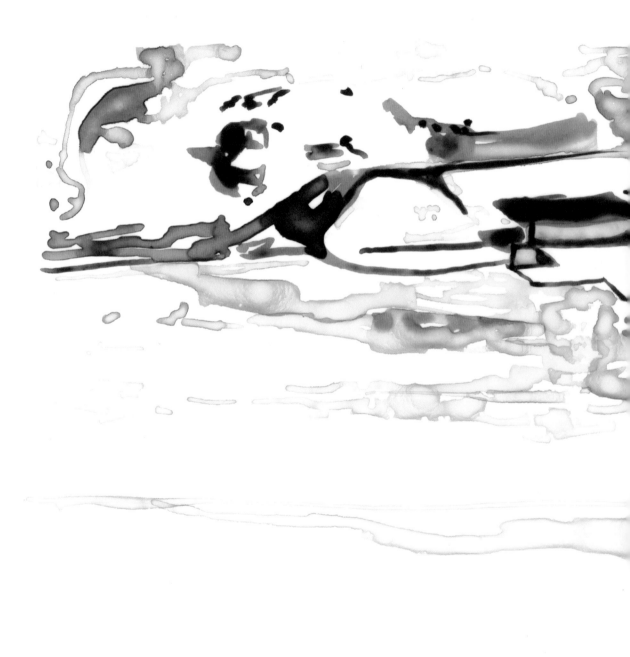

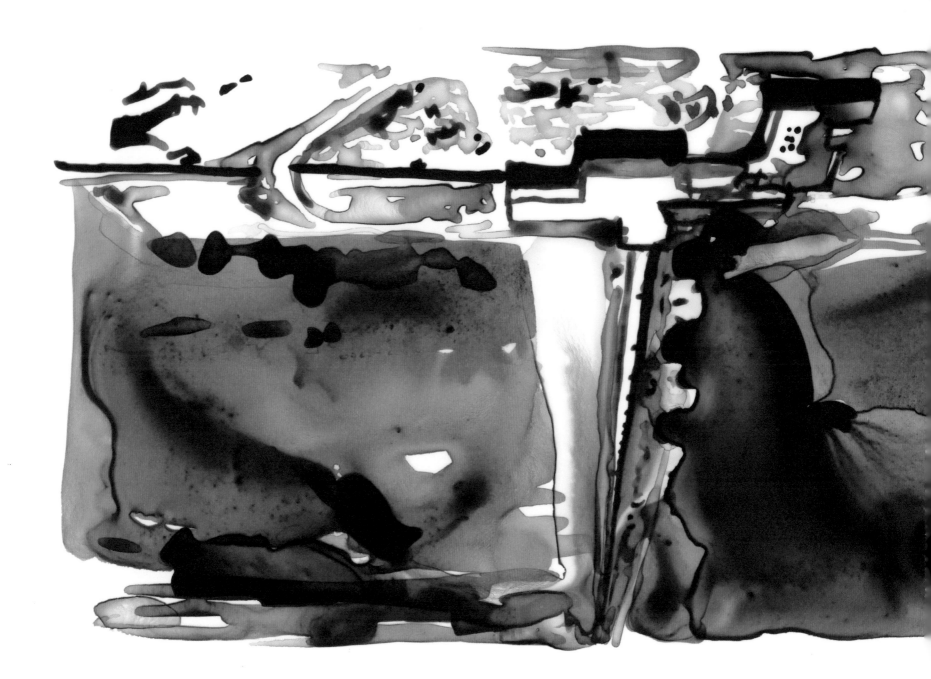

In each observatory:
On each four-kilometer arm of an L,
 a light beam is trapped
 between free hanging mirrors
 weighing eighty-eight pounds.

When an incoming wave
 tickles the L
its tendices stretch the west-pointing arm
 pulling the mirrors apart
 and stretching the light beam they trap;
and its tendices squeeze the north-pointing arm
 pushing the mirrors together
 and squeezing the beam that they trap
 — ever so infinitesimally —
 one-hundredth the width of a proton.

Ten milliseconds later
 the stretch becomes a squeeze,
 and the squeeze becomes a stretch.
By alternating stretch and squeeze
 the waves tap out their message
 and inscribe it on the beams:
Colliding Holes and Spacetime Storm.

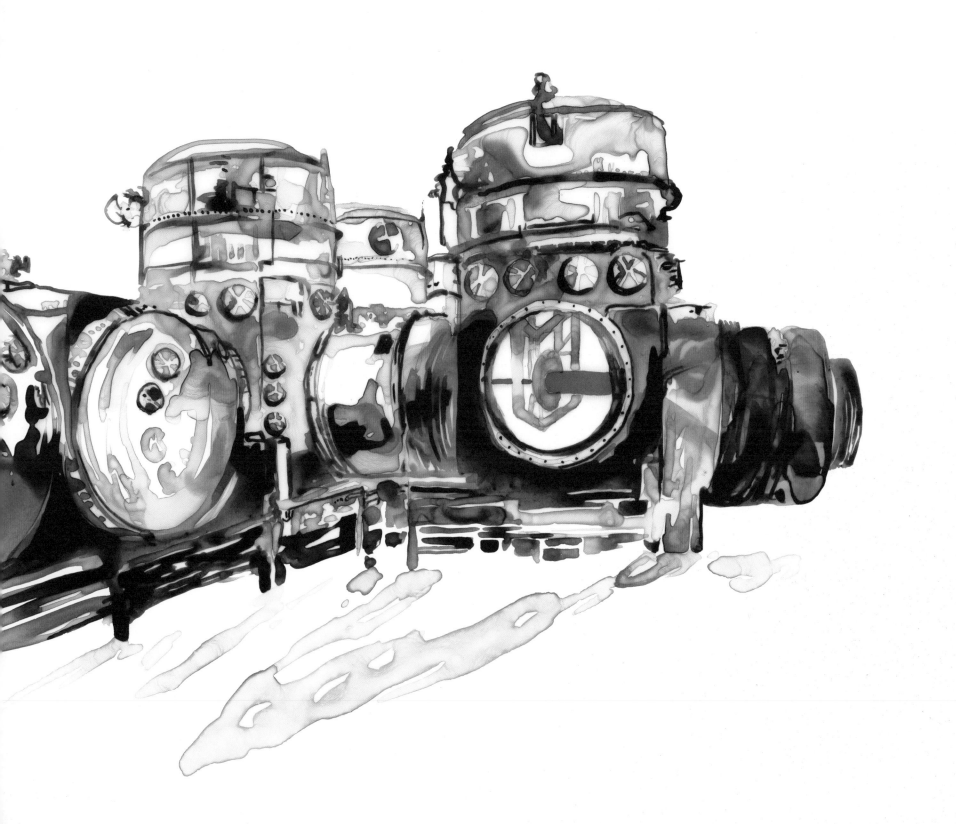

The light beam trapped in each arm
 leaks out through its corner mirror.
The two leaking beams interfere
 inside of a photodetector,
 translating their stretch-and-squeeze code
 into electrical voltage,
 recorded, at last, for humans to see
Colliding Holes and Spacetime Storm.

So that is the nature
 of the L-shaped behemoth:
It's a *gravity-wave interferometer.*

Once more, with feeling:

Gravity waves
 stretch and squeeze beams
 temporarily trapped between mirrors
 along the two arms of an L.
The beams
 leaking out
 interfere
 inside of a photodetector,
 producing electrical voltage
 and thence a recorded signal:
Colliding Holes and Spacetime Storm.

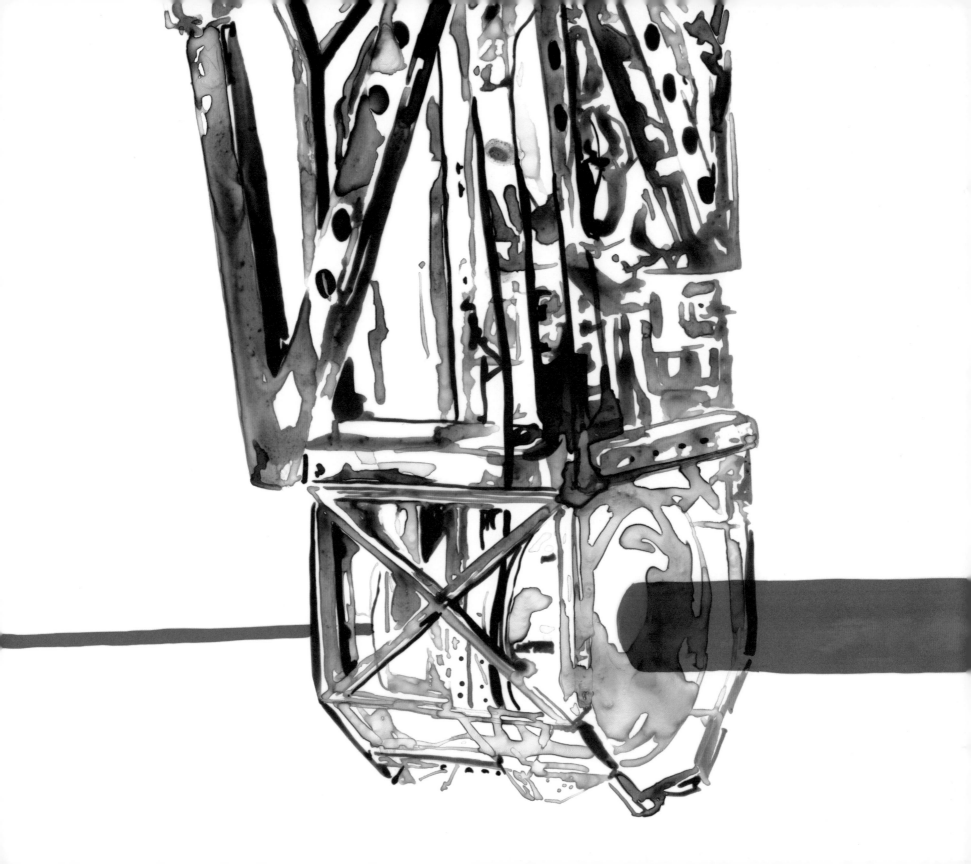

Galileo

and LIGO

The laws of physics dictate
 that only *two* types of waves
 can travel across our universe
 bringing us portraits of far, far away.

We humans have long known the first of these —
 Electromagnetic waves
 (light rays and X-rays and gamma rays,
 radio-waves and infra-red).

Einstein predicted the second type —
 Gravitational waves, comprising
 twisting-space vortices intertwining
 stretching and squeezing tendices.

It was Galileo Galilei
 four hundred years ago
who built an optical telescope
 and pointing it to the sky
 discovered Jupiter's four large moons
 thereby creating instrument-based
 electromagnetic astronomy.

Over the past quarter century
 LIGO's human fleet
 — a thousand physicists and engineers —
 constructed their two behemoths.

Upon turning them on
 in twenty fifteen,
they discovered the waves
 from colliding black holes.
 And thereby they birthed
 instrument-based
 gravity wave astronomy.

Contemplate the revolution
 in how we view our universe —
the revolution wrought by
 electromagnetic astronomy
over the past four centuries
 and twenty
 human
 generations
 since Galileo's time.

This may foretell, indeed,
 a radical new revolution
 that gravity wave astronomy
 and electromagnetic entwined
 will bring to our descendants
 over the next four centuries.
A revolution transformative
 like the one
 Galileo wrought.

How Did LIGO Come to Be?
My Own Parochial View . . .

A very long time ago
 — as the First World War was raging —
Einstein discovered the physical laws
 that came to be named for him —
the natural laws that predict and control
 The Warped Side of Our Universe.

Half a year later, in nineteen sixteen
 — probing his laws mathematically
 with mind at a feverish pitch —
Einstein predicted
 gravitational waves
 but thought them too weak
 for humans
 ever to see.

$$x_4 = it, \qquad g_{\mu\nu} = -\delta_{\mu\nu} + \gamma_{\mu\nu}$$

$$\gamma'_{\mu\nu} = \gamma_{\mu\nu} - \frac{1}{2}\delta_{\mu\nu}\sum_{\alpha}\gamma_{\alpha\alpha} \qquad \sum_{\alpha}\frac{\partial \gamma'_{\mu\alpha}}{\partial x_\alpha} = 0$$

$$\sum_{\alpha}\frac{\partial^2 \gamma'_{\mu\nu}}{\partial x_\alpha^2} = 2\kappa T_{\mu\nu} \qquad \gamma'_{\mu\nu} = -\frac{\kappa}{2\pi}\int \frac{T_{\mu\nu}(x_0, y_0, z_0, t-r)}{r}dV_0$$

Over the next half century
 — through flappers, depression, and holocaust
 the Beatles and LSD —
human technology vastly improved
 — with rockets, computers and video
 and lasers and LEDs
and astronomers probed the universe
 — finding quasars and pulsars and neutron stars
 and remnants of the big bang.

The quest to find
 gravitational waves
 no longer seemed totally hopeless.
Only *incredibly* hard.

I then was a very young Caltech professor
 of theoretical physics
newly arrived in L.A.
 — the hotbed of Hollywood starlets
 and endless sand and surf and sun.

To those I paid no mind.
My head was wrapped
 in the stars above
in love with black holes
 and all the Warped Side
 and also with gravity waves.
 They were neat.

With a remarkably talented student
 named William Henry Press
 and kindred other physicist friends
I began to develop a vision
 — theoretical, you understand —
 of what gravity waves
 might reveal to us
 if only we could perceive them.

A vision for the future of
 Gravity wave astronomy.

Annual Reviews of Astronomy and Astrophysics 1972

GRAVITATIONAL-WAVE ASTRONOMY[1,2]

William H. Press[3] and Kip S. Thorne

California Institute of Technology, Pasadena, California

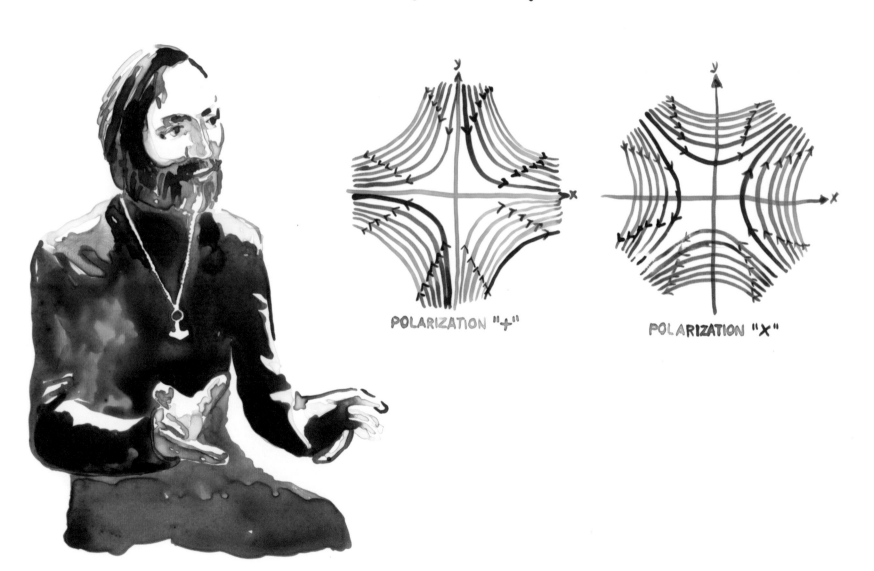

POLARIZATION "+" POLARIZATION "X"

In nineteen seventy-two
 when Bill Press and I at Caltech
 published our first vision document,
Rainer (Rai) Weiss at *MIT*
 was writing a technical manuscript
 proposing the L-shaped behemoth that
 would ultimately bring us success.
Rai's *Gravitational Interferometer:*

Gravity waves
 stretch and squeeze beams
 temporarily trapped between mirrors
 along the two arms of an L.
The beams
 leaking out
 interfere
 inside of a photodetector,
 producing electrical voltage
 and thence a recorded signal.

Insightful and practical Rai was amazing
 and theorist me, I was practically clueless.

When first I heard his proposal
 and compared with the strengths
 of the gravity waves
 that I guessed might be bathing the Earth
I thought that Rai had gone crazy.

MASSACHUSETTS INSTITUTE OF TECHNOLOGY

RESEARCH LABORATORY OF ELECTRONICS

QUARTERLY PROGRESS REPORT

April 15, 1972

Electromagnetically Coupled Broadband
Gravitational Antenna

R. Weiss

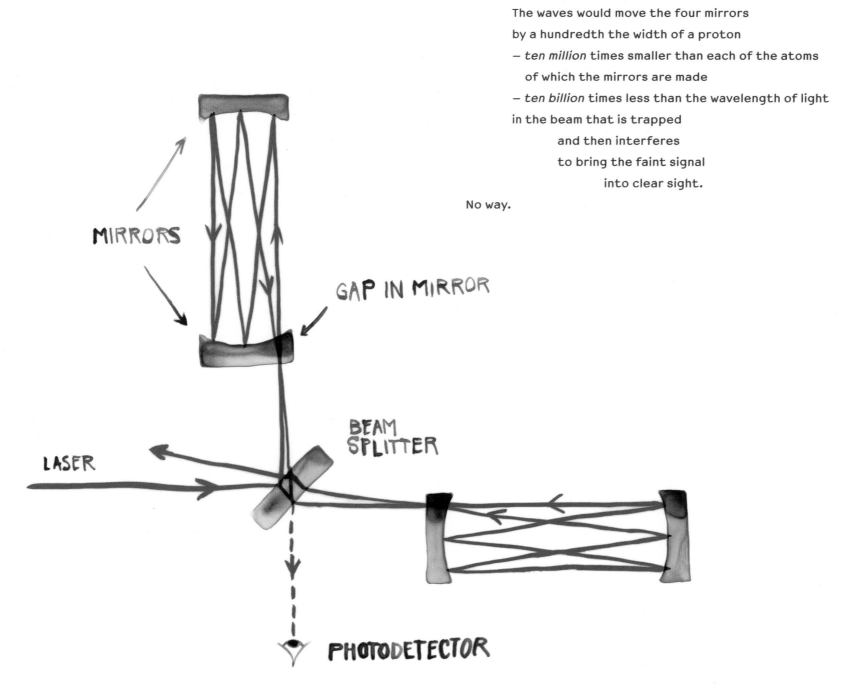

No way. No way. No way.

The waves would move the four mirrors

by a hundredth the width of a proton

— *ten million* times smaller than each of the atoms

of which the mirrors are made

— *ten billion* times less than the wavelength of light

in the beam that is trapped

and then interferes

to bring the faint signal

into clear sight.

No way.

MIRRORS

GAP IN MIRROR

BEAM SPLITTER

LASER

PHOTODETECTOR

But then I studied the manuscript
 that insightful and practical Rai had produced.
It predicted the worst of the noises
 that his behemoth might face,
 and conceived of techniques for dealing with each,
 and computed how small his dealings could make
 each of those dangerous noises.

His analysis was a tour de force
 exquisite in its beauty.
Through studying it and talking to Rai
 I soon became convinced.

"Although the risks are extremely high
 this just might work," I opined.
"And if it works the payoff for
 our human understanding of
 the universe in which we live —
that payoff will be huge for mankind."

Late one night, near to the end
 of nineteen seventy-six
I wandered the San Marino streets
 for hour after hour,
contemplating
 the frightening risks
 the human and financial costs
 and also the huge rewards
 if our gamble were to pay off.
 And also the fun, the enormous fun
 of a decades-long effort with kindred souls
 in the quest to fulfill our dreams.

At wandering's end
 in the dead of the night
I committed myself to do everything
 that I with my students
 could possibly do
to help Rainer Weiss
 and his MIT team
 succeed.

The saga of
 the next forty years
is chronicled in ways
 too myriad to count.

It's a history of *struggles* intense
 through which Rai and I formed a personal bond
 and insightful practical Rai soon became
 my transcontinental soulmate.

Together we struggled
 to conquer
obstacles terribly huge.
Solutions emerged from Rai's fertile mind
and inventive control-freak *Ron Drever*
 — whom we imported from Scotland to lead
 Caltech's
 interferometer team.

In nineteen hundred and eighty-four,
 Rai, Ron and I
 working together
 founded the LIGO Project
 — a collaborative effort of Rai's MIT
 and my home institution, Caltech.

All through the nineteen eighties
 and into the nineteen nineties
in four teams of dozens we struggled
 in multiple laboratories
 — at Glasgow and Munich
 MIT and Caltech —
 perfecting LIGO's technology and
 experimental techniques.

Crucial to our struggles were:
— Guidance from *Richard Isaacson,*
 our wise and wily counselor
 at the US National Science Foundation
 our critical source of financial support.

— The leadership of *Robbie Vogt*
 forceful and charismatic
 transforming our rag-tag scientists
 into a unified team,
 and winning the hundreds of millions of dollars
 our risky quest would require
 from American citizens' taxes
 — via the National Science Foundation,
 the United States Congress and President.

In the early nineties we faced
 intense political struggles and
 explosive personal conflicts
 — until we lured
 Caltech's *Barry Barish*
 to lead and transform our Quest.

Consummate leader Barry
 calmed our personal conflicts
 and swerved our political critics.
He understood
 that our complex quest
would require a far, far larger team
 than ever we had imagined.
A talented fleet, a thousand strong,
 plucked from more than a dozen lands.
A grand international quest.

From the late nineteen nineties to twenty fifteen
Barry and his successors
 assembled our fleet — which then
 constructed our behemoths
 — instruments so very complex that
 a hundred thousand channels of data
 monitored all the myriad things
 that possibly might go wrong, while
 a hundred physics gurus
 simulated colliding black holes
 on Beowulf computers.

What pure and enormous joy it was
 to work together on this glorious quest.

All came to fruition on Monday
 September fourteen of twenty fifteen
 with LIGO's very first signal:
Colliding Holes and Spacetime Storm.

And how did we finally feel
 at the end of our forty-year quest
 when that very first signal came in?
 — and when we were sure it was real?

The fleet of a thousand talents
 — women and men who had joined our quest —
celebrated euphorically.

No celebration for me.
 No elation. No high. No euphoria.
Instead just a sense
 of satisfaction profound
 that I had chosen wisely
 where to invest my efforts
 and the brilliance of my students.

And for insightful practical Rai,
 LIGO's chief architect?
Fully Profound Relief.

We had spent a billion dollars
 of fellow citizens' money.
And recruited a fleet of women and men
 to join our quixotic quest.
As our quest dragged on
 year after year, after year after year after year
 Rai's feelings of guilt had mounted.

That very first gravity wave
 — Colliding Black Holes and Spacetime Storm —
brought *Glorious Relief.*

Coda:

The Phone Call

At two-fifteen in the morning
 on Tuesday October three
 of twenty seventeen
I was startled awake
 by a phone's loud ring.

"It will not surprise you to learn"
 said a cheery voice on the other end
"that this year's Physics Nobel Prize
 is awarded to you and to Rainer Weiss
 and also to Barry Barish
for your contributions
 to the LIGO detector
 and to its first observation
 of gravitational waves."

"In truth it doesn't surprise me at all
 but I'm disappointed," I said.
"The prize should have gone
 to the full LIGO team
 that fleet of a thousand women and men
who made our dream come true."

Someday the Nobel Committees
 will embrace their responsibilities
 to inform the world
 of the power and joy
 of large collaborations.

Some marvelous human quests
 — from Giza and Dunkirk to Sputnik and LIGO —
can only be won through cooperative efforts
 of thousands all pulling together
 toward a nearly impossible goal.

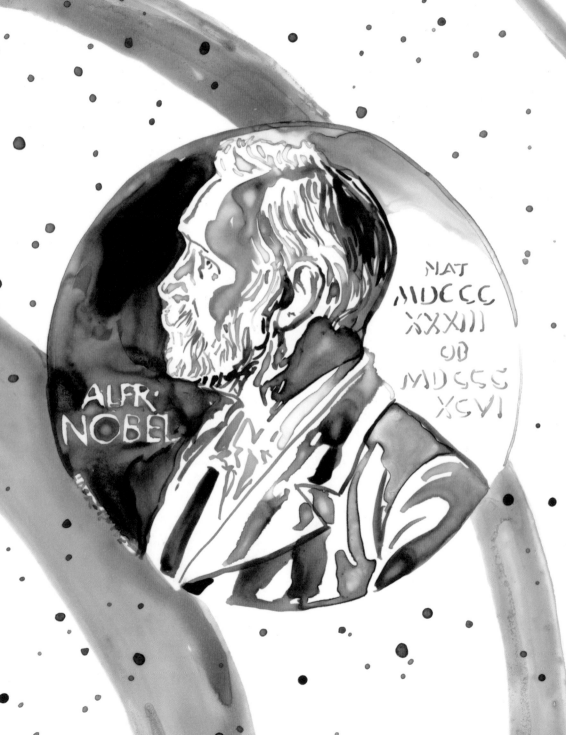

4 /
PROBING
THE WARPED
SIDE WITH
GRAVITY WAVES

The Ideal Tool

No better tool could be conceived
　　　　for probing the Warped Side's landscape
No better tool than gravity waves
　　　　　— waves that are made from warped space and time
　　　　　and so reside on the Warped Side themselves.

What insights into the Warped-Side scene
　　　　　can we glean from gravity waves?
Besides spacetime storms from colliding black holes
　　　　　what else will the waves reveal?

I'll answer with *seven vignettes*
　　　　　that illustrate our vision
　　　　　　　for gravity wave astronomy.

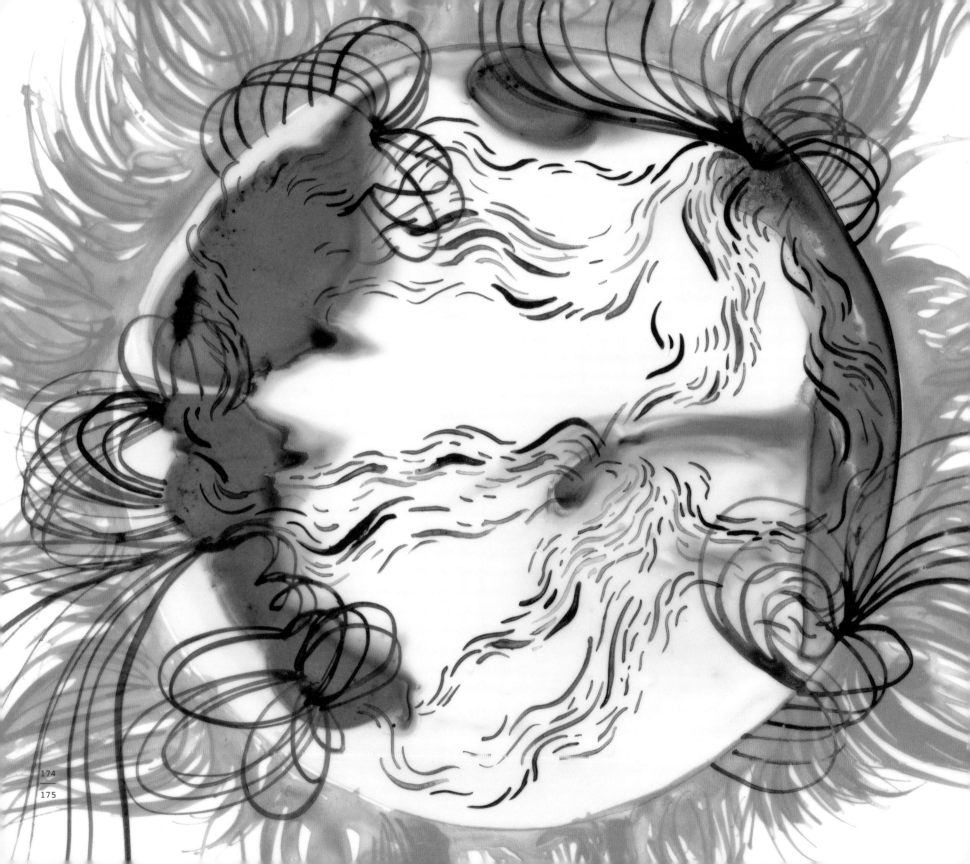

First Vignette:

Neutron Stars Collide

/ Imagine a star made of nuclear matter:
　　　atomic nuclei packed side by side,
　　　　　and then compressed tenfold more.
　　　A veritable neutron sea.

A thimbleful from the stellar core
　　　would weigh a billion tons.

This *neutron star*
　　　with the mass of our Sun
has been compressed by its gravity's pull
　　　into a hyper-dense sphere
　　　　　no larger than Amsterdam.

Such neutron stars are totally real.

They are dying cinders of everyday stars.
Stars that long, long ago
　　　exhausted their nuclear fuel,
and no longer able to keep themselves hot
　　　imploded to Amsterdam size,
　　　　　where nuclear forces stopped their implosion
　　　　　　balancing gravity.

A neutron star is made
　　　not only from
　　　　　its neutron sea
　　　but also from warped spacetime.

It's a hybrid creature
　　　inhabiting both
　　　　　the warped and material sides
　　　　　　of our marvelous universe.

A hundred million years ago
in a galaxy not far away
two neutron stars circled around,
trailing out behind themselves
vortices and tendices entwined in spiral arms:
Gravitational Waves.

As the waves sucked energy from the stars' orbit
the stars spiraled inward
on track to collide
at half of light speed.

This brutal collision
fused the stars
producing gold and platinum
— enough to fill hundreds of Earths —
and creating a brilliant fireball
that shone with Electromagnetic Waves
of every possible form:
radio waves and microwaves
infrared and light
ultraviolet and X-rays
gamma rays and even more.

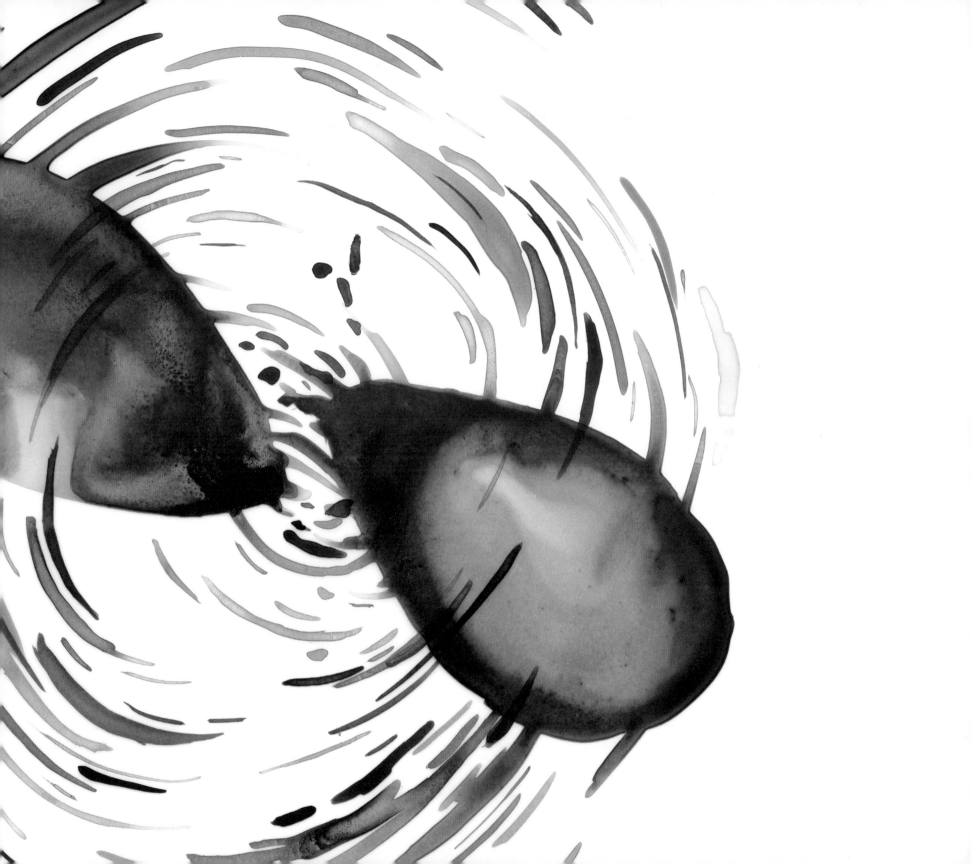

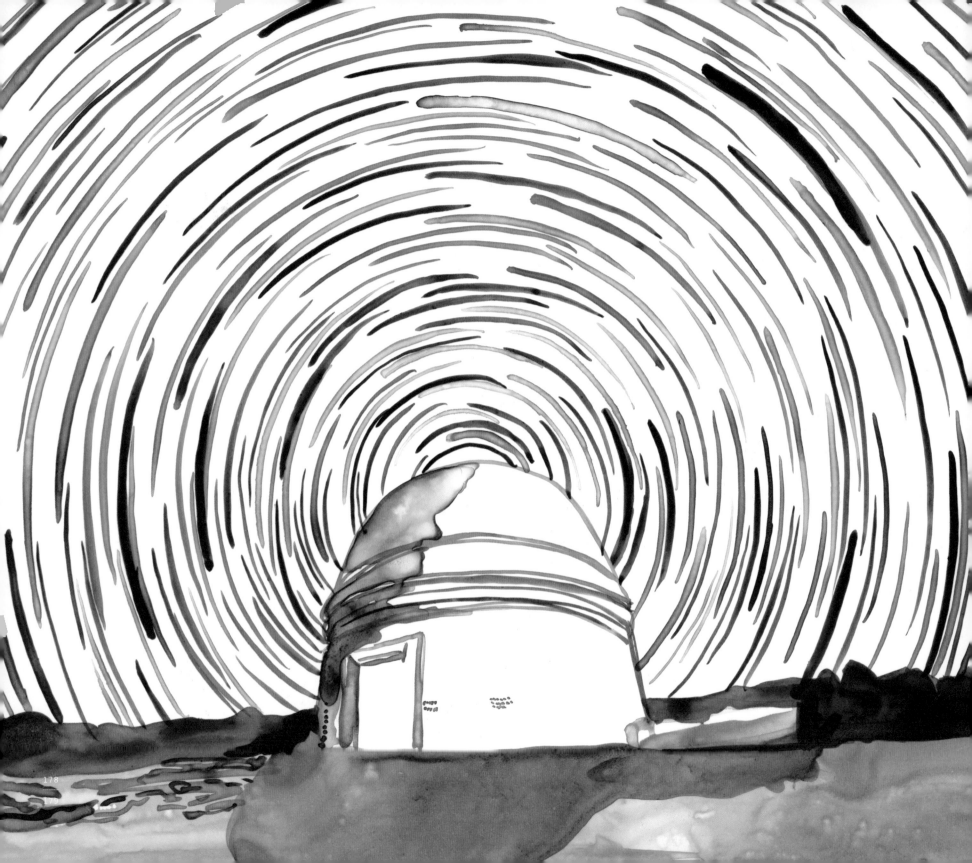

/ All these electromagnetic waves
 and all of the gravity waves
 together flew at the speed of light
 across the universe,
 carrying encoded
 within their oscillations
 details of the neutron stars
 and of the stars' collision:
 their platinum, their gold
 their fireball, their fate.

The waves arrived at Earth on
 Thursday August seventeen
 of twenty seventeen.
Their arrival was momentous.
The most intensely studied event
 in the history of human astronomy.
It fired imaginations
 of people around the world
And heralded the birth of
 Multi-Messenger Astronomy.

The messengers were the waves,
 gravity waves and electromagnetic,
 journeying together
 through intergalactic space to Earth.

This first vignette was but a dream
 until in twenty seventeen.
 the universe so forcefully
 transformed our dream to truth.

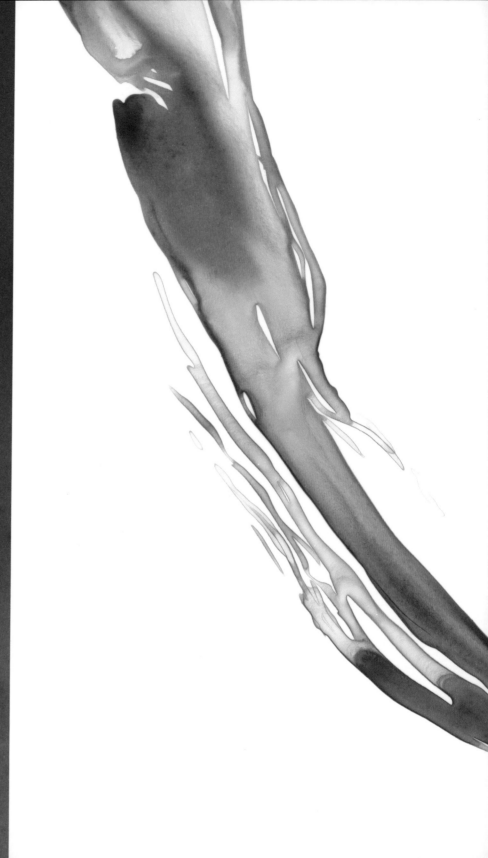

Second Vignette:

A Black Hole Spaghettifies a Star

Imagine a neutron star
　　　performing an orbital dance
　　　around a spinning black hole.
　　　　　A hole not very much larger than
　　　　　　　the neutron star itself.

As the hole and the star
　　　circle around
　　　　　together they sling out gravity waves:
　　　　　　　spiraling arms of tendices,
　　　　　　　entwined with vortices.

The waves, trailing outward and backward too
　　　drain energy from the orbital dance
　　　　　so the hole and the star draw closer.
　　　　　　　Their orbital dance speeds up.

The tendices bound to the hole
　　　stretch the star along their lengths
　　　　　and like a corset pinch its sides.
As the star and the hole draw near
　　　the stretching and pinching intensify
　　　　　— and spaghettify the star!

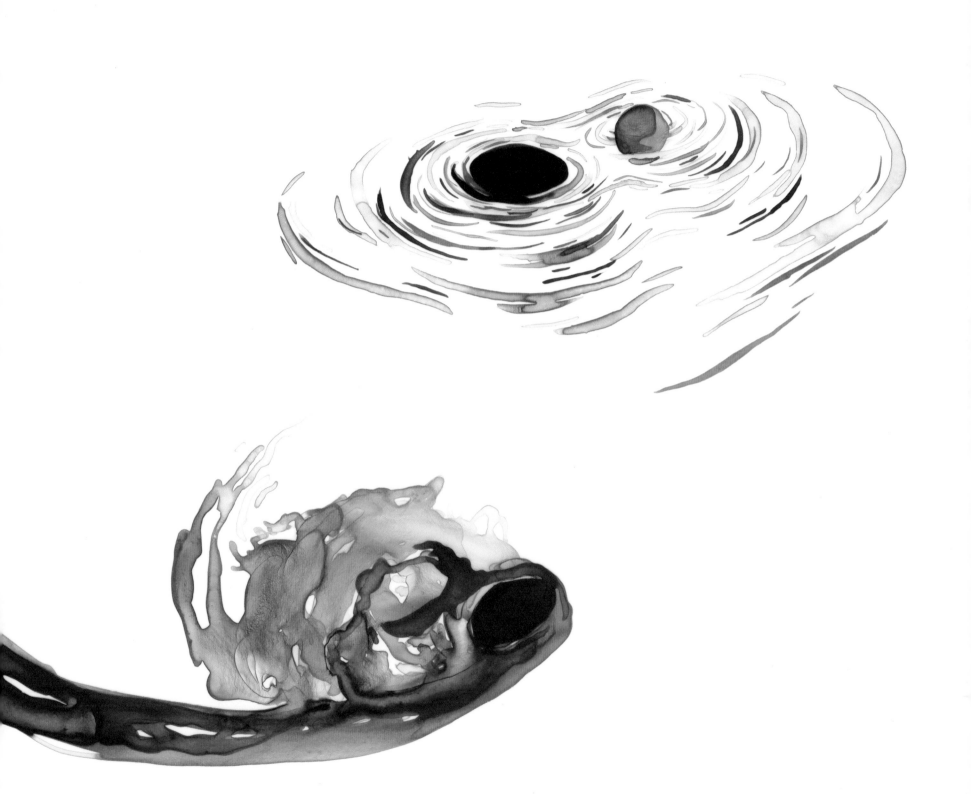

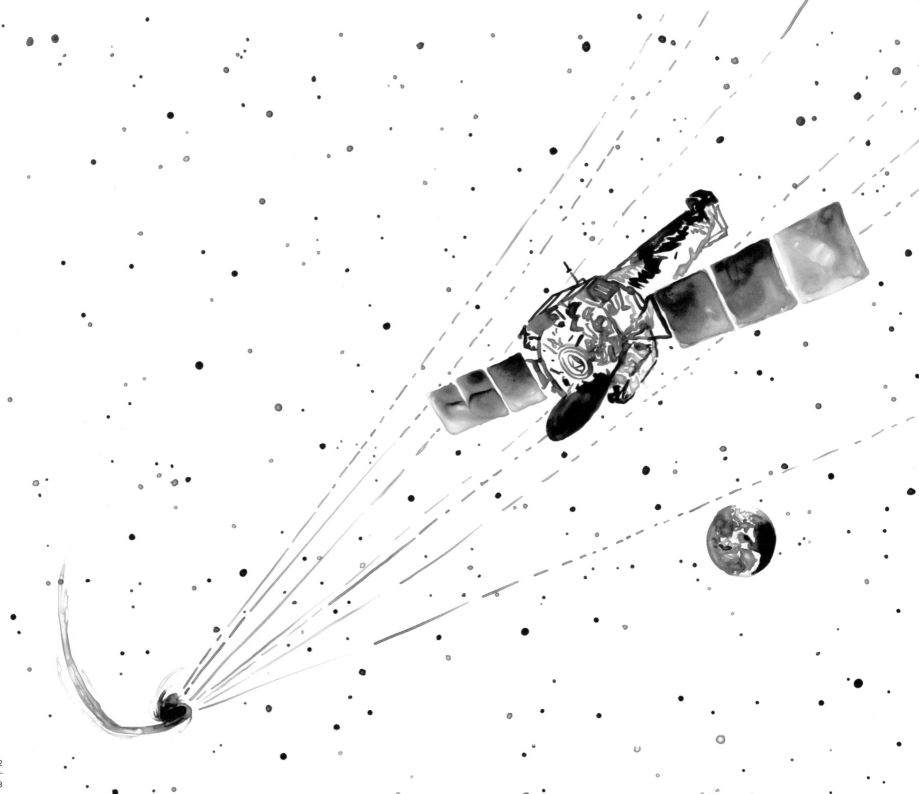

The ultra-hot guts of the star
 exposed to the blackness of space
 blaze brightly with X-rays and gamma rays
 that stream toward the Earth entangled with
 the trailing-out gravity waves.
Together the rays and waves comprise
 a multi-messenger jackpot.

This bonanza of ultrarich data
 flows into LIGO and telescopes
 that hand it off to computers, which
 translate the data to pictures:

A hungry back hole spaghettifies
 a Neutron-Star companion,
 whose smoldering guts then radiate,
 as the ravenous hole engorges.

This story today is a fable
 — a multi-messenger fable.
But soon our marvelous universe
 will make that fable true.
It will.
I'm sure it will.

Imagine a wave of *light*
one micron from crest to crest.
Stretch that wave a million-fold
so it's now a meter from crest to crest.
It's become a radio wave.

Imagine a *gravity wave*
ideal for LIGO to feel
a thousand kilometers, crest to crest
— about the size of colliding black holes
that launched the gravity wave.
Stretch this wave a million fold
to a billion kilometers crest to crest.
Its oscillations are now far too slow
for LIGO to possibly feel.

Such waves are produced by colliding black holes
that weigh a million suns
— gigantic black holes that inhabit the cores
of distant galaxies.

To feel these waves and decode them,
my physicist friends are planning
three spacecraft orbiting 'round the Sun
linked by million-kilometer-long
infrared laser beams:

LISA.
The Laser Interferometer
Space Antenna.

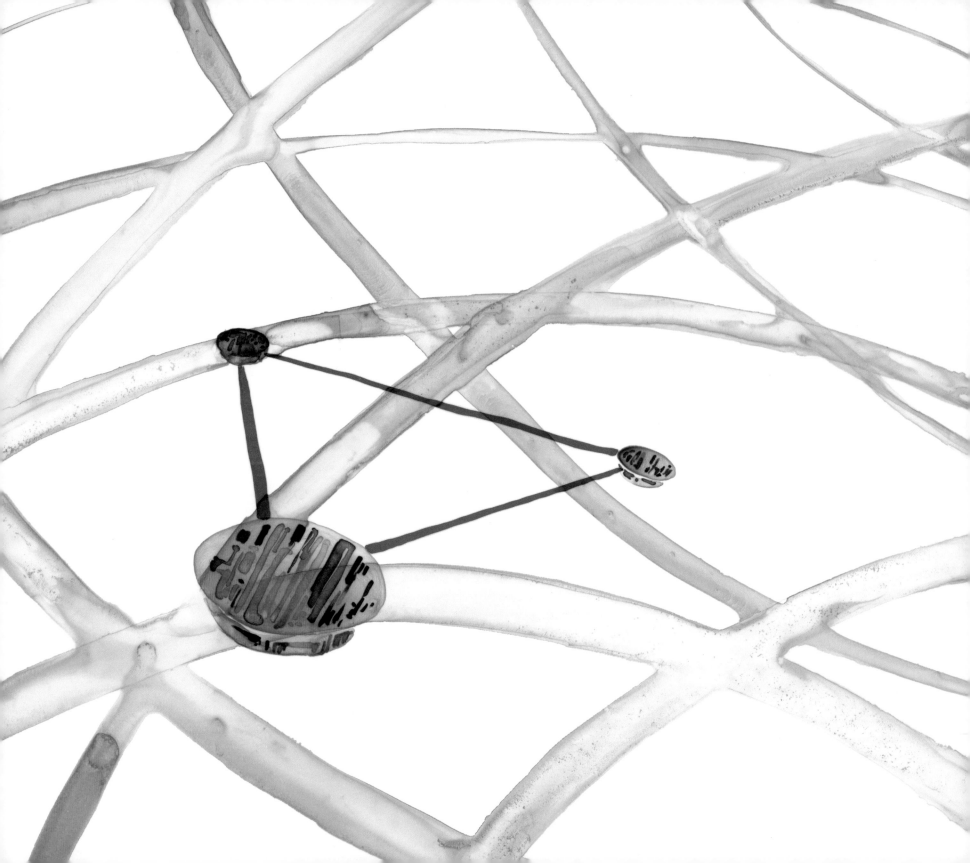

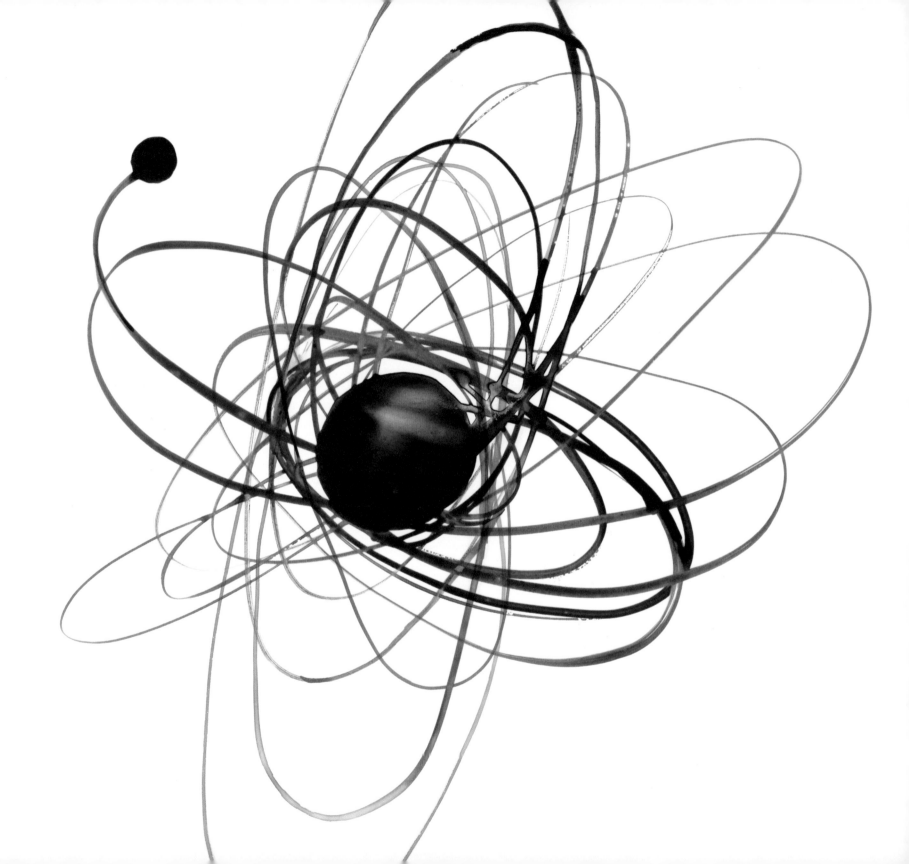

Fourth Vignette:

Mapping Black Holes with LISA

/ Imagine the orbital dance
 of a neutron star
 'round a black hole that's *huge*
 — far bigger than the star.

A black hole so large will swallow the star
 before the hole's tendices rip it apart.
So
 the star remains intact
 — a tiny heavy sphere —
 throughout its orbital dance.

The complex dance is choreographed
 by the hole's gravitational pull
 and the black hole's warped spacetime
 and the black hole's twisting vortices
 and stretching and squeezing tendices.
All of these these conspire
 to distort the stellar orbital dance
— distort it weirdly and wildly.

The star plunges inward
 to near the horizon
And there it whirls around and 'round
 and 'round and 'round
 while spiraling up
 toward the hole's north pole
 then spiraling back down.
And then it zooms back outward
 to far from the hole's horizon
And slows into a lazy drifting
 languid, lethargic arc.
Then accelerates into a plunge
 faster and faster still, until
It whips around the horizon,
 performing more and even more
 increasingly frantic gyrations.

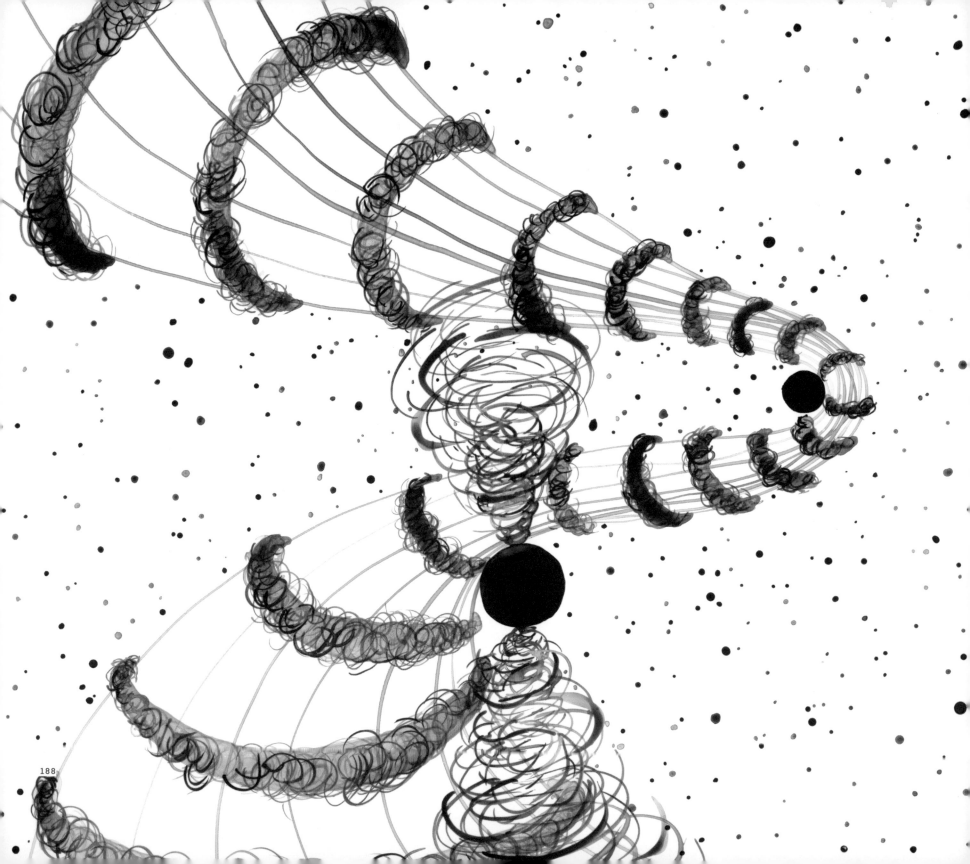

/ While the star performs this dance
 like a snail it trails, behind itself
gravitational waves:

Vortices and tendices entwined,
 together encoding a portrait of
 the star's outlandish orbit
 and a map of the hole's full warped spacetime:
 The shape of its funnel
 as a bulk-being sees it.
 The pattern of its weird time warps
 — lethargic here and speedy there —
 and the sizes and shapes of its vortices
 and also all of its tendices
 bound to the hole's horizon.

All features of the spinning black hole
 encoded in gravity waves
are carried to Earth for LISA
 to monitor and decode
 and translate into images of
The Warped Side of Our Universe.

Fifth Vignette:

 Naked Singularities

/ *Chaotic singularities*
 residing inside of black holes
are truly remarkable beasts.
Their tendices and vortices
 turbulently contorting
 with exponential explosive growth
 are lethal to humans and lethal to atoms
 and lethal to space and to time.

But they're hidden from view of our universe
 cloaked by black hole horizons
 out of which nothing
 can ever escape
 not gravity waves
 not light
 no information of any type.

More wonderful would be
 a *Naked Singularity*
 unclothed by any horizon
 visible to the whole universe.
 visible to me.

How much I should like to see one.

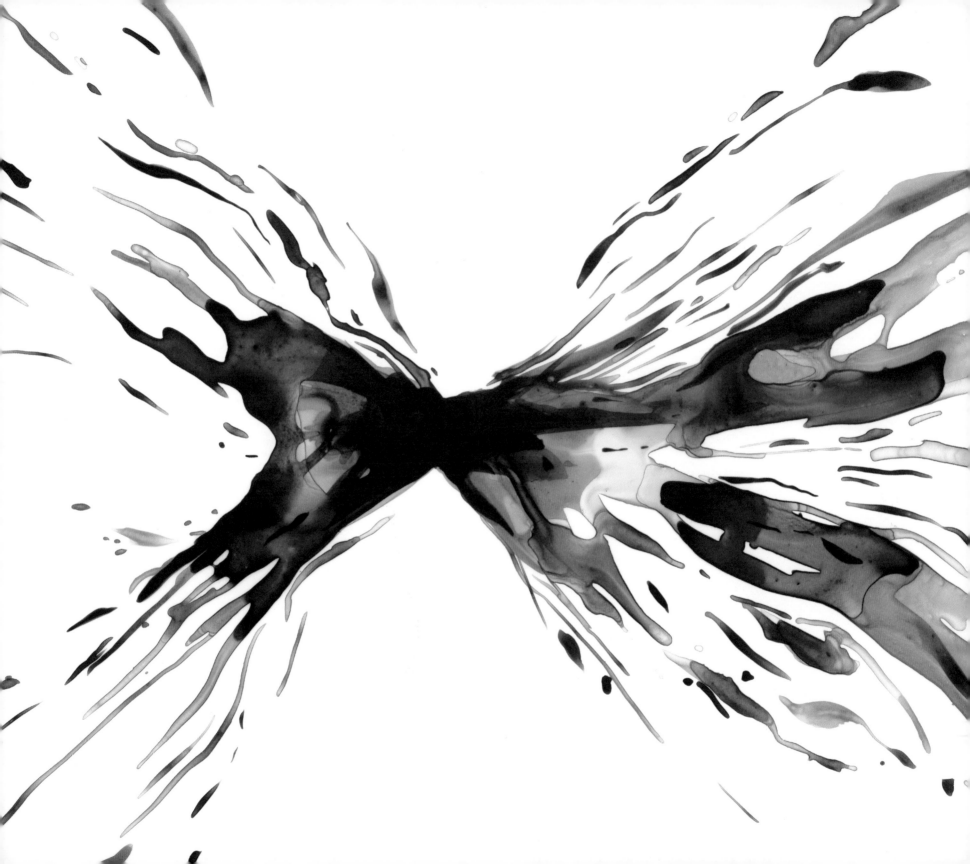

Do the laws that govern our universe
 give rise to such singularities?
 permit their very existence?
 permit their births and their lives?

Alas, we've not yet been clever enough
 to figure out the answer.
But LIGO and LISA can search for them —
 for *Naked Singularities*:

Suppose that one is orbited
 by a neutron star or a small black hole.
The singularity's tendices
 will grip the star or hole
and with its twisting vorticies
 will torque the orbit wildly
 creating weird gravity waves.

Those waves will carry a map
 of the naked singularity:
the shapes of its distorted space
its wildly speeding-and-slowing time
all its contorting tendices
and each of its twisting vortices.

All that there is to know about
 the naked singularity
 (except its quantum gravity core)
is encoded in the gravity waves
 — Not easy to extract, but
 for LISA an awesome quest.

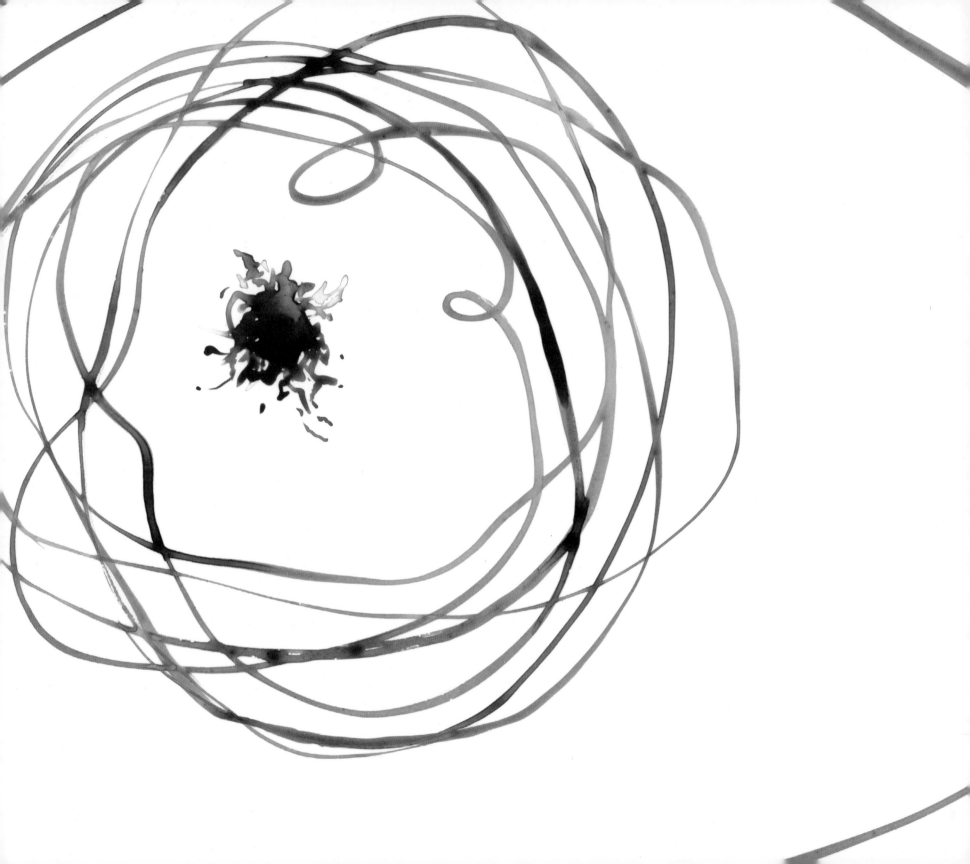

/ How was our universe born?

How did it come to be?

Religions give thousands of answers

wildly differing answers

each fiercely believed by believers.

But what does science say?

Astronomers see galaxies

all flying swiftly apart

driven by a gigantic blast

thirteen billion years ago.

They call it the *Big Bang*.

Physicists probing Einstein's laws

that govern warped spacetime

deduce there must, indeed, have been

— thirteen billion years ago —

a true *big bang explosion*.

Our universe was surely born

in a *big-bang singularity*

governed by quantum gravity laws

that we struggle to comprehend.

A big-bang singularity

whose quantum gravity core

created space

created time

created all the primordial stuff

from which

everything in our universe

emerged

and evolved

and ultimately

morphed into the patterns we see.

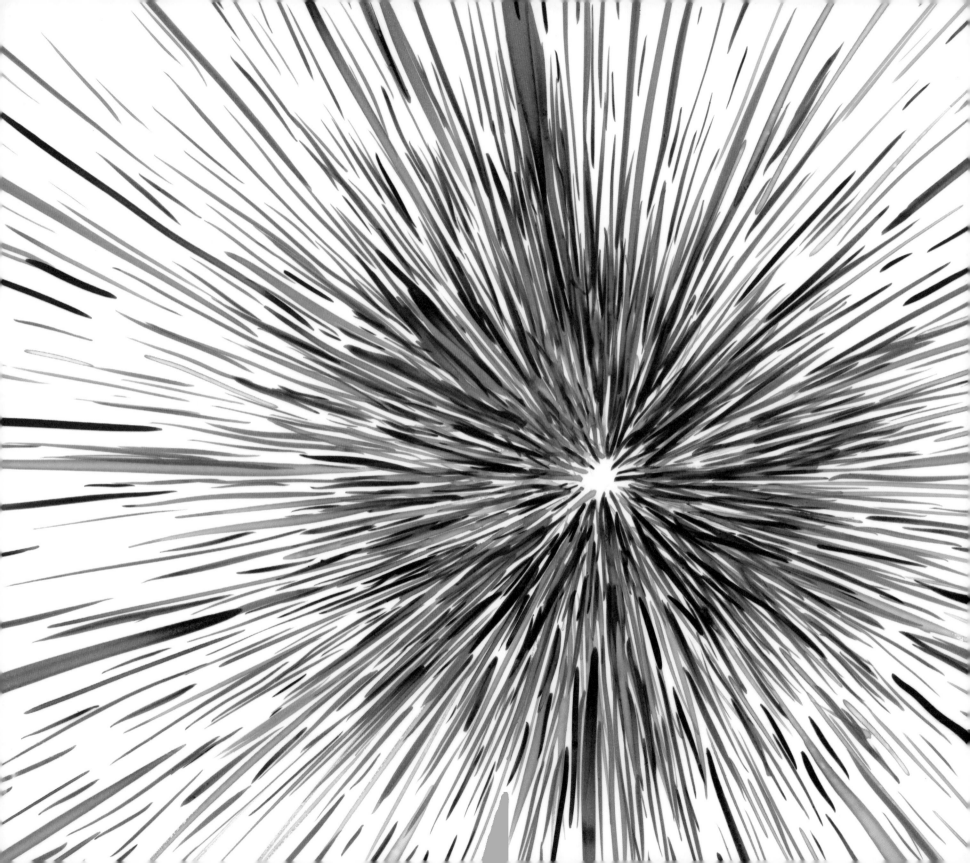

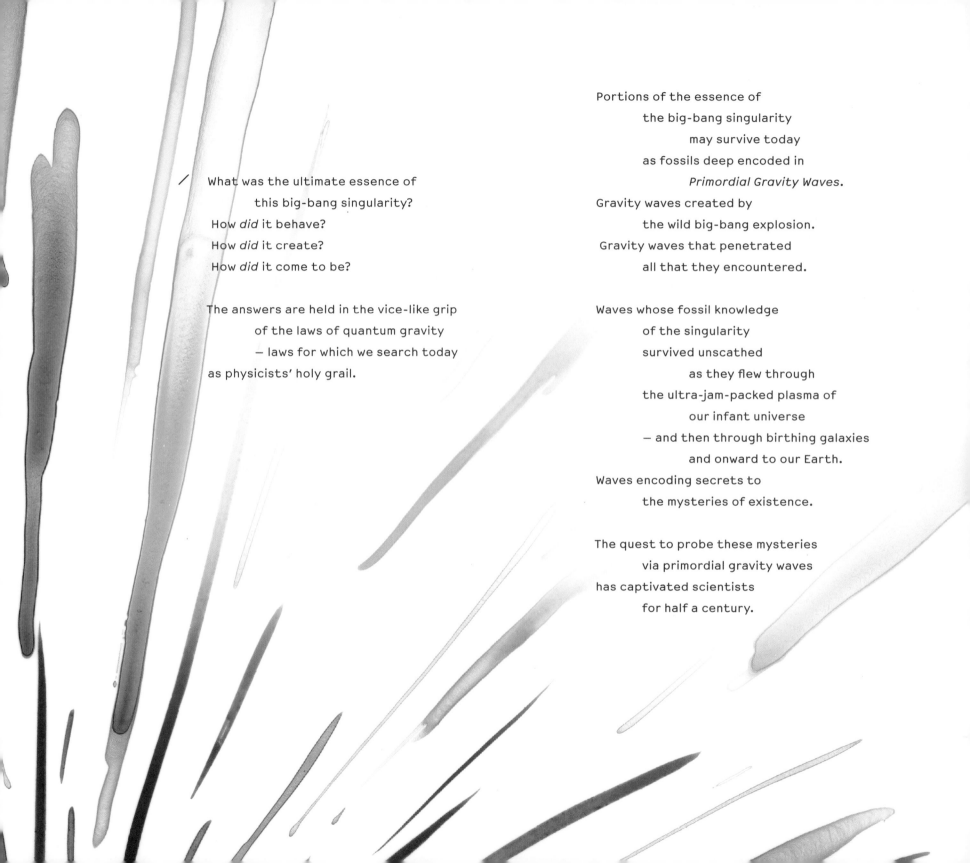

What was the ultimate essence of
 this big-bang singularity?
 How *did* it behave?
 How *did* it create?
 How *did* it come to be?

The answers are held in the vice-like grip
 of the laws of quantum gravity
 — laws for which we search today
as physicists' holy grail.

Portions of the essence of
 the big-bang singularity
 may survive today
 as fossils deep encoded in
 Primordial Gravity Waves.
Gravity waves created by
 the wild big-bang explosion.
 Gravity waves that penetrated
 all that they encountered.

Waves whose fossil knowledge
 of the singularity
 survived unscathed
 as they flew through
 the ultra-jam-packed plasma of
 our infant universe
 — and then through birthing galaxies
 and onward to our Earth.
Waves encoding secrets to
 the mysteries of existence.

The quest to probe these mysteries
 via primordial gravity waves
has captivated scientists
 for half a century.

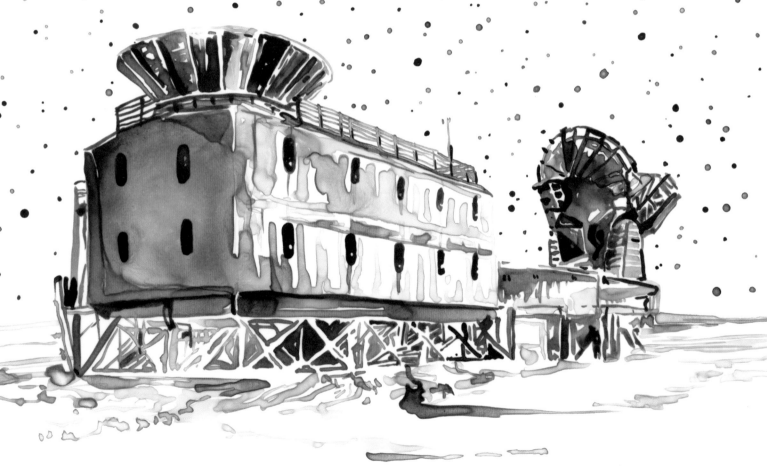

Those fossil imprints riding on
 the *Microwave Polarization*
encode the big bang's secrets to
 the mysteries of existence.

The fleet of astrophysicists
 is searching for these imprints
with *telescopes* for microwaves
 some of them orbiting 'round the Earth
 others ensconced in Antarctica
 or the Atacama Desert.

Success might come
 a few years hence.
— I hope.
 I think.
 I hope.

/ A fleet of astrophysicists
 — allies of LIGO's fleet —
has toiled for three full decades on
 a radical new
 and elegant type
 of gravity wave detector.

A detector aimed at primordial waves
 with wavelengths truly humongous:
 hundreds of millions of light-years long
 — just ten to a hundred times smaller than
 all the universe we see.

Long ago, when our universe was
 three hundred thousand years old
 — that's far before the very first stars
 and galaxies were born —
These humongous gravity waves
 placed imprints onto the *polarization*
 of *cosmic microwaves*.

And physicists are planning for
 the middle of this century
an enormously more ambitious form of
 gravity wave detector
 that's christened *BBO*.
The Big Bang Observer
 Gravity Wave Detection Mission.

It's a giant successor to *LISA*:
An enormous constellation of
 twenty-four light beams
 that link a fleet
of a dozen spacecraft
 strategically placed
on the orbit of Earth around our Sun.

It will target primordial gravity waves
 with wavelengths not very much longer than
 four hundred thousand kilometers
 — the distance from Earth to Moon.

By comparing the big bang's secrets from
 BBO's short gravity waves
and the *Microwave Polarization's*
 humongous gravity waves
We expect to learn far more about
 the birth of our universe
 — the *mysteries of existence* —
than we ever could learn
 from *BBO* or Polarization alone.

I eagerly covet discordance:
— severe disagreement of *BBO*
 and Microwave Polarization —
as that would herald
 extreme revolution
 in human understanding of
 the birth throes of our universe.

Seventh Vignette:

Cosmic Strings

The laws of quantum gravity
 seem rather likely to be
 some extension of "string theory"
 one that will deeply reveal
 the nature of Reality.

What does this string theory tell us?

Atoms are made from electrons
 orbiting protons and neutrons.
 And these all in turn are made from
 exquisitely small, vibrating "strings"
 — like vibrating rubber bands.

When our universe was exceedingly young
 some of these strings
 might have inflated
 stretching to cosmic size
 and becoming *cosmic strings:*
Exquisitely thin
 exceedingly taut
 distorted "rubber bands."
Able to stretch
 all of the way
 across our universe.

These cosmic strings
 — if they *did* form —
 inevitably collided,
 creating sharp cusps
 at their points of collision,
 cusps that then zoomed
 along the strings
 producing gravity waves.

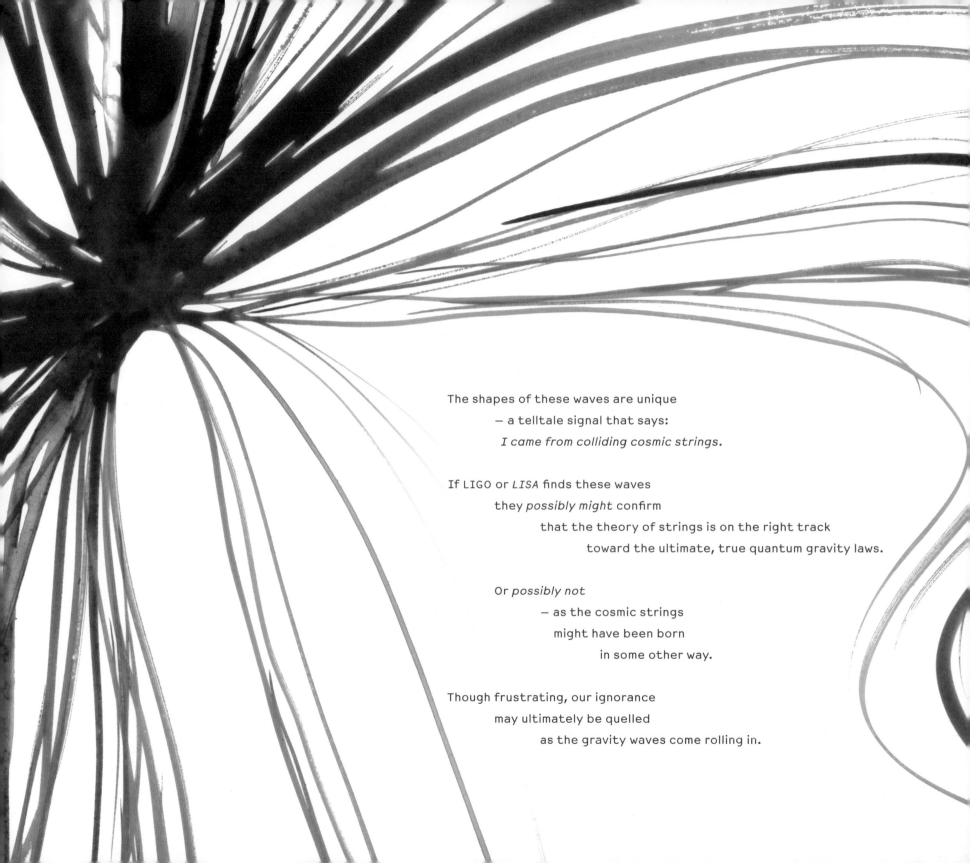

The shapes of these waves are unique
— a telltale signal that says:
I came from colliding cosmic strings.

If LIGO or *LISA* finds these waves
they *possibly might* confirm
that the theory of strings is on the right track
toward the ultimate, true quantum gravity laws.

Or *possibly not*
— as the cosmic strings
might have been born
in some other way.

Though frustrating, our ignorance
may ultimately be quelled
as the gravity waves come rolling in.

5 /
OUR
VISION

Euphoria!

What Satisfying Joy

The vision that I started to dream
in nineteen hundred and seventy-two
The vision my physicist friends and I
together further developed
over the years that did ensue
— that vision at last is coming true!

Gravity-wave astronomy
is beginning to revolutionize
human understanding of
the universe in which we live:
Our Home.

And future observations
of cosmic gravity waves
are likely to very deeply plumb
The richness and weirdness of quiet black holes:
their warped-space funnels in the bulk
their vortices, their tendices,
their time that slows down to a halt
at the hole's horizon.
Stars ripped apart by companion black holes.
A cusp that zooms down a cosmic string.
Naked singularities (if any at all exist).
And Our Universe's Big-Bang Birth.

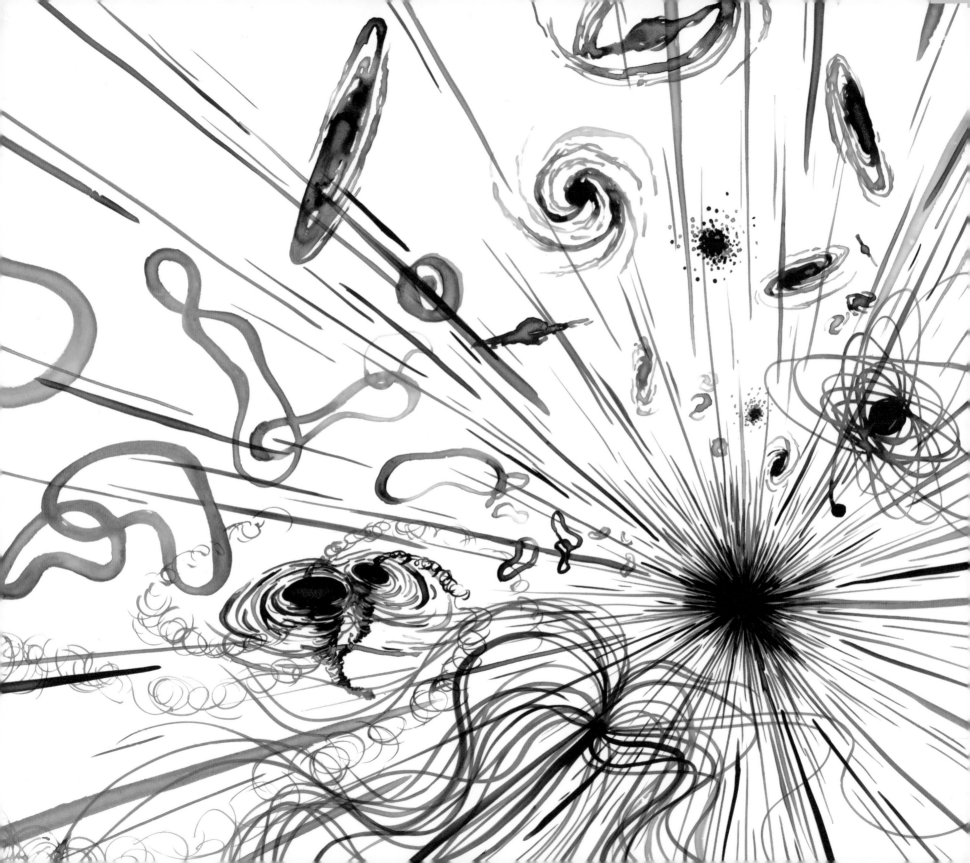

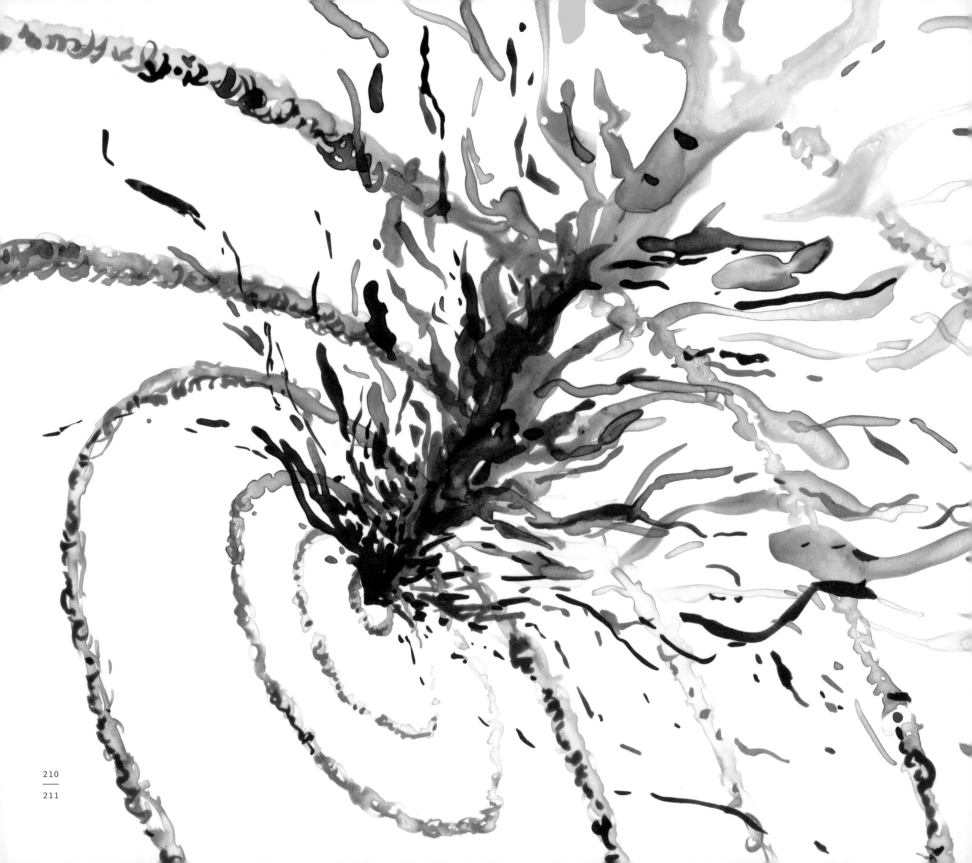

But especially inspiring
 a scintillating vision:
Gravity waves will surely bring
 prodigious surprises
 whose nature today we cannot conceive
just as Galileo
 never could imagine
 quasars, pulsars and galaxies,
 our universe and its big-bang birth.

Quantum Gravity

The Physics Holy Grail

/ The laws of quantum gravity
are physicists' *holy grail*
— our grandest quest of all —
and also the ultimate arbiters of
the Warped Side of Our Universe.

They control the singularities
inside of every black hole.
They control the core of every
naked singularity
(if any exist in our universe).
They control the fates
of time machines
They controlled the births
of cosmic strings.
They controlled the birth of our universe
and control so very much more.

We'll only fully understand
the Warped Side of Our Universe
when physicists have figured out
these quantum gravity laws.

This is the greatest quest of all
for the next generation of physicists,
and perhaps the greatest quest *in all*
the history of physics.
Past. Present. And Future.

But finding and confirming
the quantum gravity laws
cannot be accomplished
through theory alone.
— *We must see the laws in action*
in the real universe.

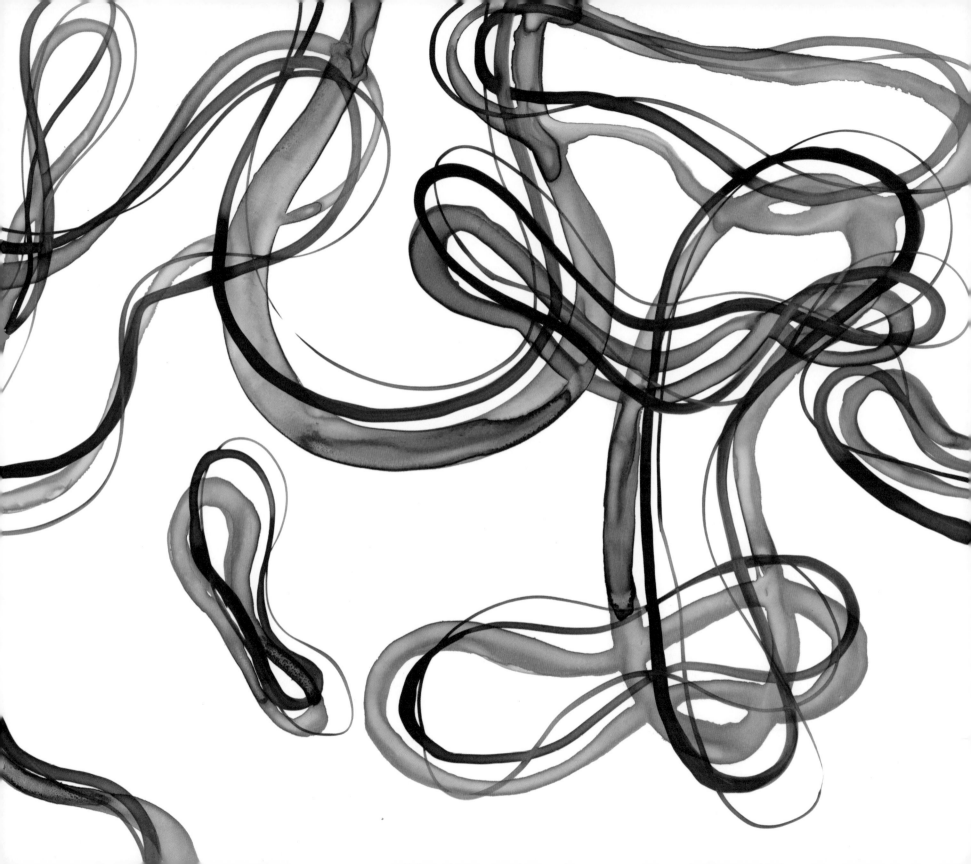

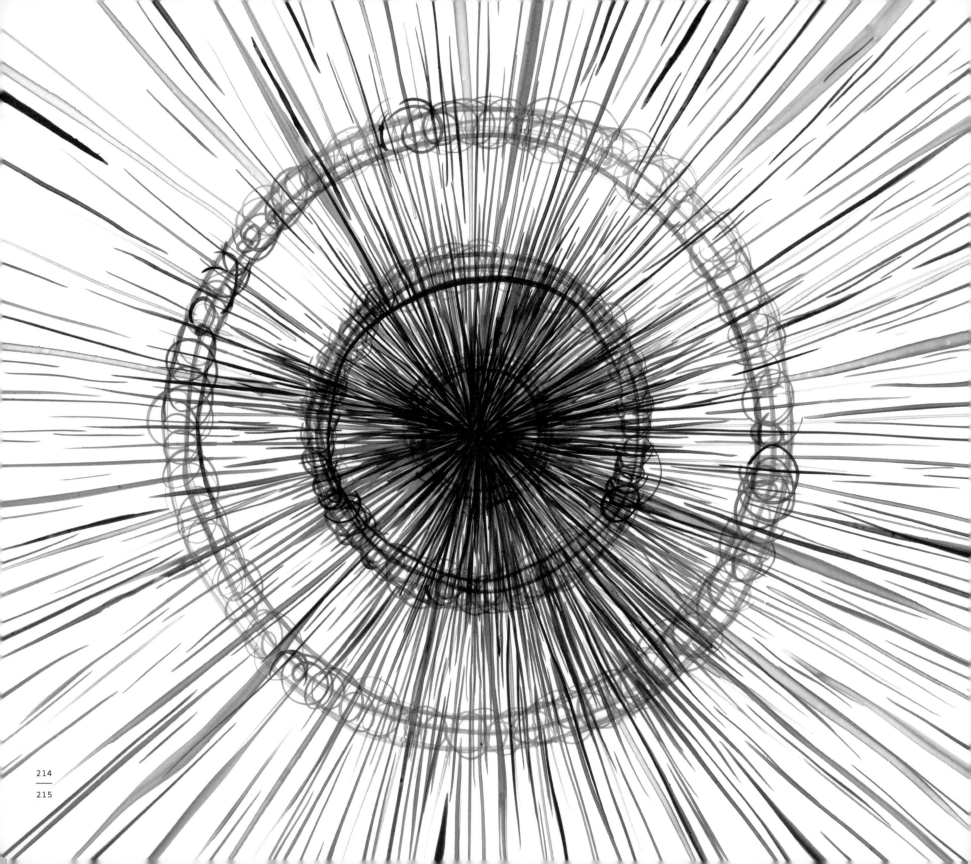

In earth-bound laboratories
 the effects of quantum gravity
 are likely far too small
 ever to be seen.
And likewise far too small
 in stars and planets, nebulae
 galaxies and quasars.

Far better it is to explore
 the laws of quantum gravity
in venues they control:

Inside black holes?
 No signals can ever emerge from there.
In naked singularities?
 Prospects to find one are terribly dim.
In time machines?
 We have none and likely we never will.
In the births of cosmic strings?
 Perhaps . . .
In our universe's big-bang birth
 — its big-bang singularity?
There resides our greatest hope!

But the infernally hot and tremendously dense
 plasma of the primal era
absorbed every form of signal
 that Nature could produce
— all signals *except gravitational waves*
 with colossal power to penetrate
 all that they encountered.

So — our *most* exciting quest of all?
The quest to discover and confirm
 the laws of quantum gravity
through theorists' struggles assisted by
 primordial gravity waves
 — gravity waves from the big-bang birth
 of our marvelous universe —
 seen through *Microwave Polarization*
 perhaps in the twenty twenties
and seen by the giant *Big Bang Observer*
 in the middle of this century.

And thereby through this combination
 of theory and gravity wave observation
 and many decades of physicists' struggle
finally grasp and tenaciously hold
 the Physics Holy Grail.

FOUNDATIONS

EPILOGUE:
HOW DO WE KNOW?

I have crafted this epilogue to explain briefly the science
and history described in this book's paintings and verse.
The explanations are organized into sections, each with
a title that is the same as the section of paintings and
verse to which it refers.

/ PROLOGUE

In 1915 Albert Einstein formulated his general relativity
theory: a set of physical laws that describe space and time as
warped by our universe's matter and energy. Over the century
since then, those laws have been tested to high precision and
have passed all tests superbly well.[1] Also over that century,
we physicists have studied the predictions of Einstein's laws
in depth and have gradually learned that the universe has a
rich warped side: its big-bang birth, black holes, gravita-
tional waves, and possibly wormholes, time machines, cosmic
strings and naked singularities, and almost certainly some
huge surprises.[2]

The quest to understand our universe's warped side was first
enunciated by the guru of theoretical physics, John Archibald
Wheeler, in the early 1960s when he was my PhD mentor.[3] I have
devoted most of my physics career to this quest, working
hand-in-hand with students and colleagues — through math-
ematical calculations that use Einstein's laws and equations,
and through the development of LIGO's tools and technology
for detecting and monitoring gravitational waves and extract-
ing the information they carry.[4]

It was my exceptionally good fortune to meet Lia Halloran —
my coauthor — in spring 2008 at a party in Pasadena hosted
by the Harvard physicist Lisa Randall. Lia and I quickly became
close friends and mutual admirers. She introduced me to her
physicist father and remarkable mother, and to her fascinating
girlfriend, Felicia, whom she would later marry. Ever since then,
I've felt warmed and stimulated by Lia and her entourage. One
autumn day, soon after we met, Lia drew for me, in a small
moleskin sketchbook, the wormhole and black hole sketch
shown in miniature here. It was a seed that ultimately grew
into this book.

FOR MY FRIEND KIP LIA HALLORAN 2008

1 / THE BLACK HOLE

In 1916-39, physicists saw black holes emerge, mathematically,
from Einstein's laws, but they had great difficulty understand-
ing what the math was trying to tell them. Even Einstein was
confused by the weirdness, and so rejected the prediction.

Only in the 1960s did the physical meaning of the black-hole math — as described in this book's verse and paintings — become crystal clear.[5] The 1960s also saw the beginning of astronomers' observational searches for black holes and their explorations of the roles that black holes play in our universe, a quest that continues today.[6]

A BLACK HOLE IS MADE FROM SPACE THAT IS WARPED (38-47)

Elsewhere[7] I have written at length about the warping of space inside and around a black hole as seen from the bulk — the warping described in verse in this section of the book.

EINSTEIN'S LAW OF TIME WARPS (48-49)

"Einstein's law of time warps" is my own name for a law that physicists usually call "gravitational time dilation."[8] This law was deduced in its simplest form in 1907 by Einstein, and then five years later in a more sophisticated form as his first major step toward formulating the laws of general relativity.[9] When a body's gravity is changing dynamically, Einstein's simplistic law of time warps fails and gets replaced by a much more complicated law.

A BLACK HOLE IS MADE FROM TIME THAT IS WARPED (50-53)

Elsewhere I discuss in detail a black hole's horizon and the slowing of time to a halt there.[10] The downward flow of time inside a black hole[11] can be understood most deeply and clearly, I think, using space-time diagrams: inside a hole's horizon, all future light cones (the directions in spacetime along which things can travel because time is flowing forward there) tilt downward, toward the horizon.[12] For the singularity, see the second section below.

A BLACK HOLE IS MADE FROM VORTICES
OF RAPIDLY TWISTING SPACE (54-57)

Einstein's relativistic laws tell us that every spinning body must drag space around itself into a tornado-like whirl, at least a little bit. This space whirl (also called *frame dragging*) around the spinning Earth is extremely small, but it has been observed and measured to a few percent accuracy by its influence on gyroscopes inside the Gravity Probe B satellite, and on the orbits of satellites named LAGEOS and LARES.[13]

Around a fast-spinning black hole, the space whirl is huge. The hole's horizon spins at close to the speed of light relative to inertial frames that are tied to the distant stars, and near the horizon, space whirls at nearly this same speed.[14]

That this whirl gives rise to vortices of *twisting* space (counterclockwise vortex at the hole's north pole; clockwise at the south pole) is obvious if one thinks about it for a few minutes; see this section's verse. But strangely, no physicists seem to have noticed it until 2010, when several students and I were struggling to devise ways to visualize a mathematical object called the Riemann curvature tensor. One of the students, Rob Owen, saw the vortices emerge from that struggle, staring him in the face.[15] The vortices, and vortex lines that guide them, describe half of the physical content of this Riemann curvature tensor.[16]

<u>A BLACK HOLE IS MADE FROM TENDICES OF STRETCHING</u>
<u>AND SQUEEZING SPACE AND A CHAOTIC SINGULARITY</u> (58-61)
The students[17] and I discovered[18] that the other half of the
Riemann curvature tensor is embodied in tendices of two
types: those that stretch things and those that squeeze
things.[19] Just as every spinning body makes space whirl, at
least a little bit, and thereby generates vortices of twisting
space that are attached to it; so also every gravitating body
generates tendices of stretching/squeezing space that are
attached to it. (Student David Nichols coined the name *tendex*,
based on the Latin *tendere* meaning "to stretch" by analogy
with *vortex*, based on the Latin *vortere* meaning "to turn.")

Near the singularity inside a young black hole, the tendices
are exceedingly strong, vicious, and chaotic. This chaotic
singularity has a technical name: it is a *BKL singularity*, so
named because three of my Russian friends with these initials
discovered it in the mathematics of Einstein's relativity
equations, in 1970: Vladimir Belinsky, Isaak Khalatnikov, and
Evgeny Lifshitz.[20]

The quest to discover the laws of quantum gravity — which,
among other things, must govern the cores of singularities
— began in the 1930s as a very small-scale effort, then grew
over the decades. John Wheeler provided a major impetus for
it in the 1950s and 1960S with his challenges to understand
the singularities inside black holes and speculations about
a "quantum foam" of tiny, fluctuating wormholes at subatomic
scales. In the 1980s, major breakthroughs convinced theoretical
physicists worldwide that string theory is a highly promising
approach to finding the quantum gravity laws. Almost overnight,
the quest for those laws became the sexiest, most fun, and
most exciting enterprise in all of theoretical physics. Progress
since then has been slow but substantial.[21]

<u>A BLACK HOLE ENTOMBS THREE SINGULARITIES</u>[22] (62-65)
The infalling singularity was discovered in the mathematics of
Einstein's relativistic laws in 1989 by two Canadian physicists,
Werner Israel and his student Eric Poisson.[23] For technical
reasons that are hard to explain, they gave it the name *mass
inflation singularity*, but I much prefer *infalling singularity*.

The outflying singularity was not discovered until two decades
later — by the American and Israeli physicists Donald Marolf
and Amos Ori.[24] They called it a *shock singularity*.

Ori has been a strong advocate of the possibility that Felicia
or anyone or anything else *might* survive being hit by these
two *gentle* singularities.[25]

2 / WORMHOLES AND TIME MACHINES

<u>THOUGHT EXPERIMENTS EXTREME</u> (70-73)
The history of my research on wormholes and time machines,
sketched extremely briefly in this section, is recounted in far
greater detail in chapter 14 of BHTW.[26]

OF ANTS AND WORMHOLES AND CRYSTAL BALLS (74-79)

In 1935, Albert Einstein and Nathan Rosen[27] realized that a solution of Einstein's equations, discovered in 1916 by Karl Schwarzschild, describes a bridge connecting two distant regions of our universe, and they explored the properties of this bridge mathematically. In 1957 John Wheeler gave a new name to such bridges; he called them *wormholes*.

The Einstein-Rosen wormhole is unique: It is the only wormhole, allowed by Einstein's general relativity laws, that has spherical mouths and spherical cross-sections, and that has no form of matter or energy threading through it.

Much later I and others explored a variety of other wormhole solutions of Einstein's equations with other shapes and properties[28] and various physicists used numerical simulations to explore what a wormhole would look like (the crystal ball of this book's verse and paintings). The most detailed and beautiful simulations were those that appear in the Hollywood movie *Interstellar* — simulations by a team at Double Negative Ltd. in London (recently renamed DNEG), who used equations that I gave to them.[29]

A WORMHOLE'S IMPLOSION (80-83)

In 1962, John Wheeler and his student Robert Fuller, using Einstein's relativistic laws, discovered that the Einstein-Rosen wormhole cannot hold itself open: its walls will collapse inward and pinch off before anything can travel through. Twenty-three years later, in 1985, Carl Sagan asked me for advice

(for his novel and movie *Contact*) about traveling through a black hole from Earth to near the star Vega. In response, as I describe in verse in this chapter's opening section, I told Carl that trying to travel through a black hole would be far too dangerous, and I suggested he use, instead, a wormhole. This triggered me to ask what is required to hold a wormhole open. I quickly discovered that it must be threaded by material with negative energy density — what I called *exotic material*.[30] Later my friend John Friedman, who understands the physics far more deeply than I, pointed out that this same conclusion was already implicit in a theorem proved in 1975 by Dennis Gannon and C. W. Lee.

VACUUM FLUCTUATIONS (84-85)

I was well aware, when advising Carl Sagan, that exotic material really does exist in the universe thanks to vacuum fluctuations. These vacuum fluctuations, as described in this section's verse,[31] are a ubiquitous phenomenon in our universe and have been known since the early years of quantum physics, the 1920s.

Physicists have also known, for more than half a century, how to produce negative energy (exotic material) with the aid of vacuum fluctuations.

In 1948, the Dutch physicist Hendrik Casimir used the equations of quantum theory to prove that two electrically conducting plates placed very close together will distort the vacuum fluctuations and thereby create an attractive

electrical force between the plates. This Casimir force was first measured with good precision in 1997 by Steve Lamoreaux at Yale University. If you hold the plates apart but let them gradually move closer and closer together, the Casimir force will do work on you, thereby reducing the energy of the vacuum fluctuations between the plates below its value (which was zero) when the plates were far apart. So between the plates the energy of the vacuum fluctuations becomes negative.

In the 1980s physicists focused on vacuum fluctuations of electromagnetic waves (light, microwaves, radio waves, . . .). They managed to *squeeze* these fluctuations by sending them through a nonlinear crystal that is appropriately pumped with nonvacuum electromagnetic waves. By *squeeze*, we mean that the amplitudes of the fluctuations oscillate in time between larger than the usual minimum amplitude and smaller, so the energy of the fluctuations oscillates between larger than zero and less than zero.[32] This squeezed vacuum is a crucial tool for current and future LIGO gravitational wave detectors.

CAN EXOTIC VACUUM FLUCTUATIONS
HOLD A WORMHOLE OPEN? (86-87)
In 1988, Mike Morris (at that time my student) and I challenged our physicist colleagues to figure out whether the quantum laws, when combined with Einstein's relativistic laws, permit enough exotic material to be collected inside a human-sized wormhole to hold it open.[33] A number of our colleagues rose to the challenge and carried out extensive analyses — to no avail.

Thirty years later, their results are pessimistic (wormholes probably cannot be held open), but not at all definitive.[34]

CREATING BIG WORMHOLES (88-89)
In the late 1950s, just a few years before I became John Wheeler's student, he intuited that space is likely filled with a quantum foam of tiny wormholes . . . wormholes whose sizes are roughly the Planck length (~10^{-33} centimeters) — a length at which the laws of relativity and of quantum physics undergo the "fiery marriage" that leads to the new laws of quantum gravity.[35] I and others have speculated on the possibility that a very advanced civilization might be able to enlarge such a quantum-foam wormhole to human size so it can be used for rapid interstellar travel.[36] But these are pure speculations with no serious analysis underlying them.

FROM WORMHOLE TO TIME MACHINE (90-91)
In 1987, two years after I started thinking about wormholes, I realized that Einstein's relativistic laws allow an ultra-advanced civilization to transform a wormhole into a time machine by sending one mouth on the high-speed trip that I describe in this section's verse and paintings. Valery Frolov and Igor Novikov, two Russian friends with whom I have coauthored many technical papers, then realized there is an easier way to perform this transformation: just place one mouth near a black hole and the other far away, and wait.[37]

DO TIME MACHINES SELF-DESTRUCT? (92-99)

In 1988 two of my other physicist friends, Robert Geroch and Bob Wald at the University of Chicago, challenged me: "Won't a wormhole automatically self-destruct whenever an advanced civilization tries to convert it into a time machine?" With a Korean postdoctoral student, Sung-Won Kim, I tried to answer this question by a detailed calculation that used an incomplete mixture of the quantum laws of physics and Einstein's relativistic laws (so-called *quantum field theory in curved spacetime*). We discovered, to our surprise, that Geroch and Wald were right: vacuum fluctuations (virtual particles) traveling through the wormhole will generate the explosion described in this section's verse and paintings. (Later work by Bob Wald, Bernard Kay, and Marek Radzikowski put this explosive conclusion on a much firmer footing.)

However, Kim and I looked in detail at our explosion and concluded that it was not strong enough to destroy the wormhole; the time machine would be created successfully.

But then my dear friend Stephen Hawking showed us a different way to think about our calculation, a way that says the explosion *will* be strong enough to destroy the wormhole. Hawking and I argued back and forth for a while — a friendly but intense argument — and finally agreed that only the full laws of quantum gravity know for sure the fate of the explosion. Nevertheless, Hawking and I both wound up rather confident, though not sure, that every time machine would self-destruct when first activated. Hawking gave this informed speculation the name *Chronology Protection Conjecture* and described it as keeping the universe safe for historians.[38]

I describe portions of my friendship with Hawking in an introduction that I crafted for the last book he wrote, which was published posthumously.[39]

LIA'S TIME-MACHINE STORY (100-105)

My coauthor, Lia, invented this lovely little story to explain in more simple terms the basic idea underlying time-machine self-destruction. Although it explains the idea, this story does have a logical flaw. Can you find it?

3 / GEOMETRODYNAMICS: WARPED SPACETIME IN A STORM, AND GRAVITATIONAL WAVES

FIRST PASS QUICKLY (108-9)

In 1916, a few months after he formulated his general relativistic laws of physics, Einstein used them to predict that gravitational waves exist. Over the century since then, we physicists have used his laws to explore the nature of these waves much more deeply. My students and I contributed to this a few years ago:[40] we discovered, in Einstein's mathematics, that these waves can be described as intertwined vortices of twisting space and tendices of stretching/squeezing space[41] — the depiction introduced in verse in the beginning of this chapter and fleshed out in the verse and paintings of the chapter's first two sections.

The word *geometrodynamics* was coined by John Wheeler in the late 1950s (about five years before I became his student) to describe the dynamical behavior of warped spacetime. Wheeler's early, seminal ideas about this are described in his book *Geometrodynamics*.[42] Wheeler urged me, his other students, and his colleagues to explore the geometrodynamics of warped spacetime by solving Einstein's relativity equations. He knew this would be a very difficult task because Einstein's equations are so difficult to solve using only pencil and paper and human brain power. So he suggested trying to solve the equations numerically, on digital computers — *numerical relativity*.

That was the late 1950s, and there were huge bottlenecks: primarily our poor understanding of the mathematical properties of Einstein's equations and the feebleness of that era's computers. Solving these bottlenecks required nearly half a century. Computer simulations only began telling us a lot about geometrodynamics in the 2000s, and only after computer simulations paved the way did analytic work (human brain power plus pencil and paper) begin to bring major insights.[43]

WHEN SPINNING BLACK HOLES COLLIDE HEAD-ON: FIGHTING, ENTWINING VORTICES MORPH INTO GRAVITY WAVES (110–19)
In 2001, Lee Lindblom and I initiated a computer-based research program on geometrodynamics — numerical relativity — at Caltech, in collaboration with a group at Cornell led by my former student Saul Teukolsky, who had already been working on numerical relativity for many years. We call our joint effort the program to Simulate eXtreme Spacetimes (SXS). Our SXS

program is one of several around the world that have contributed to breakthroughs in geometrodynamics by simulating the collisions of black holes. You will find some details of our research on the SXS websites.[44]

The raw output of a computer simulation is an enormous number of numbers, which are best converted into images and videos for human comprehension. I realized in 2010 that to facilitate this, we needed a way to visualize the Riemann curvature tensor, because this mathematical object is the principal mathematical embodiment of spacetime warpage. This visualization challenge is what led my students and me to discover twisting (clockwise and counter-clockwise) vortices, and stretching and squeezing tendices.[45]

After we discovered vortices and tendices in Einstein's mathematics, one of the first things we used them for was to explore the *spacetime storm* that is triggered when identical, spinning black holes collide head-on. The SXS team carried out the simulations, and my students visualized them. Our results — described in this section of the book — were a big and beautiful surprise. Before the simulations, we had no inkling that the vortices would behave in this fascinating and complex manner.[46]

WHEN ORBITING BLACK HOLES COLLIDE: SPIRALING VORTICES MORPH INTO GRAVITY WAVES (120-25)

Having explored the spacetime storm triggered by a head-on collision of spinning black holes, my students and I next used our vortex and tendex tools to visualize the output from an SXS simulation of an orbiting collision of two spinning black holes. Our results for the waves produced by vortices attached to the merging holes are described in this section of the book.[47]

TENDEX-GENERATED WAVES (126-29)

The gravitational waves produced by tendices attached to the merging black holes are described in this section.[48] There are remarkably close similarities between the patterns of the colliding holes' vortex-generated gravitational waves and tendex-generated waves; in technical language, they have a *near duality*.[49]

This near duality is key to the two types of waves being able to largely cancel each other on one side of the colliding black holes and reinforce on the other side, resulting in the departing waves kicking the merged, final black hole — hard. This large geometrodynamical kick was discovered in computer simulations in 2007 by Manuela Campanelli and her colleagues at the University of Texas, Brownsville.[50] My students and I explained the large kick four years later, when we discovered

THE WAVES' TREMENDOUS POWER (130-33)

For the first gravitational waves observed by humans (the waves discovered by LIGO on 14 September 2015), the peak power was about 4×10^{49} Watts — i.e., 9×10^{22} larger than our Sun's luminosity and 50 times larger than the luminosity of all the stars in the observable universe combined. This is also $1/1000$ of c^5/G, where c is the speed of light and G is Newton's gravitational constant. The waves were this strong for about 15 milliseconds, which was only long enough for the waves to travel around the black hole a few times. The product of this duration and the waves' power is about 6×10^{49} Joules, or about the energy we would get by annihilating three suns and converting all their mass into gravitational waves. The masses of the two initial black holes were 29 and 36 times the mass of the Sun, so the efficiency of the black-hole collision in converting black-hole mass into gravitational-wave energy was about (3 Msun)/(65 Msun) — i.e., about 5 percent. For comparison, the efficiencies of the strongest chemical explosions are roughly one part in a billion, and those of the strongest thermonuclear explosions are less than one part in a thousand.[52]

The quiescent black hole that was left behind, long after the waves departed, is described by Roy Kerr's solution of Einstein's equations. That this must be so was proved by pencil and paper manipulations of Einstein's equations in the 1970s,

ACROSS THE UNIVERSE TO EARTH (134-39)

This description of the waves' journey was inferred from LIGO's observations of the waves when they passed through Earth.

LIGO: THE LASER INTERFEROMETER GRAVITATIONAL-WAVE OBSERVATORY (140-49)

The description, in this section, of how LIGO's gravitational wave detectors work tries to capture the essence of more complete descriptions.[55]

GALILEO AND LIGO (150-53)

The history of modern electromagnetic astronomy since Galileo, and the revolution in our understanding of the universe that it has wrought, are fascinating.[56]

HOW DID LIGO COME TO BE? MY OWN PAROCHIAL VIEW . . . (154-67)

The very brief, poetic history of LIGO in this section is highly oversimplified. The history has been written elsewhere in far greater detail and from a less-parochial viewpoint.[57] Four of my LIGO colleagues and I are writing a long and detailed history with extensive references to LIGO technical reports and many interesting anecdotes.[58]

CODA: THE PHONE CALL (168-69)

During ten days of December 2017, while in Stockholm for the Nobel Prize festivities, I talked with members of the selection committee for the Physics Prize. They assured me that the Nobel Foundation has the authority to change the rule that says the prize can be given to at most three people. The reason for that rule, they explained, is that the main purpose of the prize is to inspire and educate people worldwide about physics (and the other fields in which the prize is awarded); and individuals are far more inspirational icons than large teams of people. I, in turn, argued (in much the same way as in this section's verse) that educating the world about the power of collaboration is an additional role that the Nobel Foundation should take on. I pointed out that the Breakthrough Prize has already done so in cases like LIGO by giving one-third of the prize to three individuals and two-thirds to the full team that made the breakthrough. The Nobel Committee members replied that the Nobel Foundation has been discussing some-thing similar but has not yet become sufficiently convinced to move forward with a change.

4 / PROBING THE WARPED SIDE WITH GRAVITY WAVES

FIRST VIGNETTE: NEUTRON STARS COLLIDE (174-79)

Shortly after James Chadwick's 1932 discovery of the neutron (at the University of Cambridge) and physicists' realization that atomic nuclei are made from neutrons and protons, Fritz Zwicky at Caltech speculated on the existence of neutron stars and that they might be created in supernova explosions. Thirty-five years later (1967), Cambridge radio astronomers Jocelyn Bell and Tony Hewish discovered pulsars, and it quickly became clear that they are, in fact, spinning neutron stars. Seven years after that, Russell Hulse and Joseph Taylor of

the University of Massachusetts Amherst, using a giant radio telescope in Arecibo, Puerto Rico, discovered pulsed radio waves from two neutron stars in orbit around each other. Hulse and Taylor's observations revealed that those stars are spiraling together at just the rate expected due to emitting gravitational waves — and that they should collide about 300 million years from now.[59] Rather quickly after that, gravitational waves from neutron-star collisions in distant galaxies became a target for the nascent gravitational wave interferometers, and LIGO and its newly operational European partner, the Virgo gravitational interferometer, saw those waves in 2017.[60]

SECOND VIGNETTE: A BLACK HOLE SPAGHETTIFIES A STAR (180-83)
My description of a black hole ripping apart a neutron star is based on computer simulations carried out by the SXS collaboration and other research groups.[61] The gravitational waves from such events are a major target for LIGO and may well be seen before this book is published. Already LIGO and Virgo have seen gravitational waves from two events where a moderately large black hole swallows a neutron star whole, without tearing it apart.[62]

THIRD VIGNETTE: LISA: THE LASER INTERFEROMETER SPACE ANTENNA (184-85)
LISA was conceived in 1974 by several gravitational-wave physicists — Peter Bender and Jim Faller (University of Colorado), Rai Weiss (MIT), Ron Drever (Glasgow) and others. Bender fleshed out the idea conceptually in the 1970s and 1980s, and NASA and the European Space Agency (ESA) agreed in the late 1990s to develop and fly LISA jointly. NASA abrogated its agreement with ESA in 2011 due to cost overruns on the Webb space telescope (which also were responsible for killing a number of other exciting space science missions). A test of much of LISA's technology was carried out in space by ESA with great success in 2017, and NASA has rejoined the LISA project as a junior partner. ESA tentatively plans to launch LISA into space in 2037.[63]

FOURTH VIGNETTE: MAPPING BACK HOLES WITH LISA (186-89)
In the mid-1990s, Fintan Ryan, a remarkable PhD student of mine, proved mathematically that the gravitational waves from a neutron star or a small black hole orbiting around a far larger, spinning black hole carry a complete map of the large hole's warped spacetime. He actually proved this only when the orbiting object is in a nearly circular, equatorial orbit.[64] However, it would be extremely surprising if the much-richer waves from other, more complicated orbits (like the one Lia depicts in this section) fail to encode that same information. But the effort to prove this and provide a mathematical algorithm for extracting that information has not yet succeeded.

When the large black hole is a thousand or more times bigger than the object orbiting it (the neutron star or small hole), the gravitational waves will be in LISA's low-frequency band, and not in LIGO's high-frequency band, and the waves will last for a year or more, bringing a highly detailed map of the big black hole. For the waves to be in LIGO's high-frequency band, the large hole must be no more than about 30 times bigger

than the orbiting object. In this case, the waves last in LIGO's band for only seconds or minutes, not years, and there are not enough wave cycles to encode a detailed map.

FIFTH VIGNETTE: NAKED SINGULARITIES (190-93)
Einstein's laws are likely almost fully correct throughout the universe except in the quantum gravity cores of singularities. Roger Penrose and Stephen Hawking were the giant intellects of their era (ca. 1960–2020) in exploring what Einstein's laws predict about our universe.

In 1969, Penrose conjectured that nothing in our universe can create a naked singularity. For example, when stars implode at the ends of their lives producing singularities, those singularities will always be surrounded by horizons. They never will be naked. This is called Penrose's *Cosmic Censorship Conjecture*.[65] Despite nearly a half century of effort, we physicists have failed to prove or disprove this conjecture. We have found, in Einstein's equations, much circumstantial evidence in favor of it, but nobody has been able to give a convincing mathematical proof.

Computer simulations of imploding matter, carried out by Matthew Choptuik (then at the University of Texas) and other physicists, have actually produced naked singularities, but *only* when their starting conditions are extremely carefully adjusted. Whenever the starting conditions are random, even just a little bit random (as will always be true in the real universe), the simulations produce singularities clothed by horizons. Nevertheless, I and my Caltech colleague John

Preskill are sufficiently skeptical of cosmic censorship (or perhaps are so crazily hopeful it will fail), that in 1991 we bet Stephen Hawking that naked singularities *can* form in the real universe.[66] And since we physicists seem to be too stupid to prove or disprove cosmic censorship using Einstein's laws, gravitational-wave astronomers are beginning the search that Lia and I describe in this section.

SIXTH VIGNETTE: THE BIG-BANG
BIRTH OF OUR UNIVERSE (194-201)
In 1929, Edwin Hubble, gazing through the 100-inch diameter telescope on Mount Wilson, California, discovered the expansion of our universe (the motion of galaxies away from each other). In the decades since then, astronomers have studied this expansion in great detail by a wide variety of observational techniques. In the 1960s and 70s Hawking and Penrose combined Einstein's relativity laws with the observational data to deduce that this expansion must have begun with some sort of singularity that is governed by the laws of quantum gravity: the big-bang singularity.[67]

In the 1970s, Leonid Grishchuk, another of my close Russian friends, used Einstein's laws to deduce that the big bang must have produced *primordial* gravitational waves, and his Russian colleague (and one of my mentors) Yakov Borisovich Zel'dovich showed that these waves are so penetrating that they should have traveled, essentially unscathed, through the hot, dense matter of the very early universe, bringing us detailed information about the big bang.[68] In 1979-82, Alexei Starobinsky,

Alan Guth, Andrei Linde, Paul Steinhardt, and others created and developed the idea that almost immediately after the big bang, the universe underwent an epoch of exponentially rapid expansion called *inflation*, and they showed that whatever gravitational waves came directly off the big bang (conventional wisdom says vacuum fluctuations) would have been amplified by inflation to produce a rich spectrum of primordial gravitational waves.[69]

In the 1990s, several theoretical physicists devised the most promising way to detect these gravitational waves and extract their information: via a pattern of *polarization* that they induce in the CMB (cosmic microwave background radiation). The quest to find this polarization pattern and measure its details has become a holy grail for observational cosmologists.[70]

This polarization pattern will only reveal the details of the extremely low frequency waves (~10^{-16} Hz; wavelengths hundreds of millions of light-years). Other information about the early moments of the universe will be contained in the higher-frequency primordial gravitational waves, but they are almost certainly too weak to be seen by near-future detectors such as LIGO. In the mid-twenty-first century, the Big Bang Observer[71] — the constellation of twelve interplanetary spacecraft linked by laser beams, described in this section — is likely to detect and measure the primordial waves at higher frequencies (~0.1 Hz; wavelengths modestly longer than the Earth–Moon separation).

In recent decades, physicists, struggling to understand the details of the big bang singularity, have developed a wide variety of fascinating ideas; but the true nature of the singularity is likely to become clear only when the laws of quantum gravity are fully understood — perhaps in 30 years; perhaps longer.[72]

SEVENTH VIGNETTE: COSMIC STRINGS (202–5)

String theory deals with fundamental strings: submicroscopic, vibrating rubber-band-like objects from which electrons, protons, neutrons, and other fundamental particles are thought to be made. Since the 1980s, physicists have regarded it as the most promising foundation for the laws of quantum gravity — or one of the most promising.

The concept of a *cosmic string* (a string so large it could reach across the universe) was formulated by Tom Kibble in the 1970s. We now understand that cosmic strings might have been created in a variety of ways in the very young universe. Most interesting to me, and a focus of this section of the book, is Joseph Polchinski's insight that some types of fundamental strings might have been inflated to cosmic size in early moments of the universe, becoming cosmic strings. In 2001, Thibault Damour and Alex Vilenkin, working with the mathematics of cosmic strings, discovered that their cusps and kinks, produced when strings collide, will generate gravitational waves with unique shapes — waves so strong that LIGO or LISA might be able to detect them.[73]

5 / OUR VISION

EUPHORIA! WHAT SATISFYING JOY (208-11)

My LIGO colleagues and I had already largely fleshed out the vision sketched in this brief section by 1989, when we submitted to the US National Science Foundation our proposal for the final design and construction of LIGO.[74] The vision began to come true with LIGO's first detections of gravitational waves from colliding black holes (the signal designated GW150914) and from colliding neutron stars (GW170817).

QUANTUM GRAVITY: THE PHYSICS HOLY GRAIL (212-15)

I briefly described theorists' quest to find the quantum gravity laws in the section above where we first met quantum gravity: *A Black Hole Is Made from Tendices of Stretching and Squeezing Space and a Chaotic Singularity* (58-61).[75] And I described astrophysicists' quest to observe gravitational waves from the big-bang singularity in the section *Sixth Vignette: The Big-Bang Birth of Our Universe* (194-201). The dream to conquer the laws of quantum gravity by combining these quests is one shared by much of the physics community. I have described it in the final few minutes of my verbal Nobel Prize lecture, and the penultimate section of the written version of my lecture.[76]

NOTES TO EPILOGUE*

╱ PROLOGUE

1 For details, see Will (1993), and Chs. 1 and 2 of my book *Black Holes and Time Warps* (Thorne 1994) — cited henceforth as BHTW.

2 For details see BHTW, and also my book with Hawking and others *The Future of Spacetime* (Hawking et al. 2002), and my book *The Science of* Interstellar (Thorne 2014) — henceforth TSI.

3 *Wheeler (1962).

4 See *Weiss, Barish, and Thorne (2018) and Thorne (2019).

1 ╱ THE BLACK HOLE

5 For all of this history, see Chs. 3–7 of BHTW (Thorne 1994).

6 For details, see Chs. 8 and 9 of BHTW; and also, much more up-to-date, Begelman and Rees (2021).

7 Search on the phrase "embedding diagram" in Ch. 3 and especially Chs. 6, 7, 11, and 13 of BHTW (Thorne 1994). See also Chs. 5 and 6 of TSI (Thorne 2014) and my Ch. 5 in a volume that celebrated Stephen Hawking's 60th birthday (Thorne 2003).

8 Einstein's law of time warps is discussed in detail in Ch. 4 of TSI. For an elementary, quantitative statement of this law — a statement that links a body's slowing of time to its gravitational pull, see the technical note for Ch. 4 of TSI (Thorne 2014, p. 291).

9 For historical discussions, see Ch. 2 of BHTW, and for greater historical accuracy and detail, Renn (2020) and Ch. 9 and pp. 196–98 of Pais (1982).

10 Thorne (2003) and Ch. 5 of TSI.

11 Discussed very briefly in Ch. 5 of TSI and in Thorne (2003).

12 See sections 17.7, 17.8, and 27.8 of Penrose (2005) for a discussion of spacetime diagrams and this light-cone tilting.

13 For the Gravity Probe B experiment see *Everitt et al. (2011); for the LAGEOS/ LARES experiment see *Ciufolini et al. (2019). For a detailed pedagogical but technical discussion of frame dragging and plans for these experiments see Ch. 6 of *Ciufolini and Wheeler (1995).

14 See Ch. 5 of TSI and pp. 286–92 of BHTW.

15 **Owen et al. (2011).

16 For a detailed discussion that requires some mathematics, see section 5.1 of *Scheel and Thorne (2014).

17 Some were graduate students, others postdoctoral students, and two former students (but by then professors): Robert Owen, Jeandrew Brink, Yanbei Chen (professor), Jeffrey Kaplan, Geoffrey Lovelace, Keith Matthews, David Nichols, Mark Scheel (professor), Fan Zhang, and Aaron Zimmerman. It was wonderful collaborating with these brilliant young people.

18 **Owen et al. (2011).

19 See Ch. 4 of TSI; and with mathematics, section 5.1 of *Scheel and Thorne (2014).

20 For a detailed discussion of the BKL singularity and how it was discovered, see pp. 466–76 of BHTW; also see pp. 230–31 of TSI, and with some mathematics, section 3.1 of *Scheel and Thorne (2014).

21 For some details of the quest for the laws of quantum gravity, and of the string theory approach and other approaches to those laws, see Smolin (2001), Susskind (2005), Green (2010), Gubser (2010), and Carroll (2019).

22 For a readily accessible account of the three singularities, see Ch. 26 of TSI.

23 **Poisson and Israel (1990).

24 **Marolf and Ori (2013).

25 For some technical details, see the last paragraph on p. 2119 of **Ori (1992).

2 ╱ WORMHOLES AND TIME MACHINES

26 Thorne (1994).

27 **Einstein and Rosen (1935).

28 See for example *Morris and Thorne (1987) and **Visser (1996).

29 See Ch. 15 of TSI, and for greater detail see *James, von Tunzelmann, Franklin, and Thorne (2015). For further details on wormholes see, for example, Ch. 14 of BHTW (where I incorrectly attribute the Einstein-Rosen wormhole to Ludwig Flamm), and Everett and Roman (2012).

30 See Box 14.1 of BHTW.

31 And in Box 12.4 of BHTW.

32 These two exotic-material examples, the Casimir vacuum and the squeezed vacuum, and another example due to Hawking, are discussed on pp. 163–67 of Everett and Roman (2012).

33 *Morris and Thorne (1988).

34 For details, see Everett and Roman (2012).

35 See, for example, pp. 76–77 of *Wheeler (1962).

36 See, for example, pp. 493–96 of BHTW.

37 See pp. 498–508 of BHTW and pp. 266–69 of TSI.

38 For some not-too-technical details of everything in this section, see pp. 505–7 and 516–21 of BHTW, and Hawking's Ch. in Hawking et al. (2002). For technical details, see **Kim and Thorne (1991), **Hawking (1992), and **Kay, Radzikowski, and Wald (1997).

39 Hawking (2018).

3 / GEOMETRODYNAMICS: WARPED SPACETIME IN A STORM, AND GRAVITATIONAL WAVES

40 **Owen et al. (2011).

41 For a slightly technical discussion, see *Scheel and Thorne (2015).

42 **Wheeler (1962).

43 For some discussion of this, see *Scheel and Thorne (2015).

44 https://www.black-holes.org and https://www.youtube.com/user /SXSCollaboration.

45 **Owen et al. (2011).

46 For some details of this simulation, see Sec. V.B.1 of *Scheel and Thorne (2014) and references cited therein.

47 For some technical details, see Sec. V.B.2 of *Scheel and Thorne (2014) and references cited therein.

48 For some technical details, see the last paragraph of Sec. V.B.2 of *Scheel and Thorne (2014).

49 See, for example, Fig. 11 of *Scheel and Thorne (2014). For much greater technical detail, see **Nichols et al. (2013), especially Sec. I.C.3.

50 **Campanelli et al. (2007).

51 **Owen et al. (2011); see also Sec. V.B.3 of *Scheel and Thorne (2014).

52 For much greater detail see, for example, *LIGO/VIRGO Collaboration (2017).

53 See Ch. 7 of BHTW.

54 **Isi et al. (2019).

55 For the general reader, see pp. 383–87 of BHTW, or Rainer Weiss's Nobel Prize lecture, part I of *Weiss, Barish, and Thorne (2018). For some technical details, see Sec. 27.6 of **Thorne and Blandford (2017, 2021).

56 For the history from Galileo to 1975, I recommend Asimov (1975).

57 See, for example, Levin (2017), and also *Weiss, Barish, and Thorne (2018); and for some of my own additional parochial details, see Thorne (2019).

58 Barish, Fritschel, Shawhan, Thorne, and Weiss (2025).

4 / PROBING THE WARPED SIDE WITH GRAVITY WAVES

59 For the concept of a neutron star and for details of this history, see Ch. 5 of BHTW and McNamara (2008).

60 The discovery and multimessenger observations of that first observed neutron-star collision are described by Billings (2017) and Miller (2017), and in technical detail by the teams of astronomers who made the observations: *Abbott et al. (2017a,b).

61 For a brief nontechnical summary see SXS (2019), and for a more detailed moderately technical summary, see *Foucart (2020). For a video from a simulation by the Maya collaboration (UT Austin, Georgia Tech and Vanderbilt), see Ferguson et al. (2021).

62 Abbott et al. (2021).

63 For details of the LISA space mission and of what it may teach us about the universe, see the European Space Agency (ESA)'s LISA website and references therein: http://sci.esa.int/lisa/; also the associated website, https://www.elisascience.org.

64 See **Ryan (1992) and an extension by **Li and Lovelace (2008).

65 See pp. 481–82 of BHTW.

66 See pp. 140–45 of my Ch. in Hawking et al. (2002).

67 See, for example, pp. 459–65 of BHTW.

68 See Secs. 24.17 and 17.4 of **Zel'dovich and Novikov (1983).

69 See, for example, Rees (1997), Steinhardt and Turok (2007), Perlov and Vilenkin (2017).

70 See, for example, Chs. 20 and 21 of **Maggiore (2018).

71 The Big Bang Observer was conceived by Caltech astrophysicist Sterl Phinney and its conceptual details were developed in 2004 by a NASA committee he led (Phinney et al. 2004).

72 For details of some of these speculations, see, for example, Rees (1997), Steinhardt and Turok (2007), Penrose (2016), and Perlov and Vilenkin (2017).

73 For details, see Sec. 22.5 of **Maggiore (2018). For another way that cosmic strings might have been made — in a phase transition in the very early universe — and other things we might learn from cosmic strings' gravitational waves, and an alternative way to detect their gravitational waves — by fluctuations in the observed arrival times of pulsar radio waves (*pulsar timing arrays*) — see, for example, Saplakoglu (2020) and Lewton (2020).

5 / OUR VISION

74 See Appendix A of Volume 1 of that proposal, *Vogt et al. (1989); also the brief published summary of that proposal: Abramovici et al. (1992).

75 For some details of the theorists' quest, see Smolin (2001), Susskind (2005), Green (2010), Gubser (2010), and Carroll (2019).

76 https://www.youtube.com/watch?v=TZLvEp_xjnY and my part III of Weiss, Barish, and Thorne (2018).

* In these notes, references prefaced by one star are moderately technical. Those prefaced by two stars are very technical. Those with no stars should be understandable to all or most readers of this book.

ACKNOWLEDGMENTS

KIP WRITES:

I never imagined collaborating with a painter until I met Lia. I'm profoundly grateful to her for introducing me to the world of art and artists and triggering our marvelous collaboration. I am a novice at writing verse. For insightful advice, huge encouragement, and powerful, compelling edits of my verse, I thank our editor, Bob Weil. I also benefitted greatly from verse advice by Diane Ackerman, Jenijoy La Belle, Dava Sobel, and Rebecca Wolf, and from Rebecca's insightful edits. I thank the long-dead poet Robert Service, whose poems inspired me as a child and youth and whose meter I have adapted.

I thank my physicist colleagues, who have been crucial to the insights and discoveries about the Warped Side of Our Universe described in this book — particularly my mentor, John Archibald Wheeler, who introduced me to the Warped Side and to Einstein's laws that govern it; Rai Weiss, the primary inventor of the gravitational interferometer and my soulmate companion in our quest to create gravitational wave astronomy; my other remarkable LIGO colleagues, a few of whose roles are described in the section *How Did LIGO Come to Be? My Own Parochial View*, others who were also crucial but too numerous to name, and especially the entire LIGO team, the fleet of a thousand, who brought our quest to fruition. And I thank my many students and theorist colleagues, from whom I have learned so much, particularly the members of the SXS numerical relativity collaboration and its leader, Saul Teukolsky; and the students and former students with whom I extracted, from SXS simulations, insights into geometrodynamics including vortices of twisting space and tendices that stretch and squeeze: Robert Owen, Jeandrew Brink, Yanbei Chen, Jeffrey Kaplan, Geoffrey Lovelace, Keith Matthews, David Nichols, Mark Scheel, Fan Zhang, and Aaron Zimmerman.

LIA WRITES:

This project has been an immense opportunity to stretch outside of my studio practice as an artist, and I am eternally grateful to Kip for our friendship and collaboration which has pushed and challenged me in exciting and new directions. This book originated as a small article, and I am indebted to my incredible studio team, Jennifer Seo, Garret Hill, Kayla Quinlan, and Adam Ottke, who have been instrumental throughout the process, organizing, documenting, and supporting the creation of this project at every step of its transformation into this beautiful book. I am thankful to Luis De Jesus, Jay Wingate, Stacie Martinez, and the wonderful folks at the gallery Luis De Jesus Los Angeles.

I thank my fantastic colleagues, collaborators, and students at Chapman University, who have worked with me on various interdisciplinary endeavors and enriched my practice in so many ways. I am especially grateful to Dean Jennifer Keane and President Daniele Struppa, for their encouragement and support of the multifaceted directions of my creative output and teaching. I am so appreciative of Dava Sobel for our amazing friendship and a shared passion to bring attention to the lineage of women in science and in discovery in the natural world. Janna Levin has been a ceaseless source of excitement and cross-disciplinary partnership orchestrating art, science, and culture crossovers, and her insight vastly encouraged and supported the nature of this project. I thank my parents who endlessly encouraged my curiosity and creativity in art and the natural world. Lastly, I thank our lone space traveler, my extraordinary wife Felicia, for patiently modeling for the paintings in this book when I gave her the strange instructions that she was being stretched, squeezed, and sucked into a black hole.

LIA AND KIP WRITE:

We thank Lisa Randall for introducing us to each other, triggering our wonderful friendship and collaboration. And we thank colleagues and friends whose advice and encouragement have influenced us significantly: Diane Ackerman, Paula Froehle, Janna Levin — and Dava Sobel for, among other things, debuting an excerpt from a draft of our book in her column "Meter" in the October 2020 issue of *Scientific American*. We thank Tom Buttgenbach for flying us, at the height of the Covid pandemic, to the LIGO site in Hanford to photograph LIGO from the air and ground as a foundation for Lia's paintings. We are particularly grateful to Maria Popova, whose love of poetry, nature, and science gave her the particular insight to know this project would be in the most ideal hands with our outstanding agent, Charlotte Sheedy.

We are grateful to the designer of this beautiful book, Rebeca Méndez, and her design assistant, Jason Lee, whose influence over its appearance has been profound. For assistance in preparing Lia's paintings for printing, we thank Tony Manzella and the wonderful team at Echelon Color, and Paul Salveson, our photographer. And we thank our agent Charlotte Sheedy and editor Bob Weil for wise advice and enthusiastic encouragement, and key members of the production, publication, publicity, and marketing teams at Liveright Books and W. W. Norton & Company: Anna Oler, Steve Attardo, Haley Bracken, Robert Byrne, Nick Curley, Rebecca Homiski, Elisabeth Kerr, Peter Miller, Steven Pace, and Don Rifkin.

CHRONOLOGY

1.3 BILLION YEARS AGO
Collision of the two black holes *GW150914* launches gravitational waves into the universe.

130 MILLION YEARS AGO
Collision of the two neutron stars *GW170817* launches gravitational waves into the universe.

50,000 YEARS AGO
GW150914 and GW170817 *gravitational waves* enter our Milky Way galaxy.

1610
Galileo initiates modern *electromagnetic astronomy* by building an optical telescope, pointing it at Jupiter, and discovering Jupiter's four largest moons.

1912
Einstein's law of time warps is formulated by Albert Einstein.

1915
The *general relativity laws* that govern the warping of space-time are formulated by Einstein (or — as I tend to regard them — are discovered by Einstein).

1916
Gravitational waves and their stretch/squeeze properties are predicted by Einstein using his general relativity laws of physics.

1920s
The laws of quantum physics are formulated through the combined work of several physicists, most notably Erwin Schrödinger, Werner Heisenberg, Niels Bohr, and Paul Dirac.

1929
Edwin Hubble discovers the *expansion of the universe*, leading to speculations that the universe might have begun in a *big-bang* explosion.

1935
Einstein and Nathan Rosen discover that a solution of Einstein's relativity equations, discovered in 1916 by Karl Schwarzschild, actually describes a *wormhole*.

1939
J. Robert Oppenheimer and Hartland Snyder use Einstein's relativity equations to analyze the implosion of a star and discover that it produces the object we now call a *black hole*, but neither they nor anyone really understands the black hole's properties until about twenty years later.

1948

Hendrik Casimir predicts that between two electrically conducting surfaces (walls), vacuum fluctuations will be modified so they have negative energy — i.e., they become (in modern language) *exotic material*. These specific modified vacuum fluctuations are now called the Casimir vacuum, and its existence was finally verified experimentally in the late 1990s by Steve Lamoreaux and by Umar Mohideen and Anushree Roy.

1956

John Archibald Wheeler conceives the idea of *quantum foam* (as the fundamental structure of space on exceedingly small scales) and speculates on its existence and properties.

LATE 1950s / EARLY 1960s

John Wheeler urges his students and colleagues to explore the highly nonlinear dynamical behavior of warped spacetime, to which he gives the name *geometrodynamics*. Triggered by this, Wheeler's students Charles Misner and then Richard Lindquist and Susan Hahn initiate an effort to explore geometrodynamics using computer simulations of colliding wormholes or black holes.

1962

John Wheeler and Robert Fuller discover that the Einstein-Rosen *wormhole implodes* (pinches off) so quickly that nothing can travel through it.

1962

Under John Wheeler's mentorship I embark on graduate study toward a PhD, focusing on Einstein's relativity and using it to explore what I now call the *Warped Side of Our Universe*.

1963

Roy Kerr discovers the solution of Einstein's equations that describes a *spinning black hole,* and many physicists begin to explore mathematically the properties of spinning black holes.

1964

Arno Penzias and Robert Wilson discover *cosmic microwaves* from the hot, young universe.

1966–70

Stephen Hawking and Roger Penrose show that Einstein's relativity laws plus astronomical observations imply that there must have been a *big bang singularity.*

1969

The Cosmic Censorship Conjecture — that *naked singularities* cannot occur in our universe — is formulated by Roger Penrose, based on extensive studies of Einstein's relativity laws.

1969

The chaotic *BKL singularity* is predicted, and its properties are explored by Vladimir Belinsky, Isaak Khalatnikov, and Evgeny Lifshitz using Einstein's relativity laws.

1972

Rainer Weiss invents the *gravitational interferometer* for detecting gravitational waves, and he explores the worst kinds of noises it would face, devises ways to deal with those noises, and estimates that such an instrument can be sensitive enough to succeed.

1972

William Henry (Bill) Press and I and colleagues begin to develop a vision for *gravitational-wave astronomy.*

1974

Richard A. Isaacson takes a position at the US National Science Foundation (NSF). Soon thereafter he becomes NSF's program director for gravitational physics, and for nearly thirty years he fosters the growth of research on the *Warped Side of the Universe*, including LIGO.

1974

Strong *(primordial) gravitational waves* produced in the big bang are predicted by Leonid Grishchuk using Einstein's relativity laws.

1974

The concept for the *LISA* gravitational wave detector is conceived by Peter Bender, Ronald Drever, Jim Faller, Rainer Weiss, and others.

1976

Einstein's law of time warps is verified to very high precision by Robert Vessot by comparing the rates of flow of time on Earth and in a rocket at very high altitude using atomic clocks.

1976

The *warping of space around the Sun* is verified and measured with very high precision by Irwin Shapiro and Robert Reasenberg, using radio signals transmitted to Mars and back.

1976

Tom Kibble predicts that *cosmic strings* may have been produced by phase transitions soon after our universe's big-bang birth.

1978

At a conference on the theoretical study of possible sources of gravitational waves, my colleagues and I realize that the *strongest gravitational waves* arriving at Earth may come from *colliding black holes and from colliding neutron stars.*

1979-82

Alexei Starobinsky, Alan Guth, Andrei Linde, Paul Steinhardt, and others formulate and develop the idea of the inflationary expansion of the very early universe.

1984

The *LIGO* project for searching for gravitational waves is created by Rainer Weiss, Ronald Drever, and me, as a collaboration between MIT and Caltech, supported by the National Science Foundation.

1985

I realize, using Einstein's relativity laws, that *a wormhole can be held open by exotic material* placed in its throat. This rather obvious conclusion was already implicit in 1975 research by Dennis Gannon and C. W. Lee. This triggers a decades-long effort by my colleagues to learn whether the laws of physics permit enough exotic material to be placed in a wormhole's throat to hold it open.

1988

Eric Poisson and Werner Israel use Einstein's relativity laws to predict the *infalling singularity* inside black holes.

1988

Mike Morris, Ulvi Yurtsever, and I conceive a *time machine* made by moving one mouth of a wormhole away from the other mouth at high speed and then back.

1989

Under the leadership of Robbie Vogt, Caltech and MIT *propose the construction of LIGO* to the National Science Foundation and preparations for LIGO begin.

1990

Sung-Won Kim and I discover that a wormhole becoming a *time machine may self-destruct* due to *vacuum fluctuations* flowing through it.

1991

Stephen Hawking formulates his *Chronology Protection Conjecture: that all time machines may self-destruct at the moment of their creation.* Hawking and I and our students conclude that the laws of quantum gravity probably control whether the explosions are strong enough to destroy time machines.

1995

Fintan Ryan shows that the *gravitational waves* emitted by a small black hole orbiting around a large black hole *carry,* encoded in themselves, *a map of the full spacetime geometry* (warpage) *of the large black hole.*

1995

The *construction of LIGO* begins under the leadership of Barry Barish.

1997
Barry Barish creates the *LIGO Scientific Collaboration*, thereby expanding LIGO to include, by 2015, more than a thousand scientists from nearly a hundred institutions in fifteen nations.

1997
Uros Seljak, Matias Zaldarriaga, Marc Kamionkowski, Arthur Kosowski, and Albert Stebbins conceive of discovering and *observing primordial gravitational waves via the polarization* that they place on *cosmic microwaves* from the very early universe.

2000
The *LISA project* is established as a joint NASA (US) and ESA (European) space mission.

2001
I leave day-to-day involvement with LIGO, so as to co-create (with Lee Lindblom) a research program at Caltech on *computer simulations of colliding black holes.* We soon team up with Saul Teukolsky's similar and much more mature program to create the *SXS project* (for computer **S**imulations of e**X**treme **S**pacetimes).

2003
Joe Polchinski predicts that during the inflationary era just after the big bang, some fundamental *superstrings* may have been *inflated* to cosmic sizes, becoming *cosmic strings.*

2004
The *initial LIGO gravitational interferometers* approach their design sensitivity and are searching for gravitational waves.

2004
E. Sterl Phinney and colleagues propose the *Big Bang Observer* — a constellation of LISA-like gravitational wave detectors that may search for primordial gravitational waves with periods of a few seconds to a few minutes in the mid-twenty-first century.

2004
Frans Pretorius, in the SXS project, performs the *first successful computer simulation of the inspiral, collision, and merger of two black holes* that were orbiting each other.

2007
Lia and I meet and become close friends at a party in Pasadena thrown by the theoretical physicist Lisa Randall.

2010
LIGO's initial interferometers complete their (fruitless) gravitational wave searches, and the LIGO team begins installing the *advanced interferometers* into the LIGO facilities.

2010-2011

Lia and I agree to write an article (her paintings and my poetic prose) for *Playboy* magazine about the *Warped Side of Our Universe*. Hugh Hefner, upon seeing Lia's paintings, orders that it not be published. We decide to expand the article into a book: this one.

2011

NASA (USA) abrogates its signed agreement with ESA (Europe) *for the LISA* gravitational wave mission, leaving ESA to carry LISA forward alone.

2011

The *outflying singularity* inside a black hole is predicted by Donald Marolf and Amos Ori using Einstein's relativity laws.

2011-2012

My former students and postdocs (Robert Owen, Jeandrew Brink, Yanbei Chen, Jeffrey Kaplan, Geoffrey Lovelace, Keith Matthews, David Nichols, Mark Scheel, Fan Zhang, and Aaron Zimmerman) and I *discover vortices of twisting space and tendices that stretch and squeeze*, sticking out of black holes, and we explore how they behave when black holes collide and in the ensuing *geometrodynamical spacetime storms*. We discover and explore these using SXS computer simulations and by mathematical manipulations of Einstein's relativity laws.

2015

The gravitational wave burst *GW150914* from colliding black holes arrives at Earth and is detected and observed by LIGO's advanced interferometers, thereby *initiating gravitational-wave astronomy.*

2017

The gravitational wave burst *GW170817* from colliding neutron stars arrives at Earth along with electromagnetic waves of every variety. They are observed by LIGO and its partner, the advanced Virgo gravitational-wave observatory, and by all types of electromagnetic telescopes, thereby *initiating multimessenger astronomy.*

2020

The *advanced LIGO interferometers complete their third search* for gravitational waves, each with much better sensitivity than before. They are seeing about *one gravitational wave signal every four days* from colliding black holes, colliding neutron stars, and black holes swallowing neutron stars.

GLOSSARY

This glossary is adapted from my book *Black Holes and Time Warps* (Thorne 1994).

ANTI-GRAVITATE
Repel gravitationally.

ATOM
The basic building block of matter. Each atom consists of a nucleus with positive electric charge and a surrounding cloud of electrons with negative charge. Electric forces bind the electron cloud to the nucleus.

BBO (BIG BANG OBSERVER)
A proposed constellation of LISA-like gravitational-wave observatories designed to observe and monitor gravitational waves from the big-bang birth of our universe.

BIG BANG
See **big bang singularity**.

BIG BANG SINGULARITY
The singularity in which our universe presumably was born; i.e., out of which the matter of our universe explosively expanded.

BKL SINGULARITY
A singularity near which tendices oscillate between stretching and squeezing in a chaotic manner that is wildly different at neighboring regions of space, and that becomes faster and faster as the singularity's core is approached.

BLACK HOLE
An object made from warped spacetime, down which things can fall but out of which nothing can ever escape.

BULK
A hypothetical (but possibly real) space with more dimensions than three, in which our universe resides.

BULK BEING
A hypothetical life form that lives in the bulk and therefore has more than three space dimensions.

CHAOTIC
Something that changes with time in a manner that is ultra-sensitive to how it begins, so that even tiny errors in our knowledge of the beginning make it unpredictable.

COSMIC STRING
A thin curve around which circumferences of circles are slightly less than π times their diameters. This object can be thought of as made from warped spacetime and so is part of the Warped Side of Our Universe.

EINSTEIN'S LAW OF TIME WARPS

A law of physics that says: when gravity is not changing rapidly as time passes, it is produced by a slowing of the rate of flow of time; the greater the slowing, the stronger the gravity.

ELECTRIC CHARGE

The property of a particle or matter by which it produces and feels electric fields.

ELECTRIC FIELD

The force field around an electric charge, which pulls and pushes on other electric charges.

ELECTRIC FORCE

The force exerted by an electric field on an electric charge.

ELECTROMAGNETIC WAVES

Waves of electric and magnetic forces. These include, depending on the wavelength of the wave: radio waves, microwaves, infrared radiation, light, ultraviolet radiation, X-rays, and gamma rays.

ELECTRON

A fundamental particle of matter with negative electric charge, which populates the outer regions of atoms.

ELECTROWEAK FORCE AND LAWS

A fundamental force and associated physical laws that existed when the universe was very young. As the universe expanded, they gave birth to the electromagnetic force and laws and the weak nuclear force and laws. The electroweak force and laws come into play today in high-energy physics experiments and processes.

EXOTIC MATERIAL OR MATTER

Material that has a negative energy density and so produces gravity that repels things rather than attracting them.

FELICIA

Lia Halloran's wife.

FIELD

Something that is distributed continuously and smoothly in space; examples are electric field and magnetic field.

GALAXY

A collection of between a billion and a few trillion stars that all orbit around a common center. Galaxies are typically about 100,000 light-years in diameter.

GAMMA RAYS

Electromagnetic waves with extremely short wavelengths.

GENERAL RELATIVITY

Einstein's laws of physics in which gravity is described by a warping of spacetime.

GEOMETRODYNAMICAL STORM

See **spacetime storm.**

GEOMETRODYNAMICS

Dynamical changes in the details of the warping of space and time (i.e., details of the geometry of spacetime).

GRAVITATIONAL WAVE

A ripple of spacetime warping that travels with the speed of light. The warping takes the form of tendices that stretch and squeeze perpendicular to the waves' direction of travel, entwined with vortices of twisting space, with the axes around which they twist also perpendicular to the direction of travel.

GRAVITY WAVE

See **gravitational wave.**

HORIZON

The surface of a black hole; the point of no return, out of which nothing can emerge.

INFRARED RADIATION

Electromagnetic waves with wavelength a little longer than light.

INTERFEROMETER, GRAVITATIONAL

A detector of gravitational waves in which the waves' tendices wiggle mirrors that hang from wires, and the interference of laser beams is used to monitor the mirrors' motions.

INTERGALACTIC SPACE

The space between the galaxies.

INTERSTELLAR SPACE

The space between the stars of a galaxy.

LAWS OF PHYSICS

The fundamental rules about matter, forces, space, and time that control how the universe behaves.

LIGO (LASER INTERFEROMETER GRAVITATIONAL-WAVE OBSERVATORY)

An Earth-based gravitational-wave observatory consisting of one gravitational interferometer near Livingston, Louisiana, and one near Hanford, Washington, whose data are combined to identify passing gravitational waves and extract the information they carry.

LISA (LASER INTERFEROMETER SPACE ANTENNA)

A gravitational-wave observatory consisting of three space-craft that track each other with laser beams, planned by the European Space Agency for launch in the 2030s. It will observe gravitational waves with wavelengths a million times longer than those LIGO observes.

MATERIAL SIDE OF OUR UNIVERSE

Objects and phenomena (such as humans) that are made from matter.

MICROWAVES

Electromagnetic waves with wavelength a little shorter than radio waves.

MILKY WAY

The galaxy in which we live.

MOLECULE

An entity made of several atoms that share their electron clouds with each other. Water is a molecule made in this way from two hydrogen atoms and one oxygen atom.

MOUTH

An entrance to a black hole (which has only one mouth) or to a wormhole (which has two mouths — one at each end of the wormhole). For a black hole, the horizon can be regarded as its mouth, or one can regard a larger region just above the horizon as its mouth.

NAKED SINGULARITY

A singularity that is not inside a black hole (not surrounded by a black-hole horizon), and that therefore can be seen and studied by someone outside it.

NATIONAL SCIENCE FOUNDATION (NSF)

The agency of the United States government charged with the support of fundamental scientific research.

NEBULA

A cloud of brightly shining gas in interstellar space.

NEUTRON

A subatomic particle with no electric charge. Neutrons and protons, held together by the strong nuclear force, make up the nuclei of atoms.

NEUTRON STAR

A star, about as massive as the Sun but only about 20 or 30 kilometers across, made mostly from neutrons packed tightly together by the force of the star's gravity.

NUCLEAR FORCE

The phrase *nuclear force* is often used to denote the **strong nuclear force** — the force between protons and protons, proton and neutrons, and neutrons and neutrons; it holds atomic nuclei together. There is also a **weak nuclear force**: a fundamental force that links neutrinos, electrons, protons, and neutrons; it is responsible for radioactivity and is central to nuclear fission.

NUCLEUS, ATOMIC

The dense core of an atom. Atomic nuclei have positive electric charge, are made of neutrons and protons, and are held together by the strong nuclear force.

ORBIT (NOUN)

The path of an object through space, or of two objects as they move around each other.

ORBIT (VERB)

To move along an orbit.

PHOTON

A particle of light or of any other type of electromagnet wave. Photons can often be thought of as transporting the wave.

PHYSICAL LAWS

See **laws of physics.**

PRIMORDIAL

Originating in the big bang.

PULSAR

A magnetized, spinning neutron star that emits a beam of radiation (radio waves and sometimes also light and X-rays). As the star spins, its beam sweeps around like the beam of a turning spotlight; each time the beam sweeps past Earth, astronomers receive a pulse of radiation.

QUANTUM (MECHANICAL) FLUCTUATIONS

Random, unpredictable fluctuations — for example, of the position of an electron inside an atom — that are controlled by the laws of quantum physics.

QUANTUM FOAM

A probabilistic foamlike structure of space that may make up the cores of singularities and probably occurs in ordinary space on scales of the "Planck length," about 10^{-33} centimeters.

QUANTUM GRAVITY

The laws of physics that may be obtained by merging ("marrying") general relativity with the laws of quantum physics. These quantum gravity laws are not yet well understood but may be some variant of "string theory" or "M-theory." When quantum fluctuations are negligibly small, these laws should become the same as general relativity. When the warpings of space and time are small, they should become the same as the standard quantum physics laws.

QUANTUM MECHANICS

See **quantum physics**.

QUANTUM PHYSICS

The laws of physics that control quantum fluctuations, when space and time are negligibly warped.

QUASAR

A compact, highly luminous object in the distant universe, believed to be powered by a gigantic black hole.

RADIATION

Any form of high-speed particles or waves.

RADIO WAVES

Electromagnetic waves of very low frequency, used by humans to transmit radio signals and used by astronomers to study distant astronomical objects.

SINGULARITY

A region of spacetime where the warping becomes so strong that Einstein's general relativity laws break down and the laws of quantum gravity take over. The singularity's *quantum gravity core* is the region where those laws totally dominate and the other laws of physics totally fail. We do not yet understand the quantum gravity core.

SPACETIME

The four-dimensional "fabric" that results when space and time are unified — as they always are, according to Einstein's general relativity laws, though we humans do not notice that unification in our everyday lives.

SPACETIME CURVATURE

The warping of spacetime, i.e., of space and of time.

SPACETIME STORM

Wild oscillations of warped spacetime (including twisting vortices and stretch-and-squeeze tendices) produced, for example, by the collision of two black holes.

SPAGHETTIFICATION

A physicist's technical term for the strong stretching of an object along one direction and squeezing along the two perpendicular directions, wrought by tendices.

TENDEX

A structure made from warped spacetime, in which space stretches (or squeezes) and thereby exerts a stretching (or squeezing) force on matter. The axis along which the stretching (or squeezing) occurs is called a *tendex line*. Through each point in space there pass three tendex lines, one (or two) that stretches and one (or two) that squeezes.

TIME MACHINE

A hypothetical device, made at least in part from warped spacetime, that can be used to travel backward in time.

ULTRAVIOLET RADIATION

Electromagnetic radiation with a wavelength a little shorter than light.

UNIVERSE

A region of space that is disconnected from all other regions of space, much as an island is disconnected from all other pieces of land.

VACUUM

A region of space from which has been removed everything that can be removed; the only things left are the irremovable vacuum fluctuations.

VACUUM FLUCTUATIONS

In a vacuum: random, unpredictable, irremovable oscillations of everything that could possibly exist (primarily particles and fields) — the probability for anything more complex is exceedingly small.

VIRTUAL PHOTONS

Photons that are temporarily created in pairs, typically as part of vacuum fluctuations, using energy borrowed from a nearby region of space. Virtual photons are a particle aspect of vacuum fluctuations.

VORTEX OF TWISTING SPACE

A structure made from warped spacetime in which space twists, and can thereby drag matter to swirl in a twisting manner. More precisely: two gyroscopes, separated along the axes of twist, will precess relative to each other, thereby revealing that the twist is a feature of inertia. The axis around which space twists (so gyroscopes precess) is called a vortex line. A vortex twists clockwise or counter-clockwise.

WARPED SIDE OF OUR UNIVERSE

Objects and phenomena (such as black holes and gravitational waves) that are made from warped spacetime.

WAVE

An oscillation of some field (for example, the electromagnetic field) that propagates through spacetime.

WAVEFORM

A curve showing the details of the oscillations of a wave as time passes.

WAVELENGTH

The distance between the crests of a wave.

WORMHOLE

A "handle" that reaches through the bulk, connecting two different locations in our universe.

X-RAYS

Electromagnetic waves with wavelength between that of ultraviolet radiation and gamma rays.

BIBLIOGRAPHY

References prefaced by one star are moderately technical. Those prefaced by two stars are very technical. Those with no stars should be understandable to all or most readers of this book.

Abbott, B. P., et al. (2017a). "Observation of Gravitational Waves from a Binary Neutron Star Inspiral." *Physical Review Letters* **119**, 161101.

Abbott, B. P., et al. (2017b). "Multi-messenger Observations of a Binary Neutron Star Merger." *Astrophysical Journal* **848**, L12.

Abbott, R., et al. (2021). "Observation of Gravitational Waves from Two Neutron Star–Black Hole Coalescences." *Astrophysical Journal Letters* **915**, L5.

Abramovici, A., et al. (1992). "LIGO: The Laser Interferometer Gravitational-Wave Observatory." *Science* **256** (5055), 325-33.

Asimov, I. (1975). *Eyes on the Universe: A History of the Telescope* (Houghton Mifflin, Boston).

Barish, B., Fritschel, P., Shawhan, P., Thorne, K. S., and Weiss, R. (2025). *A History of LIGO* (tentative title). In preparation.

Begelman, M., and Rees, M. (2021). *Gravity's Fatal Attraction: Black Holes in the Universe,* 3rd edition (Cambridge University Press, Cambridge).

Billings, L. (2017). "Gravitational Wave Astronomers Hit Mother Lode." *Scientific American*, October 16.

Campanelli, M., Lousto, C. O., Zlochower, Y., and Merritt, D. (2007). "Maximum Gravitational Recoil." *Physical Review Letters* **98, 231102.

Carroll, S. (2019). *Something Deeply Hidden: Quantum Worlds and the Emergence of Spacetime* (Penguin, Boston).

*Ciufolini, I., et al. (2019). "An Improved Test of the General Relativistic Effect of Frame-dragging Using the LARES and LAGEOS Satellites." *European Physical Journal C* **79**, 872.

*Ciufolini, I., and Wheeler, J. A. (1995). *Gravitation and Inertia* (Princeton University Press, Princeton).

Einstein, A., and Rosen, N. (1935). "The Particle Problem in the General Theory of Relativity." *Physical Review* **48, 73-77.

Everett, A., and Roman, T. (2012). *Time Travel and Warp Drives* (University of Chicago Press, Chicago).

*Everitt, C. W. F., et al. (2011). "Gravity Probe B: Final Results of a Space Experiment to Test General Relativity," *Physical Review Letters* **106**, 221101.

Ferguson, D., et al. (2021). "Disruption of a Neutron Star as It Merges with a Black Hole." LIGO Caltech, https://www.ligo.caltech.edu/video/ligo20210629v3.

*Foucart, F. (2020). "A Brief Overview of Black Hole-Neutron Star Mergers." *Frontiers in Astronomy and Space Science* **7**, 46.

Green, B. (2010). *The Elegant Universe: Superstrings, Hidden Dimensions, and the Quest for the Ultimate Theory* (W. W. Norton, New York).

Gubser, S. S. (2010). *The Little Book of String Theory* (Princeton University Press, Princeton).

Hawking, S. W. (1992). "Chronology Protection Conjecture." *Physical Review D* **46, 603-11.

Hawking, S. W. (2018). *Brief Answers to the Big Questions* (Bantam Books, New York).

Hawking, S. W., Novikov, I., Thorne, K. S., Ferris, T., Lightman, A., and Price, R. (2002). *The Future of Spacetime* (W. W. Norton, New York).

Isi, M., Giesler, M., Farr, W. M., Scheel, M. A., and Teukolsky S. A. (2019). "Testing the No-Hair Theorem with GW150914." *Physical Review Letters* **123, 111102.

*James, O., von Tunzelmann, E., Franklin, P., and Thorne, K. S. (2015). "Visualizing *Interstellar*'s Wormhole." *American Journal of Physics* **83**, 486-99.

Kay, B. S., Radzikowski, M. J., and Wald, R. M. (1997). "Quantum Field Theory on Spacetimes with a Compactly Generated Cauchy Horizon." *Communications in Mathematical Physics* **183, 533-56.

Kim, S.-W., and Thorne, K. S. (1991). "Do Vacuum Fluctuations Prevent the Creation of Closed Timelike Curves?" *Physical Review D* **43, 3939-49.

Levin, J. (2017). *Black Hole Blues and Other Songs from Outer Space* (Anchor Books, New York).

Lewton, T. (2020). "Some Physicists See Signs of Cosmic Strings from the Big Bang." *Quanta Magazine*, September 29.

Li, C., and Lovelace, G. (2008). "A Generalization of Ryan's Theorem: Probing Tidal Coupling with Gravitational Waves from Nearly Circular, Nearly Equatorial, Extreme-Mass-Ratio Inspirals," *Physical Review D* **77, 064022.

*LIGO/VIRGO Collaboration. (2017). "The Basic Physics of the Binary Black Hole Merger GW150914." *Annalen der Physik (Berlin)* **529**, 1600209.

**Maggiore, M. (2018). *Gravitational Waves, Volume 2: Astrophysics and Cosmology* (Oxford University Press, Oxford).

Marolf, D., and Ori, A. (2013). "Outgoing Gravitational Shock-wave at the Inner Horizon: The Late-time Limit of Black Hole Interiors." *Physical Review D* **86, 124026.

McNamara, G. (2008). *Clocks in the Sky: The Story of Pulsars* (Springer-Praxis, Berlin).

Miller, C. (2017). "A Golden Binary." *Nature* **551** (7678), 36-37.

*Morris, M. S., and Thorne, K. S. (1988). "Wormholes in Spacetime and Their Use for Interstellar Travel: A Tool for Teaching General Relativity." *American Journal of Physics* **56**, 395-416.

**Nichols, D. A., et al. (2012). "Visualizing Spacetime Curvature via Frame-drag Vortexes and Tidal Tendexes III. Quasinormal Pulsations of Schwarzschild and Kerr Black Holes." *Physical Review D* 86, 104028.

Ori, A. (1992). "Structure of the Singularity Inside a Realistic Rotating Black Hole." *Physical Review Letters* **68, 2117-20.

Owen, R., et al. (2011). "Frame-Dragging Vortexes and Tidal Tendexes Attached to Colliding Black Holes: Visualizing the Curvature of Spacetime." *Physical Review Letters* **106, 151101.

Pais, A. (1982). *'Subtle is the Lord . . .': The Science and the Life of Albert Einstein* (Oxford University Press, New York).

Penrose, R. (2005). *The Road to Reality* (Alfred A. Knopf, New York).

Penrose, R. (2016). *Fashion, Faith, and Fantasy in the New Physics of the Universe* (Princeton University Press, Princeton).

Perlov, D., and Vilenkin, A. (2017). *Cosmology for the Curious* (Springer International Publishing, Cham, Switzerland).

*Phinney, E. S., et al. (2004). *The Big Bang Observer: Direct Detection of Gravitational Waves from the Birth of the Universe to the Present.* NASA Mission Concept Study.

Poisson, E., and Israel, W. (1990). "Internal Structure of Black Holes." *Physical Review D* **41, 1796.

Rees, M. (1997). *Before the Beginning: Our Universe and Others* (Basic Books, New York).

Renn, J. (2020). "Genesis of General Relativity," in *Einstein Was Right: The Science and History of Gravitational Waves,* edited by Jed Z. Buchwald (Princeton University Press, Princeton).

Ryan, F. D. (1992). "Gravitational Waves from the Inspiral of a Compact Object into a Massive, Axisymmetric Body with Arbitrary Multipole Moments." *Physical Review D* **52, 5707.

Saplakoglu, Y. (2020). "Cosmic String Gravitational Waves Could Solve Antimatter Mystery." *Scientific American*, March 3.

*Scheel, M. A., and Thorne, K. S. (2014). "Geometrodynamics: The Nonlinear Dynamics of Curved Spacetime," *Physics — Uspekhi* **57**, 342-51.

Smolin, L. (2001). *Three Roads to Quantum Gravity* (Basic Books, New York).

Steinhardt, P. J., and Turok, N. (2007). *Endless Universe: Beyond the Big Bang* (Broadway Books, New York).

Susskind, L. (2005). *The Cosmic Landscape: String Theory and the Illusion of Intelligent Design* (Little, Brown and Company, New York).

SXS. (2019). "Black Holes and Neutron Stars." *Simulating Extreme Spacetimes*, https://www.black-holes.org/the-science/compact-objects/black-holes-and-neutron-stars.

Thorne, K. S. (1994). *Black Holes & Time Warps: Einstein's Outrageous Legacy* (W. W. Norton, New York); cited as BHTW.

Thorne, K. S. (2003). "Warping Spacetime," in *The Future of Theoretical Physics and Cosmology: Celebrating Stephen Hawking's 60th Birthday*, edited by G. W. Gibbons, S. J. Rankin, and E. P. S. Shellard (Cambridge University Press, Cambridge).

*Thorne, K. S. (2012). "Classical Black Holes: The Nonlinear Dynamics of Curved Spacetime." *Science* **337**, 536-38.

Thorne, K. S. (2014). *The Science of* Interstellar (W. W. Norton, New York); cited as TSI.

Thorne, K. S. (2019). Autobiography for Nobel Prize, https://www.nobelprize.org/prizes/physics/2017/thorne/facts/.

Thorne, K. S., and Blandford, R. D. (2017). *Modern Classical Physics* (Princeton University Press, Princeton).

Thorne, K. S., and Blandford, R. D. (2021). *Relativity and Cosmology.* Volume 5 of *Modern Classical Physics* (Princeton University Press, Princeton).

Thorne, K. S., Price, R. H., and Macdonald, D. A. (1986). *Black Holes: The Membrane Paradigm* (Yale University Press, New Haven).

**Visser, M. (1996). *Lorentzian Wormholes: From Einstein to Hawking* (Springer-Verlag, New York).

*Vogt, R. E., et al. (1989). *Proposal to the National Science Foundation for the Construction, Operation, and Supporting Research and Development of a Laser Interferometer Gravitational-Wave Observatory.* LIGO Technical Report. LIGO-M890001-00-M, https://dcc.ligo.org/public/0065/M890001/003/M890001-03%20edited.pdf.

*Weiss, R., Barish, B., and Thorne, K. S. (2018). "LIGO and Gravitational Waves: 2017 Nobel Lectures." *Annalen der Physik* 531,1800349, 1800357, and 1800350.

*Wheeler, J. A. (1962). *Geometrodynamics* (Academic Press, New York).

Will, C. M. (1993). *Was Einstein Right? Putting General Relativity to the Test* (Basic Books, New York).

**Zel'dovich, Ya. B., and Novikov, I. D. (1983). *The Structure and Evolution of the Universe* (University of Chicago Press, Chicago).

ABOUT THE AUTHORS

KIP THORNE

Kip Thorne had a half-century career as a theoretical physicist, focusing largely on exploring the Warped Side of Our Universe — initially (1962–65) as a PhD student at Princeton University under the mentorship of John Archibald Wheeler, and then (1966–2009) as a postdoc then professor at Caltech, and ultimately as Caltech's Richard P. Feynman Professor of Theoretical Physics. As a physicist Thorne cofounded the LIGO project and formulated its initial scientific vision. For his forty years of contributions to LIGO he shared the 2017 Nobel Prize in Physics with Rainer Weiss and Barry Barish. He was an enthusiastic mentor for fifty-three PhD students, many of whom, like Kip, have made major contributions to our understanding of the Warped Side. He is sole author of two prize-winning books for general readers about the Warped Side: *Black Holes and Time Warps: Einstein's Outrageous Legacy* (W. W. Norton, 1994) and *The Science of* Interstellar (W. W. Norton, 2014); and is coauthor of two advanced physics textbooks: *Gravitation* (with Charles W. Misner and John Archibald Wheeler, Freeman and Princeton University Press, 1973 and 2017), and *Modern Classical Physics* (with Roger Blandford, Princeton University Press, 2017). On the web you will find many of his lectures about the Warped Side and other topics, both nontechnical and technical.

In 2009, Thorne began a gradual transition from theoretical physics to a new career at the interface between the arts and the sciences. This has included Christopher Nolan's blockbuster movie *Interstellar*, which grew out of a treatment that Kip coauthored with Hollywood movie producer Lynda Obst and on which he was executive producer and science advisor; a second movie that is under development and based on a treatment by Kip, Stephen Hawking, and Lynda Obst; a collaboration on multimedia concerts about the Warped Side with Oscar-winning composer and musician Hans Zimmer and Oscar-winning visual-effects gurus Paul Franklin and Oliver James; and now this long-awaited book collaboration with Kip's dear friend Lia Halloran: their masterpiece, *The Warped Side of Our Universe*.

LIA HALLORAN

Lia Halloran grew up surfing and skateboarding in the Bay Area and developed a deep love of science while working at the Exploratorium in San Francisco, her first job in high school. She received a BFA from the University of California, Los Angeles (1999), and continued to study astronomy while pursuing her MFA in painting and printmaking at Yale University (2001). For more than twenty years her studio practice has been in dialogue with science and nature, and the empirical position science holds, but joined with the representation of women and the queer community within the culture of skateboarding, flying, science, astronomy, and various other traditionally male-dominated fields. Her studio practice is fluid and exploratory, where concepts determine the medium in which projects are executed and includes painting, drawing, long-exposure photography, video installations, and darkroom techniques of combining painting and photography in cyano-type printing using paintings as negatives.

Halloran has participated in several interdisciplinary projects and collaborations, including curating exhibitions, creating platforms for critical dialogue on contemporary art, and establishing connections between science and art. She is represented by the gallery Luis De Jesus Los Angeles and is Chair of the Art Department and Associate Professor at Chapman University, where she teaches painting and courses that explore the intersection of art and science.

She is the recipient of numerous awards, including a 2022 artist residency at the California Institute of Technology, a 2021/2022 Art Exhibition Program with the Los Angeles Department of Cultural Affairs, a City of Los Angeles (COLA) Visual Artist Fellowship (2021), and an artist residency at the American Natural History Museum Astrophysics Department, New York (2018). In 2016 she received the Art Works Grant from the National Endowment of the Arts for her project *Your Body Is a Space That Sees*.

Over the past fifteen years Halloran has presented twenty-four solo exhibitions and has shown her work in galleries, museums, and institutions nationally and internationally. Her work is included in the permanent collections of the Solomon R. Guggenheim Museum, New York, New York; Escalette Permanent Collection of Art, Chapman University, Orange, California; Progressive Art Collection, Cleveland, Ohio; Microsoft Art Collection, San Francisco, California; Simons Foundation, New York, New York; and Fidelity Investments Corporate Art Collection, Boston, Massachusetts, among others.